Paul Cézanne: *Two Sketchbooks*

This book was published with the support of The Pew Charitable Trusts and an endowment fund for scholarly publications established by grants from CIGNA Foundation and the Andrew W. Mellon Foundation at the Philadelphia Museum of Art

Paul Cézanne

Two Sketchbooks

The Gift of Mr. and Mrs. Walter H. Annenberg
to the Philadelphia Museum of Art

Theodore Reff and Innis Howe Shoemaker

Philadelphia Museum of Art

This book is published on the occasion of an exhibition
at the Philadelphia Museum of Art, May 21–September 17, 1989

Designed by Nathan Garland, New Haven, Connecticut
Composition by Southern New England Typographic Service, Hamden, Connecticut
Printed and bound in Italy by Stamperia Valdonega, Verona

Copyright 1989 by the Philadelphia Museum of Art
Post Office Box 7646, Philadelphia, Pennsylvania 19101–7646

Contents

Foreword

With their gift of two sketchbooks by Paul Cézanne in the winter of 1987, Walter and Lee Annenberg ensured that the Philadelphia Museum of Art would always be one of the greatest resources in the world for the study and enjoyment of that extraordinary artist. From the powerful early still life of 1877 in the Carroll Tyson collection to the airy grandeur of *The Large Bathers* purchased by the Museum in 1937, the twenty-five paintings and drawings by Cézanne preserved in this institution prior to 1987 offered a remarkable range of subjects and rich evidence of his evolving vision as a painter. Now, thanks to one supremely generous gesture, the Museum can also share with a wide audience the diminutive but invaluable treasures of Cézanne's sketches, which reveal his intense originality as a draftsman and his remarkable powers as an observer and delineator of form.

These sketchbooks have been cherished possessions in the Annenberg family since their acquisition almost forty years ago by Mrs. Enid Annenberg Haupt. The decision by Mr. and Mrs. Annenberg to give them to the Museum, where they would be enjoyed by generations, is characteristic of the public-spirited nature of the family, which has contributed so greatly to civic, cultural, and educational institutions and causes in the United States and abroad.

This volume, produced to accompany their exhibition at the Museum, constitutes the first publication of the sketchbooks as two coherent entities and is the result of the collaborative thought and effort of many who have sought the best way in which to present this marvelous group of drawings. The pages of each sketchbook appear in sequence and in actual size, enfolded, as it were, by the larger pages of this book, with each drawing accompanied by a brief discussion of its subject, possible date, or style. The reader can thus follow Cézanne's hand through the sketchbooks as they would have appeared when he carried them about in his pocket, while the visitor to the exhibition or to the Museum's print study room can explore and savor each drawing individually.

These two sketchbooks constitute an addition of immeasurable importance to the holdings of the Department of Prints, Drawings and Photographs. Innis Howe Shoemaker, Senior Curator of the department, has overseen this project with great enthusiasm and judicious attention to every detail. The conservation of the sketchbook pages has been accomplished with extraordinary patience and skill by Denise Thomas and Faith Zieske, respectively

Conservator and Associate Conservator of works on paper. Graydon Wood, the Museum's photographer, recorded each page with exemplary care. George H. Marcus, Head of Publications, supported by the editorial skills of Anne Engel, has accomplished wonders in the production of this complex book, with an ingenious and sensitive design provided by Nathan Garland and fine printing by Martino Mardersteig.

We are grateful to Robert Ratcliffe for permission to illustrate his very apt photographs of the sculpture Cézanne admired and sketched in the Louvre and the Trocadéro, and to Wayne Andersen for sharing his insights and notes on the provenance of Cézanne's sketches. For their gracious assistance in research and tracing the history of pages from the sketchbooks, we are indebted to Eugene V. Thaw, George McKenna, and Ay-Wang Hsia of Wildenstein & Co. As is the case with so many scholarly projects devoted to the art of Cézanne, this one also owes much to John Rewald, who has shared his extraordinary knowledge of Cézanne's work and his unmatched archives.

It is a particular pleasure to express the Museum's profound gratitude to Theodore Reff, whose enthusiasm for the subject impelled him to collaborate on this volume, despite the constraints of an unusually compressed schedule. The thoughtful scholarship of Professor Reff and Innis Shoemaker have made the book a fresh contribution to the formidable existing literature on the art of Cézanne.

Ms. Shoemaker's essay and notes, based on close study of the physical evidence offered by the sketchbooks themselves, suggest avenues for future research into the use and history of all of Cézanne's sketchbooks; Professor Reff's eloquent introduction and cogent catalogue entries on each drawing are models of their kind.

Grants from The Pew Charitable Trusts, The Florence Gould Foundation, and the Bohen Foundation have given essential support to the preparation of the exhibition, and the endowment for scholarly publications received from The Andrew W. Mellon Foundation and CIGNA Foundation has assisted the research and writing of this catalogue. Above all, the encouragement of Mrs. Enid Annenberg Haupt, whose admiration for these extraordinary drawings sustained them over so many years, and the splendid generosity of her brother, Walter H. Annenberg, have made it possible to introduce the sketchbooks to a new audience and to preserve them for the pleasure of generations to come.

Anne d'Harnoncourt
The George D. Widener Director

Introduction

Theodore Reff

Cézanne's sketchbooks were the most private means of expression this most private of painters used—the smallest, the most informal, the least demanding. Small enough to fit in a pocket, they could be carried anywhere and used at any time to record a fleeting observation or to seize again a recurrent dream. In them Cézanne could put down his first vision of a pictorial idea or explore it through a series of studies; work out a composition fully or barely begin it, turn the page, and begin again; list the colors he needed to buy, the books he wanted to read, or the addresses he was given; even keep his young son occupied by allowing him to draw. And though his notes in them were restricted to practical matters, his sketchbooks were indeed his journals; if we read them perceptively, they reveal as fully in a visual as they could in a verbal form the whole span of his emotions from the most exalted to the most sober. Alongside the plans for ambitious bather and genre paintings and the copies after grandiose works by Rubens and Puget, we find portraits of his son asleep, very simple and tender in feeling, and patient studies of a branch of foliage in flower, a few kitchen utensils, a single glass.

The sketchbooks also bring us close to Cézanne's process, even closer than do his watercolors and paintings, where the process is already exposed to an unprecedented degree. For in the sketchbooks we can follow the evolution of a single idea, the pose of a single bather, through six or eight variations as he seeks the definitive form; or trace the connection between a copy after a portrait bust or figure drawing in the Louvre and one of his own portraits or bathers; or observe the transformation, stroke by stroke, of a simple study of a kerosene lamp and some books into a statement of remarkable power and rigor. The lamp is indeed a frequent subject, reminding us that many of the sketches were made by lamplight, in the evening, when the museums were closed and the daylight Cézanne needed as a painter was gone. And the quiet intimacy of these simple studies of his immediate surroundings and companions, his furniture and unmade bed, himself lying on it at times, or his young son reading or asleep, makes them among the most touching of all his drawings.

Of the eighteen or nineteen Cézanne sketchbooks whose existence is known or can be hypothesized on the basis of groups of drawings of the same size, only seven are still intact;[1] and of these, one is very early, one very minor, one very incomplete, and in one the order of the pages has been changed. Thus only three of them provide clear, easily accessible evidence of the ways Cézanne actually used his sketchbooks in his mature years. Although the two in Philadelphia were dismantled some time after 1950, they had already been catalogued before that date[2] and can therefore be reconstructed, as they have been for the present volume. Moreover, many of the pages not reproduced by Rewald, or later by Chappuis (by then they were hidden behind the mats of the separately framed drawings), are reproduced here for the first time, and several pages that had been removed before 1950 and can now be identified are reproduced as well. Thus the two sketchbooks appear here more completely intact and correctly ordered, more fully comprehensible as the collective objects they are, than at any time in perhaps the last fifty years.

They are of course also more accessible in a public museum than they were in the private collection where I first saw them about thirty years ago, while completing the research for a dissertation on Cézanne's drawings. I photographed some of the previously unreproduced pages, but could only wonder what the ones hidden behind mats looked like. Returning to them now, after having published several articles in which pages from these sketchbooks played a part, and above all after having catalogued Degas's notebooks, I find them more interesting and moving than ever. Some of these drawings, for all their modesty of scale and privacy of vision, are in my opinion among the most beautiful of any that Cézanne made. The sketch of a kerosene lamp and books (Sketchbook I, p. 15 verso), the copy after Pilon's *Monument to Henry II* (Sketchbook II, p. v recto), the study of a standing male bather (Sketchbook II, p. xxxiv recto), although different from one another in purpose and style, share a com-

pleteness and fullness of expression that is at once classical and deeply personal, one in which the opposed qualities of spontaneity and order, of delicacy and force, are perfectly reconciled.

Comparisons with Degas's notebooks come naturally to mind, helping us define more precisely why and how Cézanne used sketchbooks such as those in Philadelphia. Unlike Degas, he did not use them as agendas, journals, or travel diaries, did not fill them with literary quotations or drafts of his poetry or with theoretical or technical notes; indeed the only writing is an occasional address or list of things to buy. But like Degas, and other artists as well, of course, Cézanne did use these most portable of drawing surfaces to record his impressions of the worlds he inhabited: the public world of urban parks (though not of streets) and of rooftops and church towers; the domestic world of chairs and beds, clocks and lamps, and his immediate family; and above all the world of art, especially the old masters in the Louvre and the museum of casts, and his own projects for paintings, whose designs he could work out conveniently in this small format. Unlike Degas, again, who usually filled one notebook at a time or a few concurrently within a short time, Cézanne seems to have used his sketchbooks in an irregular, random manner, at times for brief periods with long intervals between. Some of the copies on successive pages after works installed together in the Louvre were surely made on the same occasion, as were some of the studies, likewise on successive pages, of a particular bather type or of his son asleep. But the intervals between such occasions must have been long and the sketchbooks were often filled with much more disparate material, added from either the front or the back, since the covers are indistinguishable.

This random usage has made it difficult to date the sketchbooks with any certainty, and the difficulty is compounded by that very privacy of their contents which makes them so appealing: there was no need to inscribe a date or record a visit, no reason to allude to events in the art world or the larger world beyond it, to cite but a few of the kinds of information that are so helpful in dating Degas's notebooks. And since Cézanne rarely made studies

for paintings other than bather compositions, and in these he tended to repeat the same figure types over and over, those studies, too, are of limited value in dating the sketchbooks. Moreover, the paintings themselves are difficult to date, and their chronology has long been a subject of disagreement among scholars.

About the sketchbooks the disagreements are still greater, involving in some cases differences of a decade or more in their spans of usage.[3] The two in Philadelphia fare somewhat better than the others in this respect. Sketchbook I is dated 1870–90 by Rewald and its individual pages are dated between 1871–74 and 1896–99 by Chappuis.[4] In the same way, Sketchbook II is dated 1872–95 by Rewald and its pages between 1871–74 and 1900 by Chappuis.[5] The uncertainty is indeed so great that some of the individual drawings have been assigned dates as much as two decades apart: thus, the copy after a Hellenistic *Crouching Venus* in Sketchbook I, page 11 verso is dated 1879–80 by Berthold and 1892–96 by Chappuis,[6] and the slight sketch of a seated man in Sketchbook II, page VIII verso is dated 1892–94 by Andersen and 1871–74 by Chappuis.[7] These differences of opinion reflect not only the difficulties already discussed, but also those that emerge when we attempt to date Cézanne's drawings on the basis of their style; for once we go beyond the broad outlines of his development, on which there is general agreement, we find so many variations in his style (or styles) at a given moment, depending for example on the subject and purpose of a drawing and on the time and care devoted to it, that dating by this means alone is bound to seem somewhat arbitrary and is often disputed.

The solution, as almost everyone has realized, is to date as many drawings as possible on some basis other than style. In some cases this is fairly easy and has already been done by others. The study for the painting *Mardi Gras* (Sketchbook I, p. 18 verso), which Cézanne's son recalled having posed for in 1888, can be dated to that year. The portraits of the son, born in 1872, can sometimes be dated by his apparent age: about 1882 where he appears about

ten years old (Sketchbook I, p. 2 verso), about 1885 where he appears about thirteen (Sketchbook II, p. VI recto). And the copies after Benedetto da Maiano's *Filippo Strozzi* and Pigalle's *Love and Friendship* (Sketchbook I, p. 23 verso; Sketchbook II, p. XVI recto, etc.), both put on view in the Louvre in 1879, can be dated to that year or later. In other cases, more thorough research and ingenuity have been required, and the results are new. The graphic artist Hermann-Paul's address obviously must have been written when he lived there, which was after 1897 and before 1905 (Sketchbook II, p. L verso), just as the address on the rue de Lourcine (Sketchbook I, p. 3 recto) must have been written before 1890, when the name of the street was changed to rue Broca. The views of Paris showing the churches of Saint-Sulpice and Notre-Dame-des-Champs in a certain alignment (Sketchbook I, front endpaper, p. 8 verso) must have been drawn from the apartment on the rue de l'Ouest that Cézanne occupied between 1880 and 1882.[8] The copies after casts of Puget's Atlases were probably made, in one case (Sketchbook I, p. 15 recto), before the casts were transferred from the Louvre to the Musée de Sculpture Comparée in 1886 and, in the other (Sketchbook II, p. L verso), after they were transferred. And most important of all, the label of the stationery shop in Sketchbook I (front endpaper) shows that this book must have been bought, and therefore begun, between 1882 and 1884; hence, none of its drawings can be dated in the 1870s, as had been assumed from stylistic analysis alone.

On the basis of these and similar discoveries, it is now possible to propose a narrower span of usage for each sketchbook than those previously proposed; namely, 1882–90 for Sketchbook I and 1885–1900 for Sketchbook II. But even these results, which narrow the spans from twenty or twenty-eight years to eight years in one case, and from twenty-three or twenty-nine to fifteen in the other,[9] are somewhat unsatisfying, especially in the second case. It is still hard to imagine Cézanne picking up and putting down so small an object over a period of so many years, not to mention still being able to find it after numerous moves both within Paris and its environs and between Paris and Aix. Shorter spans

of usage would obviously make more sense, but until further discoveries or convincing observations are forthcoming, we will have to accept the ones we now have.

However long the periods in which he used the Philadelphia sketchbooks, the subjects Cézanne chose to draw in them changed very little. Of the outside world, he occasionally drew views over Paris from the windows of his sixth-floor apartment, and occasionally a corner of a public garden or a larger landscape outside the city; altogether these account for only eight percent of the drawings. At home he remained content with the same simple pieces of furniture and clothing, the same few bowls and pitchers, in twelve percent of the drawings, and he portrayed his son—at different ages, but in the same passive states, reading or asleep—in ten percent of them. Working from imagination, he tended to draw the same few types and groups of bathers repeatedly, and turned to other figure subjects only rarely; the former appear in nineteen percent of the drawings, the latter, in seven percent. At the Louvre and the Musée de Sculpture Comparée, where he made by far the largest number of drawings, forty-four percent of the total, he ignored the great artistic traditions of the ancient Near East and Egypt, of the Orient from Persia to Japan, and of the entire medieval world, much of which keenly interested Degas, Gauguin, and other contemporaries, concentrating instead on a relatively small number of works from classical antiquity and the Renaissance and Baroque periods. The impression we get is of a mind very certain of its limited tastes and interests and seeking not to expand them but rather to explore them more deeply.

It is indeed striking, when we look through these two sketchbooks used at different, if overlapping, periods in Cézanne's career, how many of the same subjects appear in both. We find copies after the same sculptures—Benedetto da Maiano's bust of Filippo Strozzi, Pilon's *Monument to Henry II*, Puget's Atlases and *Hercules Resting*, Coustou's bust of Père de La Tour, and Barye's *Lion and Serpent*—and the same Signorelli drawing of a standing male nude;

moreover, the Barye and the Signorelli appear only in these sketchbooks. We also find many studies of the same two bather types, the one facing left with his hands behind his head and the other seen from behind and holding a towel, as well as many portraits of the same person, Cézanne's son reading or asleep. And if in these cases the duplication seems natural enough, since there are similar portraits and bather studies in some of the other sketchbooks, the drawings in these two that were evidently made on the same occasion, showing the same derby-hatted man (Sketchbook I, p. 31 recto; Sketchbook II, p. XXIII verso), are harder to explain in such terms. We almost have to imagine Cézanne carrying a sketchbook in each pocket and switching from one to the other as he drew. That he used the two concurrently at certain times in the 1880s becomes more apparent, in fact, the more we move back and forth within and between them.

In examining the sketchbooks in that way—and it is one of the great advantages of seeing them intact or at least reconstructed, as they are here—we learn much from the placement or sequence of certain drawings that would not be possible when viewing them in isolation. This is especially true about the connections between the works Cézanne copied in the Louvre and his own portraits and figure paintings. Seeing the bust-length portrait of his adolescent son in the same sketchbook as the copy after Benedetto da Maiano's bust of Filippo Strozzi (Sketchbook II, pp. XXX recto, LII verso), likewise facing three-quarters to the right and strongly illuminated from the left, makes it clear how much Cézanne learned from Renaissance sculpture about the firm definition of the features and the solid, compact mass of the head. Seeing the studies of a male bather in a powerfully twisted pose interspersed with the copies after Michelangelo's similarly twisted *Dying Slave* (Sketchbook II, pp. XXXVIII recto, XLII verso, XLIII verso) not only confirms the derivation that several scholars have noted, but also makes it concrete and immediate, as if we were following Cézanne from the studio to the Louvre and back again. And in some cases, seeing a bather study and a copy juxtaposed in this way allows us to discover a new connection, and with it a new understanding of his creative process: the sketch of a bather with both arms raised, an unusually expansive pose in Cézanne's work, occurs within a few pages of the copies after drawings by Signorelli and Michelangelo of figures in very similar poses (Sketchbook II, pp. XXXI recto and verso, XXXIV recto), and suggests that Cézanne sought those models in the first place with this eventual use in mind.

For Cézanne, who unlike most of his colleagues continued to copy in the Louvre throughout his life, this practice had a psychological as well as an aesthetic basis. As John Rewald has pointed out, "Paintings and sculptures replaced living models, with the added advantage that they didn't move. Furthermore, Cézanne never felt before them that paralyzing awkwardness which always seemed to have oppressed him when he worked from a nude model."[10] Many of the copies in the Philadelphia sketchbooks are indeed of nude figures, whether painted, sculpted, or drawn; and several are isolated from much larger compositions by Rubens, Boucher, and other masters, in which they are the only nudes. Rarely does Cézanne focus on more than one figure, except in copying a sculptural group; the problems of composition that absorbed him as a painter do not seem to have concerned him as a copyist, despite his often quoted (and often misunderstood) remark about redoing Poussin from nature. Neither Poussin nor nature, in the form of landscape painting, appears among the models for the copies in these sketchbooks, nor do Chardin and still life painting; and among all the known copies, works by Poussin and Chardin appear only four times. It was not as a painter of landscape and still life that Cézanne drew after the old masters, though he may well have learned from them simply by observation; it was primarily as a painter of nude figures. But also as a painter of portraits: indeed portrait busts from ancient Rome, Renaissance Italy, and eighteenth-century France account for twenty percent of the copies in the Philadelphia sketchbooks—a proportion that seems surprising only if we continue to think of Cézanne's own portrait drawings as "pure excursions into the realm of plas-

ticity."[11] On the contrary, both the copies and the portraits reveal a deep interest in finding the means, within the self-imposed limits of his style, of conveying the enduring traits as well as the changing expression in a human face. The copies after Coustou's bust of Père de La Tour, for example, show how subtly he could explore the ways in which slight changes in viewpoint, lighting, and graphic style would alter the expression even of an unalterable terra-cotta face.

As the names already mentioned suggest, the old masters Cézanne admired and copied most frequently were those of the Baroque period or the baroque phase of an earlier period, those whose exuberant, sensual, and dramatic art struck a responsive chord in his Provençal temperament. Rubens in painting and Puget in sculpture were his favorites, to judge from the number of times he copied the magnificent pictures in the Maria de' Medici cycle and the monumental statues of Hercules and Milo of Croton. In the Renaissance, the master Rubens and Puget themselves most admired, the "great and terrible" Michelangelo, was also a favorite of Cézanne, who drew repeatedly after his statues and drawings in the Louvre. Even in antiquity, it was Hellenistic rather than archaic or classical art, statues like the *Crouching Venus* and the *Venus of Milo*, that most appealed to him, though he did copy the more severe *Borghese Mars*. And just as he walked past many of the Louvre's greatest treasures to stand before this relatively restricted number of works, so he passed through the rooms containing casts of the greatest monuments of Romanesque, Gothic, and Renaissance sculpture in the Musée de Sculpture Comparée, stopping only in those devoted to the seventeenth and eighteenth centuries. His taste, or at least its dominant trait, is summed up in his well-known remarks on Puget's sculpture, expressing his admiration for its dramatic intensity, "the *mistral* that agitates his marbles," and for its richly pictorial effect: "It is decorative sculpture, as sculpture should be. . . . [He] painted, he created shadows."[12]

For all his admiration of the baroque drama and colorism of Puget's statues, Cézanne often copied them so incompletely, or from viewpoints so eccentric, that their narrative content is obscured. In most of his drawings after the *Hercules Resting*, the figure is seen from the back, where his lion skin and club are concealed; and in most of those after the *Milo of Croton*, either the view chosen or the incompleteness causes Milo's hand, caught in the tree trunk, and the attacking lion to be invisible. The copies after one of the Toulon Atlases (Sketchbook II, pp. L recto and verso) were drawn from a position so nearly below and to one side that they are scarcely recognizable, and the same is true of a copy after the *Milo of Croton* (Sketchbook I, p. 25 verso).

This indifference to narrative meaning, and even at times to representational meaning, extends beyond the copies to many other subjects Cézanne treated. It can make simply trying to identify them a complicated affair, especially when a sketch is unfinished, as most of them are to some degree. The drawing of a tall chair back embroidered with a floral pattern (Sketchbook I, p. 21 recto) is so delicate and diffuse that it has been described as a study of actual foliage. The small sketch of a pair of sewing scissors (Sketchbook I, p. 24 recto), although always recognized as such, remains in its unfinished state an enigmatic image; and the two household objects on another page of this sketchbook (p. 43 recto) can only be described as a bowl or a lamp alongside something bulb-shaped. These difficulties increase when we turn to Sketchbook II, where many of the small objects represented have the enigmatic look of familiar things we cannot quite identify, as in a painting by De Chirico. Is it a drapery "swelling like a wave" or a bowler hat on page III recto? A bowl or a boy's head or a visored cap on page IV recto? Is it the artist's hand holding a cloth or his son's hand supporting his head on page XLVI recto? A shirt or jacket or overcoat whose notched collar alone appears on page XLVII verso? The answers are less important than the questions; for these oblige us to realize once again how much Cézanne omits or simplifies in representing his world, how much he concentrates instead on discovering a pictorial order within it. Indeed, the order created by a form or pattern often emerges from his sketches more vividly than a recognizable image of the thing itself. The artist "is neither over

scrupulous nor too sincere nor unduly subservient to nature," he advised a younger colleague, "but he is more or less the master of his model and, above all, of his means of expression."[13]

In concentrating on the pattern that unites an object with its neighbors or its background, Cézanne places the greatest emphasis on its shape and consequently on the outlines that define its shape. Hence his frequent use of dark, heavily incised strokes along the edges of forms, whether he is drawing a household object, a bust or statue, or a human being. Rarely do these strokes trace a continuous outline, however, in the manner of neoclassical and academic drawings. For Cézanne, the object is inseparable from its surroundings, and the repeated, broken lines evoke their constant interaction, like the repeated touches of color along the edges of the forms in his paintings and watercolors. It is indeed as a painter that Cézanne draws, and his statements on drawing prove that he was perfectly aware of this: "Lines and modeling do not exist; drawing is a relationship of contrasts or simply the relationship of two tones, white and black."[14] And again: "Pure drawing is an abstraction. Drawing and color are not at all distinct, everything in nature has color."[15] Even the least developed of his sketches (e.g., Sketchbook I, pp. 21 recto, 22 recto) contain some indications of tone—the equivalent of color in his paintings—to suggest the shading of a form, the shadow it casts, or the other forms and spaces around it. In some of those that were more fully worked (e.g., Sketchbook I, pp. 11 verso, 18 recto), the shading remains confined to the areas nearest the contours, creating concentrated darks that make the largely untouched forms within them seem to emerge with almost dazzling brightness; whereas in some of the others (e.g., Sketchbook I, pp. 8 verso, 15 recto), the more extensive shading evokes space and atmosphere or unusually oblique illumination.

Although "everything in nature has color," as Cézanne pointed out, many of the things he chose to draw were monochromatic or were viewed in circumstances that made them appear so. Thus, the bronze or marble sculptures in the Louvre, the plaster casts in the Musée de Sculpture Comparée and in his studio, the porcelain or metal objects in his kitchen, even his sleeping son in bed and his own bed when seen by lamplight were all ideally suited for rendering in the black-and-white medium of a pencil drawing.[16] Some of the subjects he chose were intrinsically colorful, it is true, and a few of the drawings in the Philadelphia sketchbooks (e.g., Sketchbook I, pp. 18 verso, 26 recto) are reworked in watercolor, while the incidental touches of watercolor on a few of the others (e.g., Sketchbook I, pp. 17 recto, 45 verso) imply that these sketchbooks originally contained more drawings reworked in this way and thus must have given a more generally colorful impression than they do now. (In the essay that follows, Innis Shoemaker identifies a number of these watercolors, which had already been removed when the sketchbooks were first catalogued in 1950.) But even in their present, almost entirely monochromatic state, the Philadelphia sketchbooks convey the vividness, one could even say the colorfulness, of a sensibility acutely alive to the world around it. And at the same time, and with the same force, they convey the sobriety of an intellect long accustomed to the patient, disciplined observation of even the smallest elements in that world.[17]

Notes

1. See Chappuis, 1973, vol. 1, pp. 21–22.

2. See Rewald, 1951, vol. 1, pp. 23–29, 42–49.

3. Of the five published by Rewald, the three not in Philadelphia have been dated as follows. The Chicago sketchbook: 1875–85 by Rewald (1951, vol. 1, p. 30); 1869–86 by Schniewind (1951, vol. 1, p. 21); 1876–85 by Andersen (1962, pp. 196–200); 1870–85 by Chappuis (1973, vol. 1, p. 23). The Louvre sketchbook: 1880–81 and 1888–95 by Rewald (1951, vol. 1, p. 39); 1888–90 by Andersen (1965, p. 317, note 19); 1888–99 by Chappuis (1973, vol. 1, p. 23). The Block/Thaw sketchbook: 1875–85 by Rewald (1951, vol. 1, p. 50); 1873–94 by Chappuis (1973, vol. 1, passim: dates of individual pages).

4. Rewald, 1951, vol. 1, p. 23; Chappuis, 1973, vol. 1, passim.

5. Rewald, 1951, vol. 1, p. 42; Chappuis, 1973, vol. 1, passim.

6. Berthold, 1958, no. 19; Chappuis, 1973, no. 1097.

7. Andersen, 1970, no. 255; Chappuis, 1973, no. 225.

8. I take the liberty of calling "new" a discovery I first published in 1959. It is the method used there that still seems to me new and capable of wider application.

9. See the estimated spans of usage by Rewald and Chappuis, cited above.

10. Rewald, 1951, vol. 1, p. 16, as translated by Olivier Bernier in Rewald, 1982, p. 9.

11. Rewald, 1951, vol. 1, p. 15; trans. Rewald, 1982, p. 8.

12. Cited in Gasquet, 1926, p. 191.

13. Cézanne, 1984, p. 298.

14. Quoted in Larguier, 1925, p. 135.

15. Larguier, 1925, p. 135; see also Bernard, 1926, p. 32.

16. This observation is first made in Rewald, 1951, vol. 1, pp. 14, 16.

17. For her many helpful suggestions, both in the introduction and the catalogue entries, I want to thank Barbara Divver.

The Philadelphia Sketchbooks: Past and Present

Innis Howe Shoemaker

The two Cézanne sketchbooks now in the Philadelphia Museum of Art have been known to the public since 1951, when John Rewald published them as part of a group of five sketchbooks that had been together in a Lyons collection since the artist's family sold them in the 1930s.[1] At the time of Rewald's publication, these two sketchbooks had just been acquired by Mr. and Mrs. Ira Haupt of New York; they remained in that collection until Mrs. Haupt sold them in 1983 to her brother Walter Annenberg and his wife, who donated them four years later to the Philadelphia Museum of Art. This is the first time that all the surviving pages of the sketchbooks have been reproduced and it is also the first time that Philadelphia Sketchbooks I and II have been studied as independent entities.

Except for differences in their dimensions, most of Cézanne's sketchbooks have the same general characteristics. They are bound with natural linen or canvas over paper board and bear evidence of use, with dirt and spots of watercolor and oil paint. They are modest, utilitarian sketchbooks containing off-white, wove-paper pages, often with no watermark; in some of them the white pages are interspersed with colored sheets, which Cézanne generally left blank. Cézanne usually drew in graphite pencil, and a few of the sketches are modestly heightened with watercolor. A number of true watercolors over some graphite underdrawing have also been identified as having come from sketchbooks, but almost all of them are now loose sheets, which were mostly removed before the sketchbooks themselves were sold. The original appearance of many of Cézanne's sketchbooks must therefore have been much richer and more diverse than is apparent in the ones that are still bound. Indeed, it can be demonstrated that several watercolors were removed from one of the Philadelphia sketchbooks, and almost certainly from the other as well, and watercolors must be imagined as having enlivened the sequence of graphite drawings reproduced here.

The Philadelphia sketchbooks were still bound when Rewald published them in 1951, but each of them already lacked several pages.[2] Shortly after they entered the Haupt collection, they were unbound and their covers and pages were matted and framed. The incomplete and dismantled state of the Philadelphia sketchbooks is, however, far from unusual. In fact, it is difficult to call very many of Cézanne's sketchbooks intact in the strictest sense, that is, in their original bindings and with all the original pages. Adrien Chappuis, whose catalogue raisonné of 1973, *The Drawings of Paul Cézanne*, offers the most complete summary of available information on the artist's known sketchbooks,[3] lists eighteen, though many have been dismantled and their pages dispersed. Thus, some of the sketchbooks on Chappuis's list are essentially groupings of loose sheets of like dimensions and without surviving covers, now in many different collections. Some of the sketchbooks listed still have their original covers, even if not all are bound. However, a bound sketchbook is not necessarily an intact one, and in at least one case it is known that a book has been taken apart and rebound.[4]

The five sketchbooks published by Rewald in 1951 were bound, although the two in Philadelphia each lacked several pages, while the one in Chicago may have been rebound but appears to be intact. The sketchbook in the Louvre is also bound and Chappuis notes that it is intact, although he also suggests that one page may have been removed from it.[5] The sketchbook now in the Thaw collection was rebound and renumbered in a slightly different order while it was in the Leigh Block collection, but it does not seem to lack any of its pages.

The first major publication of Cézanne's sketchbooks was Lionello Venturi's *Cézanne, son art—son oeuvre* of 1936.[6] Venturi catalogued only seven sketchbooks: four of them belonged to Chappuis, and three to the Kunstmuseum, Basel. All seven of the sketchbooks had had pages removed from them, although one of Chappuis's sketchbooks, now in the collection of Mr. and Mrs. Paul Mellon, lacked only one page. The Basel sketchbooks were without covers while three of the four that Chappuis owned still had their original bindings. In 1962 Chappuis catalogued the Basel sketchbooks, making some corrections to the entries in Venturi's catalogue, and in 1973 published all of the known pages

of the seven sketchbooks in his catalogue raisonné, reconstructing the scattered contents of each of them.[7] Also listed by Venturi and later by Chappuis were several sheets in the Kunstmuseum, Basel, which were independent of the three Basel sketchbooks.[8] Chappuis identified some of those sheets as the contents of two additional sketchbooks, which he called the "10.3 x 17 cm. sketchbook" and the "18 x 24 cm. sketchbook." Those sketchbooks are far from complete and, as with the seven sketchbooks just discussed, pages from each are to be found in several collections.[9]

Four other Cézanne sketchbooks were listed by Chappuis in 1973: the so-called *Carnet violet moiré* in the collection of Mlle Edmée Maus, Geneva, which appears to be intact and is in its original binding;[10] the so-called *Carnet de jeunesse* in the Louvre (RF 29949), which lacks at least one page[11] but retains its covers; and an incomplete series of pages from an early sketchbook in the Bezalel National Museum in Jerusalem. Finally, Chappuis mentions "a few rare leaves done in the artist's youth that would seem to come from two sketchbooks otherwise unknown." He suggests that all the pages may have come from the same sketchbook.[12]

The covers and the contents of the two Philadelphia sketchbooks are similar to Cézanne's other sketchbooks. The smaller one, Sketchbook I, measures 11.6 by 18.2 centimeters, which is a unique size among Cézanne's known sketchbooks; all of the pages are off-white, wove paper with no watermark. A label pasted on the inside of the front cover of Sketchbook I, however, shows that Cézanne bought it at the Papeterie Michallet in Paris during a brief period between 1882 and 1884, when the shop was owned by Pluchet, a successor to the original owner.[13] The source of the slightly larger Sketchbook II is unknown. Its pages are also of off-white wove paper with no watermark, and its dimensions (12.7 x 21.6 cm) are very close to those of three other known Cézanne sketchbooks,[14] which makes it nearly impossible to identify precisely any of the pages that were removed from it.

The two sketchbooks have numbers at the lower right corners of most of the recto pages. On some sheets, the numbers have been erased, proba-

bly for aesthetic reasons when the sheets were separated for matting and framing. Sketchbook I is numbered in a soft bluish-gray colored pencil with Arabic numerals, and Sketchbook II, in the same kind of pencil with Roman numerals. This is typical of the numbering of the pages of the other Cézanne sketchbooks, whether bound or unbound. Another characteristic of the numbering of Cézanne's sketchbooks is that the total number of pages contained in each sketchbook, multiplied by two, is noted on the back endpaper by the same hand that numbered the pages. In the case of the Philadelphia sketchbooks, these notations may be interpreted as follows: "47 x 2," inscribed on Sketchbook I, indicates that when the book was numbered it contained forty-seven recto and verso sheets;[15] Sketchbook II, inscribed "LII x 2," had fifty-two recto and verso sheets.

It has been apparent to all scholars who have studied Cézanne's sketchbooks in detail that the pages were numbered by a single individual.[16] No one has supposed that Cézanne himself numbered the pages and, as Chappuis observed, he would have had no reason to do so. Paul Cézanne *fils* has been suggested, because he was responsible for the dispersal and the dismantling of some of the sketchbooks, but those who knew him personally did not believe he would have troubled to do so.[17] What is evident, in any case, is that the pages of Cézanne's sketchbooks were numbered before they left the family, since Paul Cézanne *fils* dispersed them to more than one person. Chappuis reasonably observed that they were probably numbered in order to keep track of their contents when they were entrusted to photographers or shown to visitors.[18]

Chappuis makes it clear that the Cézanne family made no effort to preserve the sketchbooks intact.[19] It is not surprising that of the pages separated from the sketchbooks many were either watercolors or more complete drawings, as their attractiveness and potential market value were certainly greater. Chappuis has suggested that drawings and watercolors were extracted from the sketchbooks by the family for a variety of reasons: to exhibit or sell, to give as gifts, or to have them photo-

graphed for publications such as Georges Rivière's *Le Maître Paul Cezanne* of 1923, in which some thirty drawings and watercolors were reproduced, several of which came from sketchbooks.[20]

The evidence of early publications and exhibitions suggests that the family began to break up the sketchbooks at least by 1920,[21] but it would seem that the dispersal of individual pages and of the sketchbooks themselves did not occur actively until the early 1930s. Chappuis observes that around 1930 Paul Cézanne *fils* began to sell greater numbers of drawings and watercolors than paintings because there was a demand for less expensive works, and he notes that Ambroise Vollard sold some sheets in 1933 and 1934.[22] In the same years, Kenneth Clark acquired some loose sketchbook sheets directly from Paul Cézanne *fils* and from the dealer Paul Guillaume.[23] In addition, Maurice Renou, one of the Paris dealers involved in the sale of Cézanne's sketchbooks, revealed to Chappuis that Paul Cézanne *fils* had given him and Paul Guillaume a group of loose drawings and some sketchbooks to sell in the spring of 1934. Renou related that at that time several of the sketchbooks were already not complete, the bindings were partially damaged, some sheets had vanished, and the covers of two of them had become detached. He could not, however, remember precisely which sketchbooks had been in this lot. Chappuis speculates that these were the seven sketchbooks catalogued by Venturi in 1936, three of which were acquired by the Kunstmuseum, Basel, and four by Chappuis himself.[24] This story is corroborated by Rewald, who saw those seven sketchbooks in the possession of Guillaume's widow shortly after the dealer's death in 1934, when Rewald had them photographed by Poplin.[25]

Chappuis suggests that Paul Cézanne *fils* decided to sell the group of five sketchbooks (which included the two now in Philadelphia) a little later than the lot he had dispersed in the spring of 1934, perhaps between 1934 and 1938, and that Maurice Renou sold them at that time to a collector in Lyons.[26] Kenneth Clark, however, claimed that when he visited Guillaume's shop in 1933 or 1934 the dealer told him of a collector from Lyons who was interested in some sketchbooks and who was coming to Paris to see them; Clark believed that it was then that the so-called Lyons sketchbooks were sold.[27] One explanation for the conflicting stories about the Guillaume/Renou provenance may be simply that Cézanne *fils* gave the sketchbooks to both Guillaume and Renou to sell, as Renou said had been done with the drawings and sketchbooks that Cézanne *fils* dispersed in the spring of 1934. It seems reasonable to conclude, in any case, that around 1934 the five sketchbooks passed to the Lyons collector/dealer Poyet, from whom they went to the Brochier collection, also in Lyons. It is not absolutely certain when those transactions took place, nor is it known when the sketchbooks reentered the hands of Renou and Poyet, by that time in business together in Paris, who then sold them in 1950 to the New York dealer Sam Salz.[28]

A press release issued on January 18, 1951, by the Art Institute of Chicago states that Salz offered that museum's curator Carl Schniewind first choice of the "Lyons" sketchbooks.[29] Mr. and Mrs. Leigh Block, Chicago collectors, apparently upon Schniewind's advice, obtained their sketchbook next, and then Mr. and Mrs. Ira Haupt of New York acquired the two sketchbooks now in Philadelphia. The fifth sketchbook was donated by Salz to the Louvre, upon Rewald's suggestion. In 1951 Rewald listed all of the pages of the five "Lyons" sketchbooks, and illustrated many of them, thereby creating a record of them as a group before they were allocated to their new owners.

As mentioned above, the two Philadelphia sketchbooks were unbound and the individual pages were matted and framed soon after Mr. and Mrs. Haupt acquired them.[30] Blank pages, of course, were not framed and they seem to have disappeared; Rewald's 1951 catalogue list of the sketchbook pages, which designates the blank pages in the sequence of the bound books as well as those that had been removed, is therefore an especially valuable inventory. Only two subsequent inventories have been made of the sketchbooks: one around 1977 by Wildenstein while they were in the Haupt collection,[31] and the other when they entered the Philadelphia Museum of Art in 1987. The three inventories differ slightly from one another.

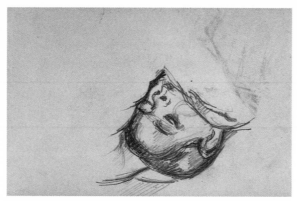

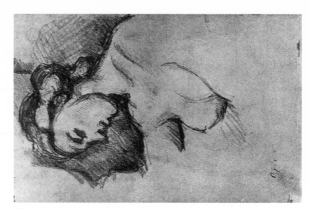

Figure 1
Sketchbook I, page 3 verso
The Artist's Son Asleep
Graphite pencil; traces of watercolor;
graphite offset from page 4
Philadelphia Museum of Art
Acc. no. 1987-53-4b

Figure 2
Sketchbook I, page 4 recto
Female Figure, after Couture
Chappuis, 1973, no. 638
Pencil, 11.6 x 18.2 cm
Location unknown

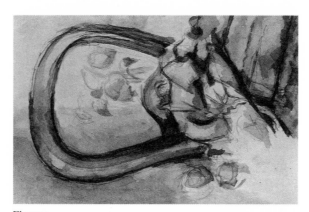

Figure 3
Sketchbook I, page 4 verso
Back of a Chair
Rewald, 1983, no. 188
Pencil and watercolor, 11.6 x 18.2 cm
Location unknown (photograph
courtesy of John Rewald)

One of the most fascinating challenges presented by the study of the Philadelphia sketchbooks is that of identifying the pages that were removed from them and locating, insofar as is possible, where those sheets could have fallen within the sequence of the books. It has also been possible to learn something about the dismantling of Cézanne's sketchbooks generally by tracing the provenances and the early publication and exhibition histories of the sheets since their removal. Chappuis (1973) and Rewald (1983) have each published several of the pages that were removed from the Philadelphia sketchbooks, but efforts to check those sheets for page numbers and measurements and to propose others as pages missing from these sketchbooks have been impeded by the fact that the relevant sheets could be studied only from photographs. Still, the recording of dimensions and page numbers in Chappuis's catalogue of the drawings has proved to be admirably correct, and his suggestions for matching loose sheets with known sketchbooks are reliable and most useful.

There has, in fact, been little to add to Chappuis's reconstruction of missing sheets for the two sketchbooks under discussion here. It has been possible, however, to be more precise about the locations of some of the pages within Sketchbook I, following a study of page numbers, or of images of drawings that have transferred, or offset, onto adjacent pages,[32] or of related subjects that occur on nearby pages. Unfortunately, this process has been less successful for Sketchbook II, because while the dimensions of the first sketchbook are unique, those of the second are similar within one- or two-tenths of a centimeter to three of Cézanne's other sketchbooks. It has not been possible, therefore, to suggest missing pages for the second sketchbook much beyond what has already been published.

According to Rewald's catalogue list of 1951, six pages were missing from the first sketchbook: pages 4, 5, 16, 19, 20, and 46.[33] Of those, it is possible to identify page 4, which is one of the sheets Chappuis identifies as having come from the sketchbook but without any designation of its location (fig. 2).[34] Fortunately, an Arabic number four can be detected in the photograph of the drawing, which is a copy after a female figure in Couture's vast painting *Romans of the Decadence* now in the Musée d'Orsay.[35] The number appears in the lower righthand corner of the sheet opposite the binding; not only is it the number of a page known to be missing from the sketchbook but it is also similar in style to the other numbering and in the proper location on the sheet. The sketch after Couture can be identified as the recto as all of the page numbers appear on the recto sides of the sketchbook.

The verso of the sheet, which is published as the recto by Rewald, is a very beautiful watercolor of the back of a chair surrounded by flowered wallpaper (fig. 3).[36] Further evidence for the identification of this sheet with page 4 of the sketchbook is an offset clearly visible on the verso of page 3 (fig. 1), which shows an angular configuration of straight lines identical to a shape in the upper righthand corner of the watercolor. Evidently, these lines were transferred from the watercolor, through the graphite of the drawing on page 4 recto, onto the verso of page 3. The offset on page 3 verso is definitely a graphite transfer, and the pressure Cézanne evidently applied to that area of the watercolor on page 4 verso could easily have transferred through the dark area of graphite in the drawing after Couture. The offset provides an additional piece of evidence about the sequence of execution of the drawing and the watercolor on page 4, and shows that the drawing must have been made before the watercolor, since otherwise the transfer of graphite to page 3 could not have taken place.

The watercolor of the chair back was published in Venturi's catalogue raisonné in 1936,[37] when it was already in the collection of Kenneth Clark. In 1963 Clark told Wayne Andersen that he had acquired the sheet in 1934 from Paul Guillaume at the time Paul Cézanne *fils* decided to sell a large group of drawings, watercolors, and sketchbooks. Andersen also believed that Sketchbook I, from which this sheet had been removed, was in the same lot of works being offered by Guillaume at that time.[38] This would mean that sheets with watercolors were being sold separately even as the sketch-

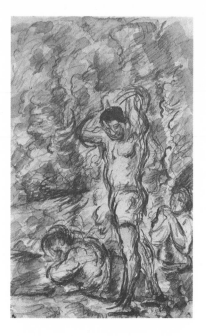

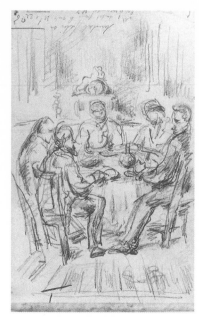

Figure 4
Sketchbook I, page 46 recto
Three Bathers
Rewald, 1983, no. 120
Pencil and watercolor, 18 x 11.5 cm
Location unknown

Figure 5
Sketchbook I, page 46 verso
The Dinner
Chappuis, 1973, no. 1192
Pencil, 18 x 11.5 cm
Location unknown

book from which they came was on the market, a not surprising but still interesting aspect of the history of the dismantling of these sketchbooks.

Chappuis and Rewald have also suggested that the exceptionally striking sheet with a watercolor of *Three Bathers* (fig. 4)[39] on one side, and a quite complete drawing, *The Dinner* (fig. 5),[40] on the other side came from the first sketchbook. It is proposed here that this sheet is the missing page 46, and in fact that number may be barely detected at the lower edge of a photograph of the watercolor. Page 46 falls in a sequence of other bather compositions and figure studies; the immediately preceding pages 43, 44, and 45 contain studies of the standing figure in the center of the watercolor composition. Moreover, it is just possible to trace what would appear to be an offset from *The Dinner* on the recto side of page 47. This sheet must have been removed from the sketchbook at an even earlier date than the one discussed above. Wildenstein purchased it from Georges Bernheim on October 29, 1930, and it was still with Wildenstein when it was published by Venturi in 1936. The sheet was sold in 1936 to Jone Price, a collector in California.[41]

Two other sheets that may have come from Sketchbook I can be proposed primarily on the basis of their published dimensions; it has not been possible to find out from the photographs whether these contained page numbers, or to detect evidence of offsets on the sheets in the Museum's collection. Chappuis tentatively proposed that a drawing after the antique marble *Faun and Child* in the Louvre (fig. 6) came from Sketchbook I.[42] In the sequence of missing pages, this could have been any one of pages 16, 19, or 20, all of which are part of a long series of drawings that Cézanne made in the Louvre. It could also be the missing page 5, which would have been adjacent to the drawing after Couture's painting, also made in the Louvre. One clue for the location of this sheet might come from the unusual watercolor of *Leaves and Flowers* on its reverse (fig. 7),[43] which seems to include motifs very similar to those in the wallpaper background of the watercolor already shown to have been on page 4 verso of the sketchbook (fig. 3). Although Rewald has suggested widely separated dates for these two works—he dates the

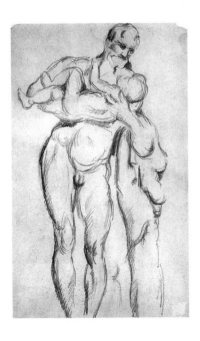

Back of a Chair about 1882 or slightly later, and *Leaves and Flowers* about 1895—the visual connection between the two watercolors is striking and prompts a very tentative proposal that the latter sheet could have been page 5. It is also interesting to note that like the *Back of a Chair*, *Leaves and Flowers* was also formerly in the collection of Kenneth Clark. The latter was listed but not illustrated by Venturi in 1936,[44] and one assumes that Clark acquired it with the other Cézanne drawings and watercolors that he purchased from Paul Cézanne *fils* and Paul Guillaume in 1933 or 1934.

 Another watercolor, *A Rose* (fig. 8), is tentatively suggested here for the first time as a missing page from Sketchbook I on the basis of its published dimensions,[45] but it is not possible to propose a location in the sketchbook for this watercolor. Although it was not in Venturi's catalogue of 1936, it was shown at Thomas Agnew and Sons, London, in July of that year. Rewald notes that the works in the exhibition were mostly lent by Mme Paul Guillaume, "who probably had them on consignment from Vollard and Cezanne *fils*."[46]

In 1951 Rewald listed two additional sketches with the pages of Sketchbook I, which are not among the pages in the Philadelphia Museum of Art today: pages 13 and 39. Page 13, a cut page that had become detached from the binding, shows a seated bather on the recto (fig. 9) and a sketch of War after Rubens's *Apotheosis of Henry IV* on the verso (fig. 10). This little sheet has passed through several hands and is now in a private collection.[47]

Page 39, which is listed simply as "Sketch" in Rewald's catalogue,[48] was not among the eighty-one framed drawings in the Annenberg collection when the Museum received them in 1987. It appears on the inventory list of the sketchbook pages that was prepared by Wildenstein in the late 1970s. However, the various discrepancies that exist between that list and the actual drawings make it possible to suppose that page 39 was not actually among them when the list was prepared. In fact, it may have been so slight a sketch that it disappeared along with the blank pages when the sketchbooks were taken apart and framed. If the four sheets proposed here have been correctly identified, then only three pages from Sketchbook I remain to be located.

Rewald lists seven pages as missing from Sketchbook II: pages II, XI, XIV, XXI, XXII, XXV, and XXXIII.[49] According to his catalogue, page XIX was blank and page XX had touches of watercolor on the verso. Neither of these is among the sheets in Philadelphia, and one can only suppose that they probably disappeared when the sketchbooks were taken apart and framed in the 1950s. Additionally, page LI, which Rewald describes as "accounts in the hand of Cézanne, in ink," appears in the Wildenstein inventory, but it is not with the sketches in the Museum today; it, too, may have disappeared together with the two other missing sheets noted above. There are therefore now a total of ten pages missing from Sketchbook II, for seven of which there is no information.

As has already been mentioned, the dimensions of Sketchbook II (12.7 x 21.6 cm) are so close to those of other Cézanne sketchbooks that identifying the missing pages is virtually impossible without checking each sheet in the original for physical evi-

Figure 9
Sketchbook I, page 13 recto
Seated Bather
Chappuis, 1973, no. 627 A
Pencil, 11.6 x 16.5 cm
Private collection

Figure 10
Sketchbook I, page 13 verso
Allegorical Figure of War, after Rubens
Chappuis, 1973, no. 627
Pencil, 16.5 x 11.6 cm
Private collection

dence. One clearly identifiable attribute of Sketchbook II is the series of tack punctures that appear 2 centimeters from the edge of every sheet opposite the binding, from the front cover all the way through page XXXII, a mark that could certainly authenticate six of the seven missing sheets that occur among those thirty-two pages. It is quite evident that Sketchbook II included quite a number of watercolors because spots and touches of watercolor remain on many pages, in the binding edges, and along their outer margins; in addition, two drawings that remain with the other sketchbook sheets are heightened with watercolor. Perhaps because of this, the book has suffered more than most of Cézanne's sketchbooks: pages are cut short and several of them (pp. XLV, XLVI, XLVII) are severely smudged, as though they might have been rubbed together when other pages were being extracted.

Chappuis identified one watercolor as possibly coming from this sketchbook.[50] It is an extraordinary late composition of *Bathers before a Mountain* (fig. 11), dated 1902–6 by Rewald, with a pencil sketch of houses on the verso. One cannot tell from the photographs whether there is a page number on the sheet, nor is there evidence of a tack puncture. Although it may be optimistic to suggest a location for it in the sketchbook, it is worth noting that there is one long sequence of sketches of bathers between pages XXX and XXXVIII, which would make the watercolor in question a possible candidate for the missing page XXXIII. According to Rewald, this sheet was first shown in June 1935 at Renou and Colle, Paris, in an exhibition in which most of the works were lent by Paul Cézanne *fils*, and it was listed as in his collection in Venturi's catalogue.[51] Thus, like the watercolors removed from Sketchbook I, this one was also extracted during the 1930s.

Although it has not been previously suggested, the watercolor *A Pear* (fig. 12)[52] shows evidence of being one of the sheets that was removed from the second sketchbook. Its measurements, published by Rewald as 12.7 by 20.8 centimeters, correspond in the shorter dimension to the other sheets in the sketchbook. More significantly, however, the evidence of a tack puncture in the right-

Figure 11
Bathers before a Mountain
Rewald, 1983, no. 607
Pencil and watercolor, 12.7 x 21.6 cm
From the British Rail Pension Fund's
Works of Art Collection

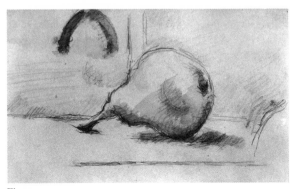

Figure 12
A Pear
Rewald, 1983, no. 197
Pencil and watercolor, 12.7 x 20.8 cm
Location unknown (photograph
courtesy of John Rewald)

hand side of the sheet makes it quite possible to identify it as one of the six missing sheets from the first thirty-two pages of the sketchbook. As it has not been possible to see the watercolor in the original, there is no way of knowing whether a page number appears on the sheet. Rewald notes that the watercolor was in the collection of Kenneth Clark and that its present whereabouts are unknown.

It has been suggested in this essay that as many as three watercolors from Kenneth Clark's collection originally came from the Philadelphia sketchbooks, which would indicate that the watercolors were extracted from the sketchbooks and dispersed at the same time, probably in about 1933 or 1934, when Clark said that he had bought his lot of drawings and saw the group of sketchbooks with Paul Guillaume.[53]

A close examination of the eighty-one pages from the two sketchbooks in the Philadelphia Museum of Art has afforded the opportunity to focus upon them within the broader context of Cézanne's other sketchbooks and to gain a fuller idea of their original appearance. By identifying several watercolors that once were in these sketchbooks one learns that at least some of Cézanne's sketchbooks were much more colorful objects than could be supposed from those that have been published in facsimile. Also, by placing watercolors within the sequence of the pages one discovers how Cézanne sometimes used his sketchbooks to work through single subjects on adjacent pages in rough graphite sketches as well as in full watercolor compositions—as is apparent in the studies of a standing bather on pages 43 through 46 of Sketchbook I. It is certain that as additional pages are identified and placed securely within the sketchbooks, one will find out even more about these remarkable documents of Cézanne's working method.

1. Rewald, 1951. The five sketchbooks published in this book had just been acquired by the New York dealer Sam Salz from Renou and Poyet, Paris. Rewald catalogued them under the name of their new owners, in the following order: Carnet I, Collection of Mr. and Mrs. Ira Haupt, New York; Carnet II, The Art Institute of Chicago; Carnet III, Musée du Louvre, Paris; Carnet IV, Collection of Mr. and Mrs. Ira Haupt, New York; Carnet V, Collection of Mr. and Mrs. Leigh B. Block, Chicago.

2. Ibid., pp. 23–29, 43–49.

3. Chappuis, 1973, vol. 1, pp. 21–22.

4. Ibid., vol. 1, p. 22. This is the former Leigh Block sketchbook which is now the property of the Eugene V. and Clare E. Thaw Charitable Trust, on permanent loan to The Pierpont Morgan Library, New York.

5. Ibid., no. 1088.

6. Venturi, 1936, vol. 1, pp. 304–19.

7. Chappuis, 1962, vol. 1, p. 26; Chappuis, 1973, vol. 1, p. 22. If one counts the number of sheets that are scattered around in different collections and believed by Chappuis (1973) to have come from the Chappuis and Basel sketchbooks, one comes up with the following numbers: 17 from the first Chappuis sketchbook (CP I); 19 from CP II; 1 from CP III (the sketchbook now in the Mellon collection); 10 from CP IV; 11 from Basel I(BS I); 4 from BS II; 9 from BS III. This information has changed since 1973; for example, some of the sketches that Chappuis listed as in the von Hirsch collection were subsequently bequeathed to the Kunstmuseum, Basel.

8. Venturi, 1936, vol. 1, pp. 350–52. Venturi's list was later corrected by Chappuis, 1962, vol. 1, p. 27, in his catalogue of the Basel sketches.

9. Chappuis (1973, vol. 1, p. 21) identifies 10 sheets from the 10.3 x 17 cm sketchbook in the Kunstmuseum, Basel, and one in another collection (no. 302). He listed 68 sheets from the 18 x 24 cm sketchbook in the Kunstmuseum, Basel, and 14 in other collections.

10. See also Andersen, 1965, pp. 313–18. A limited-edition facsimile of the *Carnet violet moiré* was published by Daniel Jacomet (Paris, 1955).

11. Chappuis, 1973, no. 65.

12. Ibid., vol. 1, p. 22.

13. Sebastien Bottin, *Annuaire et almanach du commerce, de l'industrie, de la magistrature et de l'administration* (Paris, Firmin Didot frères, 1882–84).

14. See Chappuis, 1973, vol. 1, pp. 21–22. The page dimensions of the Thaw sketchbook are 12.6 x 21.7 cm, and those of one of the unbound sketchbooks in the Kunstmuseum, Basel (the so-called BS II), measure 12.5 x 21.5 cm. A dismantled sketchbook, most of which is in the Chappuis collection, Trésserve (the so-called CP II) measures 12.5 x 21.7 cm.

15. In fact, Sketchbook I originally had at least 48 pages. The remnant of a torn sheet, which was not numbered, is attached to page 10. Rewald (1951, p. 25) noted that it may have been torn out by the artist.

16. Chappuis (1962, vol. 1, pp. 16–17) discusses the numbering of the pages of Cézanne's sketchbooks at length, on which this discussion is based.

17. Chappuis (ibid., p. 124, note 18) quotes Maurice Renou on this subject.

18. Ibid., p. 17. There is usually no way of knowing whether pages were removed from the sketchbooks prior to their having been numbered unless evidence remains within the book itself.

19. See note 7 above.

20. Chappuis, 1962, vol. 1, p. 12.

21. By checking the works shown in the exhibitions listed by Jayne Warman (Rewald, 1983, pp. 469–73), it has been possible to determine that four watercolors from sketchbooks were shown at the Montross Gallery, New York, in 1920; others were shown in 1921 and 1926, but none can be identified again with certainty until 1934. Chappuis (1973, nos. 852/937 and 1217/945) identifies two sheets that were removed from sketchbooks for reproduction in Rivière, 1923.

22. Chappuis, 1962, vol. 1, p. 12.

23. This information was kindly provided by Wayne Andersen from notes made April 18, 1963, when he visited Kenneth Clark and his wife at Saltwood Castle.

24. Chappuis, 1962, vol. 1, p. 12.

25. This information was conveyed to the author by John Rewald, October 26, 1988. The Poplin photographs were published in Venturi's catalogue of 1936.

26. Chappuis, 1962, vol. 1, p. 124, note 8.

27. From notes taken by Wayne Andersen in 1963 (see above note 23). In a letter to Carl Schniewind of the Art Institute of Chicago, dated November 30, 1951, Clark also wrote: "The Lyons sketchbooks were sold through Paul Guillaume and were bought by M. Renou. He may, indeed, have been a friend of the family but he acquired the sketchbooks quite late (I think it was 1931). I saw them in Paul Guillaume's shop at the time and made notes of them as I thought of buying them myself."

28. Rewald (1983, nos. 124, 127, 146, 559) provides this information about the provenance. It has not been possible to find any additional information about the Lyons collector Brochier, with whom the sketchbooks resided until Renou reacquired them around 1950.

29. The press release was consulted in the files of the Art Institute of Chicago. The information about the sale of the sketchbooks was corroborated by John Rewald in a conversation on October 26, 1988.

30. The matting and framing of the sketchbook pages certainly had been done by the time that Gertrude Berthold (1958, p. 145) noted having studied them in Mr. and Mrs. Haupt's apartment.

31. A copy of this list is now in the Philadelphia Museum of Art. It gives individual bibliographical references for each sheet and a concordance, somewhat incomplete and erroneous, of sketchbook page numbers and Chappuis catalogue numbers. According to Wildenstein, the list was prepared by outside researchers hired for that purpose. The drawings were not photographed while the list was being prepared.

32. For a clear example of an offset image, see Sketchbook I, page 27 recto, which is offset from page 26 verso.

33. Rewald, 1951, pp. 23–29.

34. Chappuis, 1973, no. 638.

35. Andersen (1963, p. 46, note 4) mentions the number 3D on the sheet, which was apparently added after its removal from the sketchbook, but does not make note of the number 4.

36. Rewald, 1983, no. 188.

37. Venturi, 1936, no. 850.

38. Andersen, 1963, p. 44.

39. Rewald, 1983, no. 120.

40. Chappuis, 1973, no. 1192.

41. Venturi, 1936, nos. 900, 1219. Information about the early provenance of this sheet was kindly provided by Ay-Wang Hsia of Wildenstein and Co., New York.

42. Chappuis, 1973, no. 304.

43. Rewald, 1983, no. 545.

44. Venturi, 1936, vol. 1, p. 149.

45. Rewald, 1983, no. 208.

46. Ibid., p. 473.

47. Berthold (1958, no. 207) as in the collection of John Rewald; Chappuis (1973, nos. 627/627A) as in the collection of Mr. and Mrs. E. V. Thaw.

48. Rewald, 1951, p. 28.

49. Ibid., pp. 42–49.

50. In Rewald, 1983, no. 607.

51. Ibid., p. 472; Venturi, 1936, no. 1108.

52. Rewald, 1983, no. 197.

53. Venturi (1936, vol. 1, pp. 348–49) lists 34 drawings and watercolors in the Clark collection. Chappuis (1973, vol. 1, p. 11) wrote that he had not been able to identify all of the drawings included on Venturi's list.

Sketchbook I

Theodore Reff

with notes on mediums
and additional pages by
Innis Howe Shoemaker

Notes to Sketchbook I

The sketchbook pages are an off-white wove paper. The primary medium is graphite pencil, sometimes heightened with watercolor. Spots, stains, or traces of other mediums, which have no relationship to the image, are listed after the primary medium, separated by semicolons. Offsets from the images on adjacent pages are noted last. Residual stains from tape used previously for mounting are not noted.

The dimensions of the pages of Sketchbook I are 11.6 by 18.2 centimeters. Dimensions are noted in the descriptions only for sheets that differ significantly from the standard dimensions.

Page numbers are noted where they are still visible. Sketchbook I is numbered in Arabic numerals at the lower right corner of the recto page, in a soft blue-gray pencil.

Pages known to be missing from Sketchbook I are noted in the sequence of the book, corresponding to Rewald, 1951, which is the earliest known inventory of the pages. Missing pages that have been identified and can be placed in sequence are also noted.

Bibliographical sources are cited in abbreviated form, using the author's name and date of publication, with full references appearing in the Bibliography.

The numbers given for the works in the Musée du Louvre are those that appear in the series of museum catalogues published between 1922 and 1924, which are listed in the Bibliography.

Front cover

Linen-covered board; spots of oil
paint
12.5 x 18.5 cm
Acc. no. 1987-53-1a

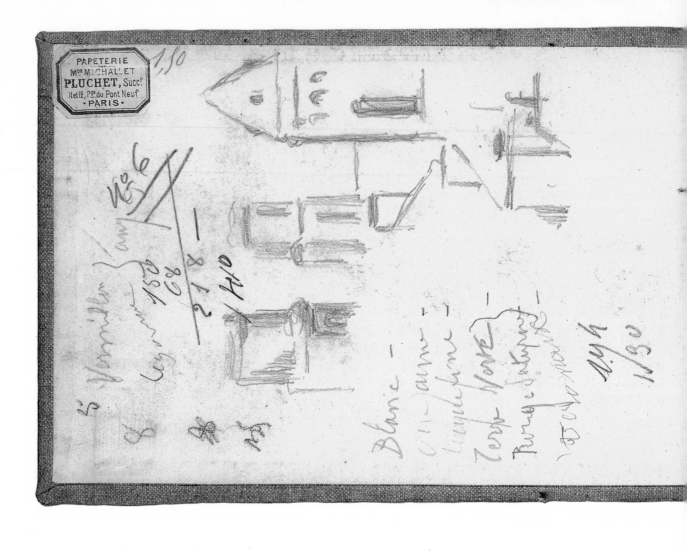

Front endpaper

View of Paris; Notations
1882
Graphite pencil
Label of stationery shop printed in blue ink at upper right: Papeterie / Mon[sieur] Michallet / Pluchet, Succ[esseu]r / 11 et 12, P[assa]ge du Pont Neuf / Paris
Inscribed in graphite pencil at top: Vermillon / [ill. wd.]; [in foreign hand:] / Cézanne / No 6; at lower left: Blanc / Ocre jaune / lacque fine / Terre Verte / Rouge Saturne / [in foreign hand:] Veronaise
Acc. no. 1987-53-1b

Rewald, 1951, p. 24; Reff, *Burlington*, 1959, p. 175, fig. 25; Chappuis, 1973, no. 805 (one church incorrectly identified)

The identification of the church with twin towers as Saint-Sulpice and the one with a single tower as Notre-Dame-des-Champs makes it possible to fix Cézanne's line of sight. Among the streets he is known to have lived on, this line intersects only the rue de l'Ouest, where he had a sixth-floor apartment in 1880–82 (Imbourg,

1939, p. 3). But since he could not have bought this sketchbook before 1882 or after 1884, the years in which Pluchet succeeded Michallet in running the stationery shop (according to the Didot-Bottin commercial directories of Paris for those years), the drawing can be dated 1882. Other views of the city made in the same apartment are the drawing on page 8 verso of this sketchbook, two further drawings (Chappuis, 1973, nos. 581, 806), and a painting (Venturi, 1936, no. 175). What distinguishes this one, the smallest in the group, is its almost archaic severity and innocence of vision.

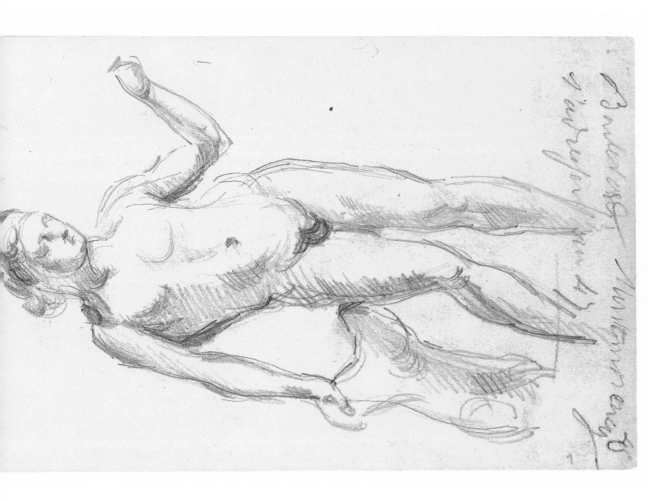

Page 1 recto

Antique Bacchus
Graphite pencil
Numbered in pencil: 1
Inscribed in black crayon at bottom, page inverted: Boulevard Mont-morency 45 / s'adresser au 47
Acc. no. 1987-53-2a

Rewald, 1951, p. 24 (unidentified); Berthold, 1958, no. 47; Reff, 1962, pp. 178–79, fig. 7; Chappuis, 1973, no. 563 (inscription omitted)

A vigorous, swiftly drawn copy after the antique *Bacchus of Mazarin*, also called the *Bacchus of Versailles*, in the Louvre (no. 337), seen from the front. The effect of light and shade is vivid, but Cézanne's chief interest seems to have been the figure's relaxed, grace-fully curving stance, with the left leg straight and the other bent, the left arm bent and the other straight. On this model of classical *contrapposto* he then based the stance of one version of his bather with outstretched arms (Venturi, 1936, no. 544).

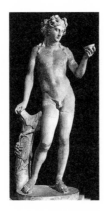

Bacchus
Antique marble

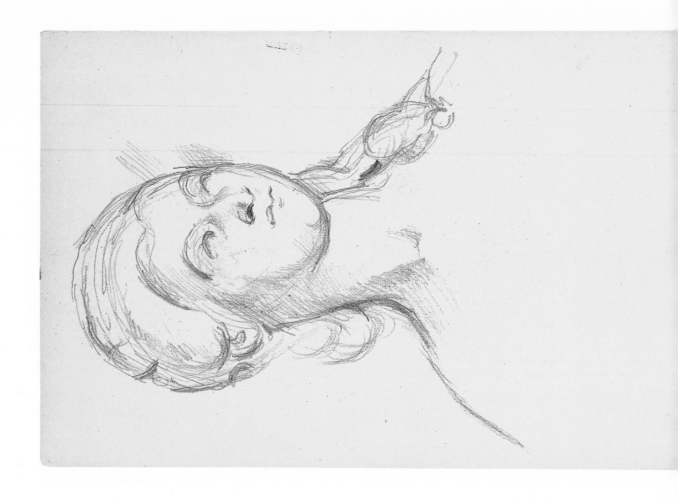

Page 1 verso

Pajou's Madame du Barry
Graphite pencil; graphite offset from
page 2 recto
Acc. no. 1987-53-2b

Rewald, 1951, p. 24, pl. 151 (uniden-
tified); Berthold, 1958, no. 200;
Chappuis, 1973, no. 1031

That Cézanne chose to draw after a
portrait bust of Louis XV's mistress
may seem at first surprising. But he
was presumably attracted less by the
subject than by the compact, rounded
forms and smoothly curving lines of
Augustin Pajou's classicizing bust of
Madame du Barry in the Louvre (no.
1435), from which he was able to
extract a still more tightly coiled
pattern of curvilinear rhythms. Its
abstract, almost geometric force is
however softened by the subtle play
of light and shade over the forms.

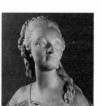

Augustin Pajou. *Madame
du Barry* (detail). Bisque

Page 2 recto

*The Artist's Leg and Bedding; His Son
Asleep*
Graphite pencil; oil paint; graphite
offset from page 1 verso
Numbered: 2 (erased)
Acc. no. 1987-53-3a

Rewald, 1951, p. 24; Andersen, 1970,
no. 136 verso (unidentified); Chap-
puis, 1973, no. 855 (incorrectly iden-
tified, confused with no. 857A)

Two rapid sketches that bring us into
the artist's bedroom. At the left, he
looks down at his own legs, one shoe
projecting, the other presumably
hidden beneath the covers, as he lies
in bed. At the right, he begins to
draw his young son Paul, who is
apparently asleep, as he is in several
of the sketches on the following
pages.

Page 2 verso

The Artist's Son Asleep
c. 1882
Graphite pencil; graphite offset from
page 3 recto
Acc. no. 1987-53-3b

Rewald, 1951, p. 24; Andersen, 1970,
no. 139 (incorrect page number and
reproduced vertically); Chappuis,
1973, no. 857 (reproduced horizon-
tally but inverted)

Paul Cézanne *fils*, who was born in
1872 and appears here to be about ten
years old, was obviously a more
compliant model asleep than he was
awake, and several drawings in this
sketchbook show him in that condi-
tion (pp. 3 recto and verso, 10 recto
and verso). At the same time, in
isolating the long, ovoid form of the
head, much as Brancusi would later
do in sculpture, Cézanne has created
a fascinating form, made all the more
striking by its contrast to the rumpled
bedsheet on which it seems to rest.

Page 3 recto

The Artist's Son Asleep

Before 1890
Graphite pencil; graphite offset from page 2 verso
Numbered: 3 (erased)
Inscribed in graphite pencil at left, page horizontal: Lambert 17 rue de Loursine [Lourcine, which was changed to rue Broca in 1890]
Acc. no. 1987-53-4a

Rewald, 1951, p. 24, pl. 23; Andersen, 1970, no. 138; Chappuis, 1973, no. 839

The sketchbook was held vertically with the binding at the top.

The extreme foreshortening in both sketches, altogether unusual in Cézanne's portraiture, where he normally maintains a greater distance from his subject, implies not only his intimate proximity to his sleeping son, but also his fascination with the artistic problem of rendering the features seen thus in distorted form— a problem he has not entirely mastered, despite the vigorous confidence of his lines.

Page 3 verso

The Artist's Son Asleep

Graphite pencil; traces of watercolor;
graphite offset from missing page 4
(p. 18, fig. 2)
Acc. no. 1987-53-4b

Rewald, 1951, p. 24; Andersen, 1970,
no. 137; Chappuis, 1973, no. 848

This is one of a handful of drawings
(see also Chappuis, 1973, nos. 820,
835) in which the powerful black lines
and compact forms suggest less the
tenderness and vulnerability of the
sleeping boy than his potential
strength, like that of the young Her-
cules (with whom Cézanne identified
himself) lying in his cradle.

Page 4 recto (missing)

Female Figure, after Couture
Numbered: 4

Rewald, 1951, p. 24 (as missing);
Chappuis, 1973, no. 638 (as from
Sketchbook I); Andersen, 1963, pp.
44–46

This missing page (location unknown;
p. 18, fig. 2) can be identified with
the sketch of a female figure after
Thomas Couture's *Romans of the
Decadence* (Musée d'Orsay, Paris).

Page 4 verso (missing)

Back of a Chair

Venturi, 1936, no. 850; Rewald,
1951, p. 24 (as missing); Chappuis,
1973, under no. 638; Rewald, 1983,
no. 188

The offset of part of this missing
watercolor (p. 18, fig. 3) may be seen
on page 3 verso of this sketchbook.

Page 5 recto (missing)

Rewald, 1951, p. 24 (as missing)

Page 5 verso (missing)

Rewald, 1951, p. 24 (as missing)

Page 6 recto

Reclining Female Nude
Graphite pencil; traces of oil paint
Numbered: 6 (erased)
Acc. no. 1987-53-5a

Rewald, 1951, p. 24, pl. 83 (as study
for *Leda*); Berthold, 1958, no. 301 (as
unidentified copy); Schapiro, 1968,
pp. 39–40; Chappuis, 1973, no. 483

A figure with a long and interesting
history in Cézanne's art, this reclining
nude first appears, holding a mirror,
in a small, heavily painted picture of
about 1870 (Venturi, 1936, no. 111);
then as Leda with her hand in the
swan's beak, in a painting of 1886–90
(ibid., no. 550), for which there is also
a preparatory drawing (Chappuis,
1973, no. 484); and finally in an
extensively revised canvas of the same
period (Venturi, 1936, no. 551), in
which her right hand and the swan

are overlaid with the drapery and
fruit of an unfinished still life. From
the beginning, and most clearly in the
present drawing, Cézanne seems to
have relied on a graphic model for this
uncharacteristic image of a voluptu-
ous nude with flowing blond hair,
altering only the raised right arm,
but his specific source has not been
identified.

Leda and the Swan
(Venturi, 1936, no. 550)

Page 6 verso

Female Figure, after a Clock
c. 1882
Graphite pencil; graphite offset from
page 7 recto
Acc. no. 1987-53-5b

Rewald, 1951, p. 24; Berthold, 1958,
no. 330; Chappuis, 1973, no. 583

Although apparently a portrait, this strongly modeled drawing is in fact a copy after a bronze mantel clock that was one of Cézanne's favorite models; nine other copies are known. The clock, evidently in the Charles X style, appears most completely in the three largest copies (Chappuis, 1973, nos. 457–59); the others, mostly in sketchbooks, focus on the seated woman or her torso or head alone. The particular clock has not been identified, but it very likely adorned the apartment Cézanne occupied on the rue de l'Ouest in 1880–82: one of the drawings occurs beside a view of Paris definitely made there (Chappuis, 1973, no. 581), and four of the others occur beside copies made in the Louvre (ibid., nos. 457, 721) or portraits of his son datable to those years on the basis of his apparent age (ibid., nos. 458, 821).

Page 7 recto

Reclining Female Bather
Graphite pencil
Numbered: 7 (erased)
Acc. no. 1987-53-6a

Rewald, 1951, p. 24, pl. 82; Berthold, 1958, no. 302 (as unidentified copy); Hoog, 1971, p. 13; Chappuis, 1973, no. 262

This nude woman seen from behind leaning on her elbow appears in two of Cézanne's bather compositions of the early 1870s (Venturi, 1936, nos. 113, 265) and in two watercolors (Rewald, 1983, nos. 36, 37) and several drawings (Chappuis, 1973, nos.

62, 261, 405) related to them. But since the present drawing cannot have been made before 1882, when this sketchbook was begun, it should be considered a reprise of the earlier type, perhaps intended for a painting that was never realized or is now lost; it is in fact executed with the dark, precise strokes typical of the 1880s.

Bathers (Venturi, 1936, no. 113)

Page 7 verso

Landscape
Graphite pencil
Acc. no. 1987-53-6b

Rewald, 1951, p. 24, pls. 60–61 (as view of L'Estaque); Reff, *Burlington*, 1959, p. 172, fig. 24 (as Provençal landscape); Chappuis, 1973, no. 765 (as Provençal)

The type of panoramic landscape shown here spreading across two sketchbook pages—a view from a hilltop across a valley dotted with houses and trees and rising to mountains in the distance—was one that Cézanne especially liked. Hence it occurs among the pictures he painted both in the north, in the area of Auvers (e.g., Venturi, 1936, no. 150), and in the south, in the environs of Aix (e.g., ibid., nos. 302, 304). Since most of the other drawings in this sketchbook were definitely made in Paris, including the one on page 8 verso, the north is the more likely locale, though none of the landscapes definitely painted there corresponds closely to this one.

Page 8 recto

Landscape
Graphite pencil; graphite offset from
page 7 verso
Numbered in pencil: 8
Acc. no. 1987-53-7a

Page 8 verso

View of Paris
1882
Graphite pencil
Acc. no. 1987-53-7b

Rewald, 1951, p. 25, pl. 45; Reff, *Burlington*, 1959, pp. 172, 175, fig. 13; Chappuis, 1973, no. 806

A view of the same churches, Saint-Sulpice and Notre-Dame-des-Champs, as on the front endpaper of this sketchbook, though seen from a slightly different position—perhaps another window in the rue de l'Ouest apartment—to judge from the intervals between the towers and their alignment with the rooftops and chimneys; hence also a drawing datable to 1882. Unlike the other one, however, this is a fully developed composition built on a rigorous scheme of interlocked horizontal and vertical elements and conveying a much clearer sense of light and atmosphere through its broad shading and subtle indications of clouds.

This interest in a panoramic, atmospheric view of the city is one that Cézanne shared with several of the Impressionists; Monet's views of the Tuileries Gardens, painted in 1875–76, are the most relevant examples. But their literary equivalents in Zola's novel *Une Page d'amour*, published in 1878, are perhaps more relevant, for these five long descriptions of the same part of Paris in different seasons and at different times of day were particularly admired by Cézanne, who wrote to Zola about them (Cézanne, 1984, p. 163).

Page 9 recto

Child's Head and Hand
Graphite pencil; graphite offset from
page 8 verso
Numbered: 9 (erased)
Acc. no. 1987-53-8a

Rewald, 1951, p. 25; Andersen, 1970,
no. 264; Chappuis, 1973, no. 824

Although not previously identified as
such, the subject is undoubtedly
Cézanne's young son Paul, at about
the same age as in the sketches on
pages 3 verso and 10 verso in this
sketchbook, and with the same sullen
expression as in a sketch on a larger
sheet of studies (Chappuis, 1973, no.
821, lower left).

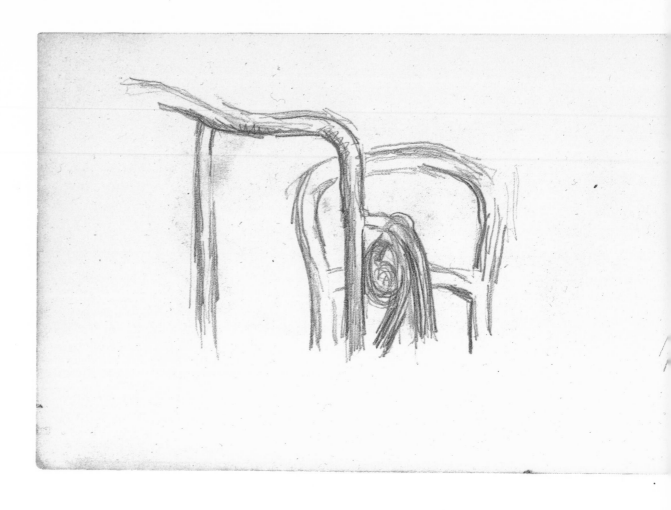

Page 9 verso

Bed and Chair Frames
Graphite pencil; graphite offset from
page 10 recto
Acc. no. 1987-53-8b

Rewald, 1951, p. 9; Chappuis, 1973,
no. 336

A striking example of Cézanne's
ability to discover an order or pattern
in a fortuitous juxtaposition of famil-
iar objects, this study of a corner of an
iron bed frame overlapping the upper
part of a wood chair frame is pursued
with such intensity that the whole
seems to become something organic
and alive. It is also somewhat myste-
rious, since the nexus of the pattern,
the spiral form within the curved
"arm" of the bed frame, remains
difficult to identify.

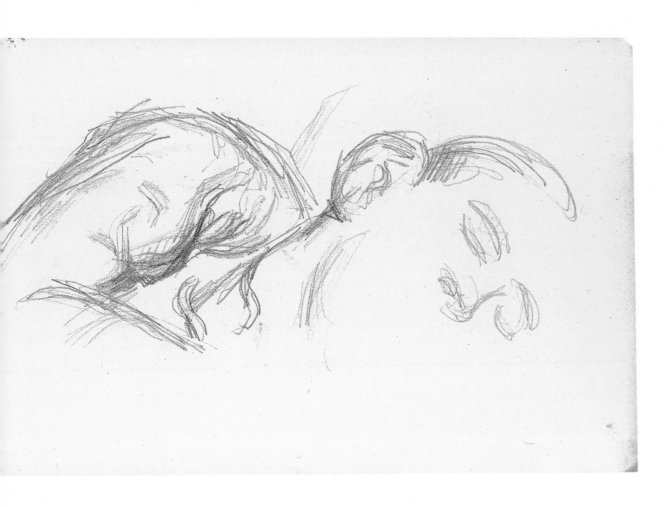

Page 10 recto

The Artist's Son Asleep
Graphite pencil; graphite offset from
page 9 verso
Numbered: 10 (erased)
Acc. no. 1987-53-9a

Rewald, 1951, p. 25; Andersen, 1970,
no. 136 (incorrectly listed as p. 2
verso); Chappuis, 1973, no. 858

In contrast to the other drawings in
this sketchbook of his son asleep (pp.
2 verso, 3 recto, 10 verso), this one
focuses not on his familiar, languid
features but on the folds of the cloth-
ing around his shoulder—a series of
curved forms so massive that it has
been read as "a roll formed by a blan-
ket" (Chappuis).

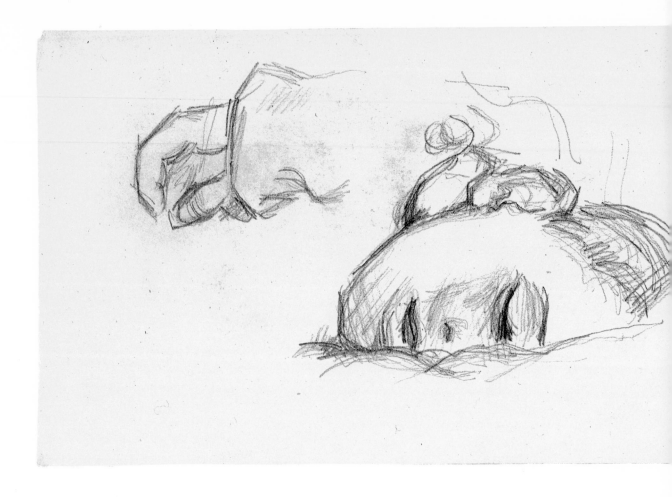

Page 10 verso

Head and Hand of the Artist's Son Asleep
Graphite pencil; graphite offset from
page 11 recto
Acc. no. 1987-53-9b

Rewald, 1951, p. 25; Andersen, 1970,
no. 140; Chappuis, 1973, no. 854

Seeing his son asleep has once again
led Cézanne to approach his model
more closely than he normally would.
But if the juxtaposition of the two
sketches is similar to that on page 9
recto of this sketchbook, here the
insistent horizontality and downward
droop of the limp fingers and facial
features convey the feeling of sleep as
effectively as the rising or vertical
forms convey wakefulness in the
other drawing.

Unnumbered page recto

Watercolor; illegible mark in ink
Attached to page 10

Rewald, 1951, p. 25

Rewald has suggested that the
remainder of this page may have been
torn out by the artist.

Unnumbered page verso

Graphite pencil
Attached to page 10

Rewald, 1951, p. 25

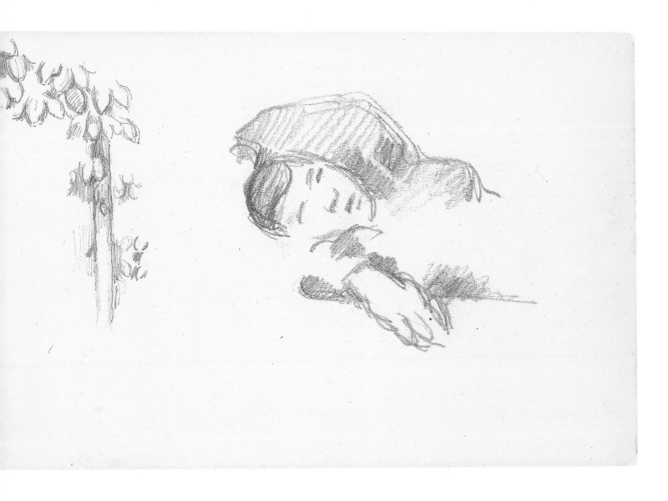

Page 11 recto

Small Tree; Person Asleep
Graphite pencil
Numbered: 11 (erased)
Acc. no. 1987-53-10a

Rewald, 1951, p. 25; Andersen, 1970, no. 141; Chappuis, 1973, no. 822

The trunk and leaves of the tree are observed with the kind of concentration that led Picasso to say about Cézanne: "When he is before a tree he looks attentively at what he has before his eyes. . . . If he has a leaf, he doesn't let go. Having the leaf, he has the branch. And the tree won't escape him" (Ashton, 1972, p. 161).

The sleeping figure, previously identified as the artist's son, may well be his wife, whom he also represented asleep in several drawings (Chappuis, 1973, nos. 359, 711, 846, 875). In that case, the "cushion" above her head (Chappuis) would be her raised left arm and breast.

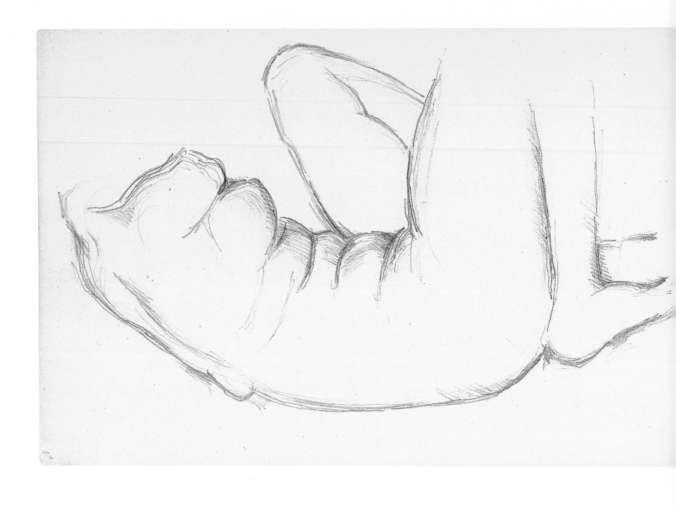

Page 11 verso

Antique Crouching Venus
After 1879
Graphite pencil
Acc. no. 1987-53-10b

Rewald, 1951, p. 25, pl. 118;
Berthold, 1958, no. 19, pl. 87;
Chappuis, 1973, no. 1097

This is the most precisely drawn but also the most sensual of Cézanne's three copies (the others are Chappuis, 1973, nos. 1096, 1098) after the Hellenistic marble known as the *Venus of Vienne*, which was discovered in that city in 1878 and put on view in the Louvre the following year (no. 2240). Cézanne's choice of it as a model reflects the same taste for full, fleshy, female figures that informs his numerous copies after Rubens; the *Crouching Venus* has in fact been called "a type which might be compared to Rubens's nude women" (Bieber, 1981, p. 83).

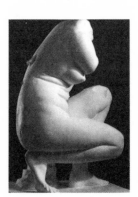

Crouching Venus
Plaster cast

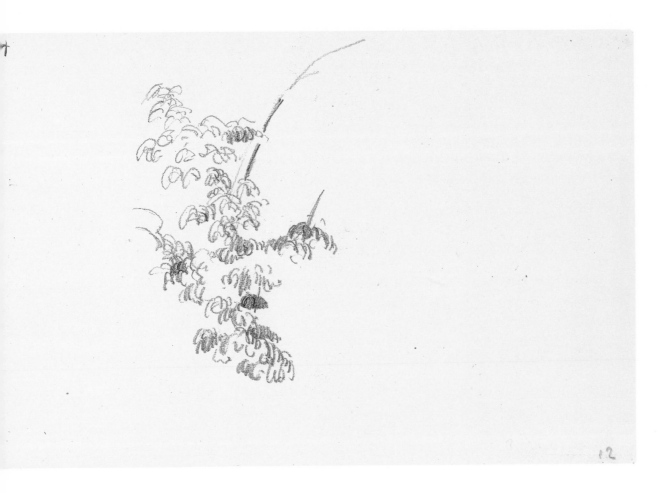

Page 12 recto

Foliage
Graphite pencil
Numbered in pencil: 12
Acc. no. 1987-53-11a

Rewald, 1951, p. 25; Chappuis, 1973, no. 474A

This sketch of a few branches with leaves shows Cézanne experimenting with a pattern of small, curly strokes whose varied spacing and density provide an equivalent rather than an accurate description of the natural forms. In the more meticulous drawing on page 11 recto of this sketchbook, on the other hand, the trunk and individual elements are explicitly and lovingly described.

Previously unillustrated.

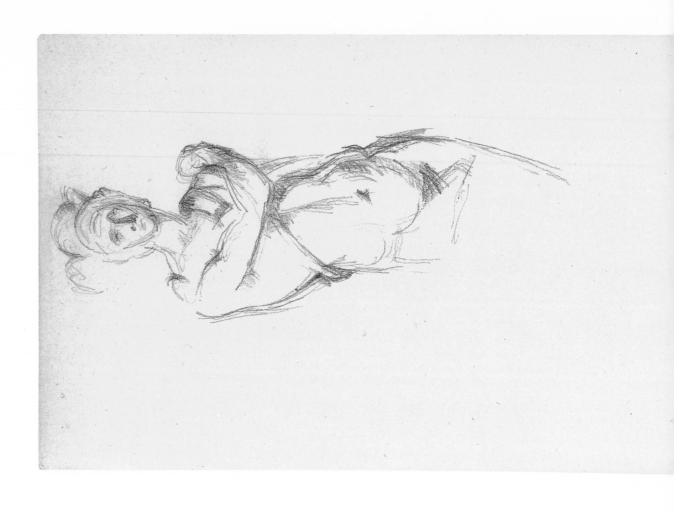

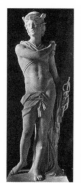

Pierre de Francqueville
Mercury. Marble

Page 12 verso

Francqueville's Mercury
Graphite pencil
Acc. no. 1987-53-11b

Rewald, 1951, p. 25 (unidentified);
Berthold, 1958, no. 278 (unidenti-
fied); Reff, 1960, p. 148 (incorrectly
identified); Chappuis, 1973, no. 474
(unidentified)

It is hardly surprising that the model
for this copy has never been identi-
fied. It is a statue of mediocre quality,
in poor condition, attributed to the
minor Flemish sculptor Pierre de
Francqueville, or Francheville, which
entered the Louvre in 1872 (no. 1306)
but left in 1938 for the Château de
Fontainebleau, where it is today. In
drawing it, Cézanne exaggerates its
Mannerist aspect, suggesting it is a
fine bronze figurine rather than a life-
size marble statue, and making its

slender proportions seem still more
effeminate, its small head still more
miniaturized beneath its large,
winged hat. Something of its languid,
serpentine pose recurs in his painting
Boy with the Red Vest (Venturi, 1936,
no. 682).

Page 13 recto (missing)

Seated Bather

Rewald, 1951, p. 25; Chappuis, 1973, no. 627A

This missing page (private collection) was listed by Rewald as a sketch of a seated bather.

Page 13 verso (missing)

Allegorical Figure of War, after Rubens

Rewald, 1951, p. 25; Berthold, 1958, no. 207; Chappuis, 1973, no. 627

This missing page (private collection) was listed by Rewald as a study after Rubens's *Apotheosis of Henry IV* (Louvre).

Page 14 recto

Allegorical Figure of France, after Rubens
Graphite pencil
Numbered: 14 (erased)
Acc. no. 1987-53-12a

Rewald, 1951, p. 25, pl. 136;
Berthold, 1958, no. 223; Hoog, 1971,
p. 10; Chappuis, 1973, no. 597

A swift, sketchy copy after the figure at the far right in Rubens's *Exchange of the Two Princesses*, one of the pictures in the Maria de' Medici cycle in the Louvre (no. 2098). Contrary to what one might expect, Cézanne preferred Rubens to Poussin among the old masters, and the Maria de' Medici paintings were by far his favorite group of works, to judge from the number of copies he made after figures in them: twenty-three in all, including two others in this sketch-book (pp. 13 verso, 14 verso) and four in Sketchbook II (pp. xv verso, xxvii recto, xxxix verso, xli verso). In the present drawing he seems to have been concerned primarily with the swirling rhythms of the power-fully twisting form of the figure of France, bending over to introduce the princesses to each other.

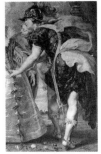

Figure of France, detail
from Peter Paul
Rubens, *Exchange of the
Two Princesses*

Page 14 verso

Allegorical Figure of Health, after Rubens
Graphite pencil; graphite offset from
page 15 recto
Acc. no. 1987-53-12b

Rewald, 1951, p. 25, pl. 138;
Berthold, 1958, no. 219; Chappuis,
1973, no. 594

Like the copy after another picture in
Rubens's Maria de' Medici cycle on
the recto of this page and the one in
Sketchbook II, page XLI verso, this
one, which is based on the *Birth of
Louis XIII* (Louvre, no. 2092), isolates
a single figure at the right edge of the
composition. But in contrast to the
drawing of the elegantly costumed
figure of France on the recto, this one
emphasizes the powerful stature and
sculptural form of the virtually nude
figure of Health. At least this is true
of the lower half; in the upper half it
is much flatter, and the baby in the
arms of Health is oddly diminutive.

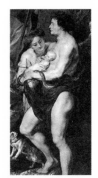

Figure of Health, detail
from Peter Paul Rubens,
Birth of Louis XIII

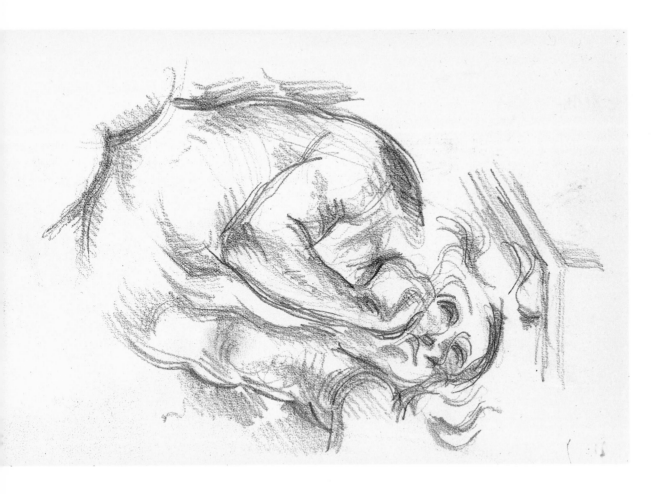

Page 15 recto

Puget's Atlas
Before 1886
Graphite pencil; graphite offset
Numbered: 15 (partially erased)
Acc. no. 1987-53-13a

Rewald, 1951, p. 26, pl. 131;
Berthold, 1958, no. 128, pl. 134;
Chappuis, 1973, no. 689

Pierre Puget's powerfully muscled and frequently contorted figures held a great appeal for Cézanne, who drew after them repeatedly in the Louvre. In this copy, as in the other four (Sketchbook II, pp. L recto and verso; Chappuis, 1973, 391, 1132), he worked from plaster casts of the two Atlases flanking the monumental portal of the Hôtel de Ville at Toulon; the present copy and one other show the Atlas at the right side of the portal. Since these casts were in the Salle Puget at the Louvre until 1886, when they were transferred to the Musée de Sculpture Comparée, the recently opened museum of casts at the Trocadéro (no. c164), and since the copies on the preceding and following pages in this sketchbook were definitely made in the Louvre, it is likely that this one too was made there; hence before 1886. The angle of vision, more nearly horizontal than would have been possible at the Trocadéro, and the extensive shading in broad patches of soft, parallel strokes also suggest the earlier dating.

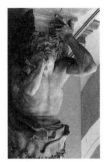

Pierre Puget, *Atlas*
Plaster cast

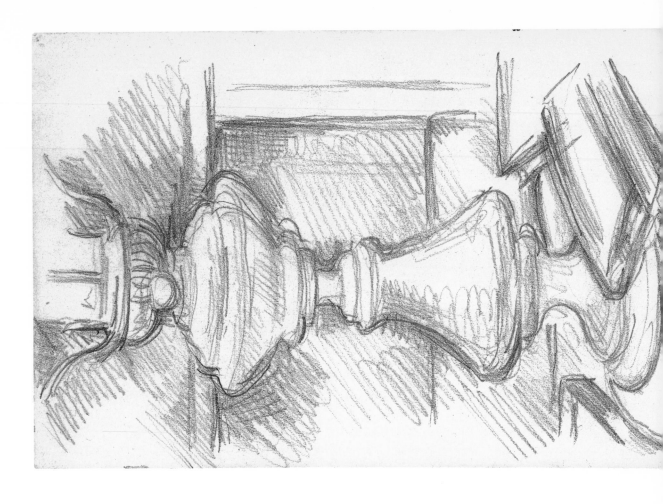

Page 15 verso

Kerosene Lamp and Books
Graphite pencil
Acc. no. 1987-53-13b

Rewald, 1951, p. 26, pl. 69; Chappuis, 1973, no. 955

This exceptionally bold sketch of a familiar household object is a clear example of Cézanne's ability to transform the simplest study into a highly structured design, in this case, by integrating the forms of the lamp with those of the books below it and the wall paneling behind it. The vigorous shading in long parallel strokes and the heavily repeated contours of the objects enhance the sense of monumental power and scale. His other sketches of lamps (Chappuis, 1973, nos. 343, 956), less fully developed than this one, lack those qualities.

Page 16 recto (missing)

Rewald, 1951, p. 26 (as missing)

Page 16 verso (missing)

Rewald, 1951, p. 26 (as missing)

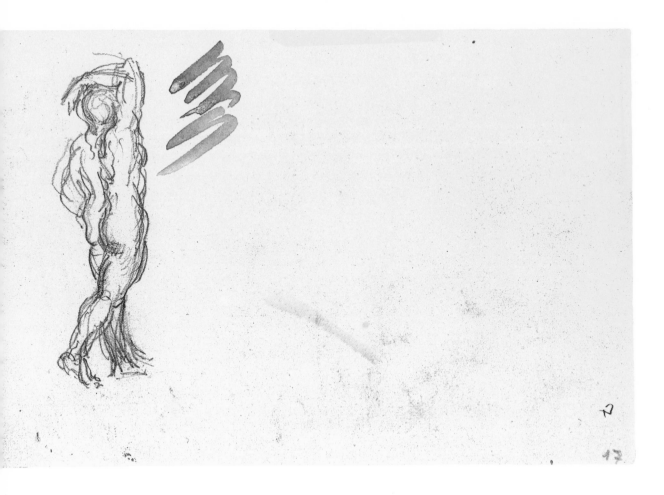

Page 17 recto

Standing Female Bather
Graphite pencil; watercolor; graphite offset
Numbered in pencil: 17
Acc. no. 1987-53-15a

Rewald, 1951, p. 26

A female bather standing in this pose seems to recur only in a watercolor dated about 1900 (Rewald, 1983, no. 600); but since the other bathers in it and the general design of that work appear in a painting of about 1890 (Venturi, 1936, no. 540) and in some related drawings (e.g., Sketchbook II, pp. xxxv recto, xxxvii recto), the present drawing, too, very likely dates from the earlier period.

Previously unillustrated.

Group of Bathers
(Rewald, 1983, no. 600)

Page 17 verso

Landscape with Donkey
Graphite pencil; graphite offset
Acc. no. 1987-53-15b

Rewald, 1951, p. 26, pl. 43; Hoog,
1971, p. 41; Chappuis, 1973, no. 761

Although it is clearly related in both subject and design to *The Thieves and the Donkey* (Venturi, 1936, no. 108), a painting of about 1870, this very confident and accomplished drawing has little in common stylistically with the more crudely executed drawings of that period. It has therefore been dated 1876–79 (Chappuis), but the closest equivalents to the graphic devices employed here, especially the parallel, curling strokes used in representing trees and foliage, are in land-scape sketches of the mid-1880s (e.g., Chappuis, 1973, nos. 903, 905). But if the earlier date is therefore untenable, the relation to the early painting nevertheless remains a puzzle.

66

Page 18 recto

Coysevox's Faun Playing a Flute
After 1870
Graphite pencil; graphite offset from
page 17 verso (reflecting the shape of
the image on page 18 verso)
Numbered: 18 (erased)
Acc. no. 1987-53-16a

Rewald, 1951, p. 26 (unidentified);
Berthold, 1958, no. 149; Chappuis,
1973, no. 592

In drawing after Charles-Antoine
Coysevox's marble statue of a faun
playing a flute, which was moved
from the Tuileries Gardens to the
Louvre in 1870 (no. 1119), Cézanne
softens and slightly blurs the sharply
defined stone forms and, by concen-
trating his shading along their edges,
creates a vivid sense of light and
shade. As a result, the figure seems
bathed in atmosphere and sunlight, as
if it were seen once again outdoors
rather than in a museum.

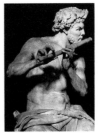

Charles-Antoine
Coysevox
Faun Playing a Flute
(detail). Marble

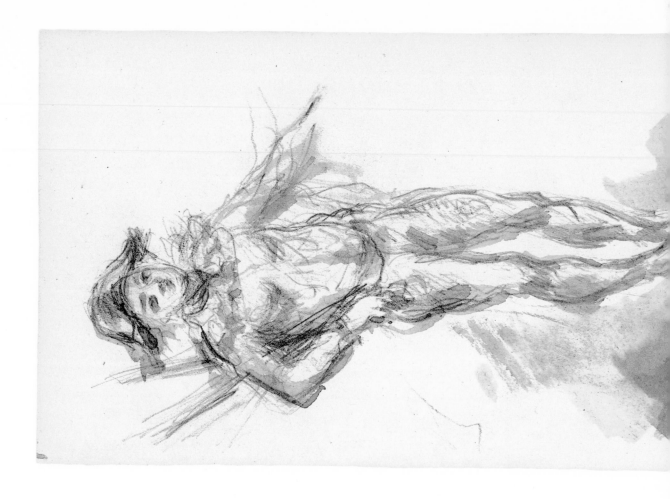

Page 18 verso

Harlequin
c. 1888
Graphite pencil heightened with
watercolor
Acc. no. 1987-53-16b

Rewald, 1951, p. 26, pl. 35;
Schapiro, 1952, pl. 19; Knoedler,
1963, no. 23, pl. XXIV; Andersen,
1970, no. 172; Hoog, 1971, p. 12;
Chappuis, 1973, no. 944

The relation of this rough sketch to
the well-known painting *Mardi Gras*
(Venturi, 1936, no. 552), reliably
dated 1888, is somewhat problematic.
Far from being "the only study specifi-
cally for the final version" (Andersen),
it is more likely the earliest study, still
unresolved in many respects, and
corresponding less closely to the
painting than do the other drawings
(Chappuis, 1973, nos. 938–41) and
the watercolor (Rewald, 1983, no.
295), all of which are larger and more

carefully executed. And whereas the
model for the other studies was
clearly Cézanne's son, then aged six-
teen, the model here appears younger
and may even be another boy.

Page 19 recto (missing)

Rewald, 1951, p. 26 (as missing)

Page 19 verso (missing)

Rewald, 1951, p. 26 (as missing)

Page 20 recto (missing)

Rewald, 1951, p. 26 (as missing)

Page 20 verso (missing)

Rewald, 1951, p. 26 (as missing)

Page 21 recto

Chair Back
Graphite pencil; graphite offset
Numbered: 21 (erased)
Acc. no. 1987-53-14a

Rewald, 1951, p. 26

The sketchbook was held vertically with the binding at the bottom.

The delicately drawn flowers and leaves in this sketch seem to float so lightly across the page that the subject might appear at first to be a landscape. It is more likely a corner of a tall chair back embroidered with a floral pattern, the same chair that appears in some of Cézanne's portraits of his wife in the early 1890s (Venturi, 1936, nos. 570–72). But the same pattern also appears in another drawing of that decade (Chappuis, 1973, no. 1135), where it looks more like a framed embroidery on the wall and another chair stands in front of it.

Previously unillustrated.

Page 21 verso

Person's Head
Graphite pencil; graphite offset from
page 22 recto
Acc. no. 1987-53-14b

The very beginning of a sketch of
what appears to be a person's head
looking down, like the more fully
developed sketch on page 22 recto of
this sketchbook and the still more
explicit one on page 42 verso.

Previously unillustrated and
unrecorded.

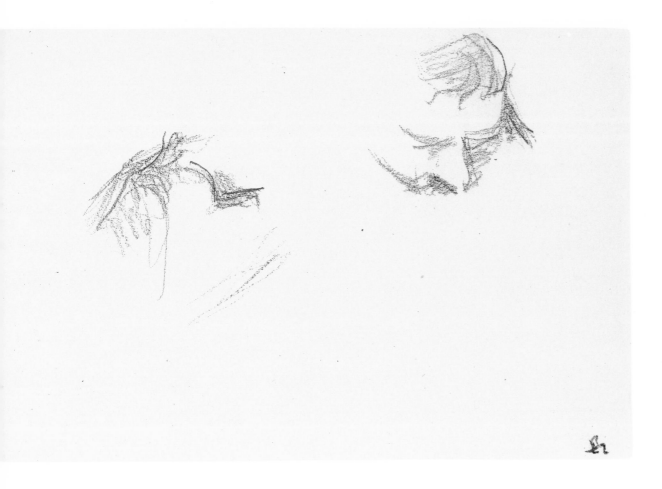

Page 22 recto

Person's Head
Graphite pencil; graphite offset from
page 21 verso
Numbered in pencil: 22
Acc. no. 1987-53-17a

Rewald, 1951, p. 26

The beginnings of two sketches,
interesting as revelations of Cézanne's
process, in which broad shading and
sharp linear definition alternate con-
tinuously. One sketch is of a head,
probably that of the artist's son, look-
ing down (compare Chappuis, 1973,
nos. 867–70); the other is unidentifia-
ble.

Previously unillustrated.

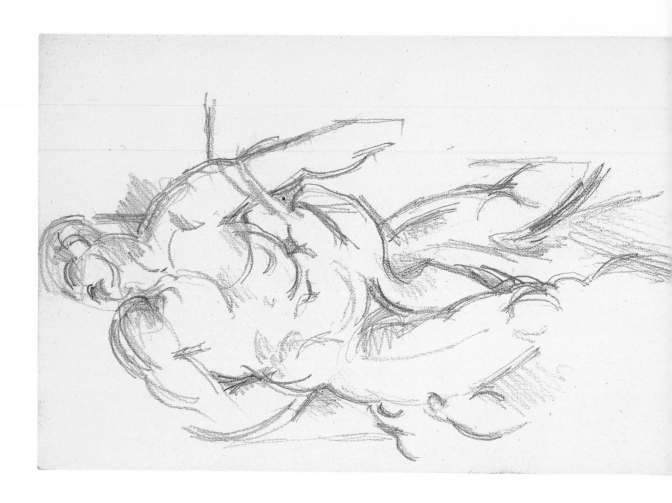

Pierre Puget
Milo of Croton. Marble

Page 22 verso

Puget's Milo of Croton
Graphite pencil
Acc. no. 1987-53-17b

Rewald, 1951, p. 26; Berthold, 1958,
no. 104; Chappuis, 1973, no. 977

If Rubens was Cézanne's favorite painter, Pierre Puget was his favorite sculptor, to judge again from the number of copies he made in the Louvre. In fact, the passionate and melodramatic side of the Provençal artist's work appealed even more to Cézanne, who reportedly said, "There is the *mistral* in Puget, that is what agitates the marble" (Gasquet, 1926, p. 191). The complex, intensely dramatic group of Milo struggling to escape the lion (Louvre, no. 1466) is one of the Pugets that Cézanne drew most often: there are eleven copies besides this one (Chappuis, 1973, nos. 207, 502–6, 976, 978, 1131, 1200–1201). Three of them show the same frontal view as this copy, a subordinate view in which Milo's powerful anatomy is conspicuous but the crucial narrative elements, the tree trunk holding his left hand immobile and the lion seizing his right hand and thigh, are invisible or obscure.

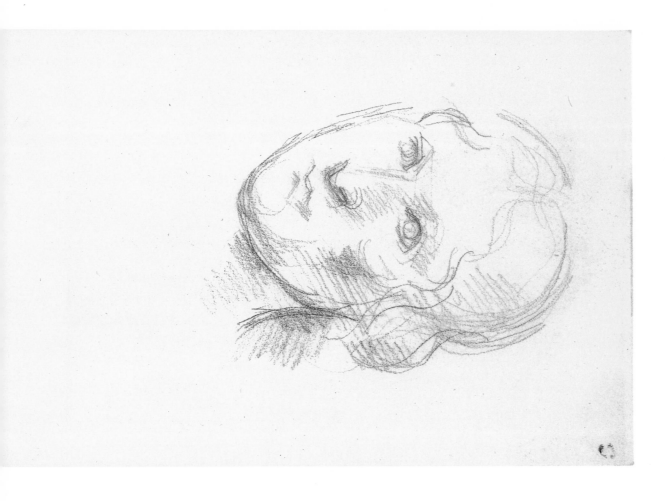

Page 23 recto

Head of Man
Graphite pencil
Numbered in pencil: 23
Acc. no. 1987-53-18a

Rewald, 1951, p. 26 (unidentified);
Berthold, 1958, no. 202 (incorrectly
identified); Reff, 1960, p. 147 (incor-
rectly identified); Chappuis, 1973,
no. 600 (unidentified)

The identity of the portrait Cézanne
copied in this swift but fine and subtle
sketch remains unknown, despite the
efforts of several scholars and a recent
campaign in the galleries and store-
rooms of the museums in which he
habitually worked. It appears to be an
eighteenth-century bust of a man, of a
kind Cézanne often drew, but none of
those on view in his day in the Louvre
or the Musée de Sculpture Comparée
corresponds closely enough, nor does
any painted portrait in the Louvre. A

painted, or indeed a drawn, portrait
seems a less likely model, given the
subject's lack of engagement with the
viewer.

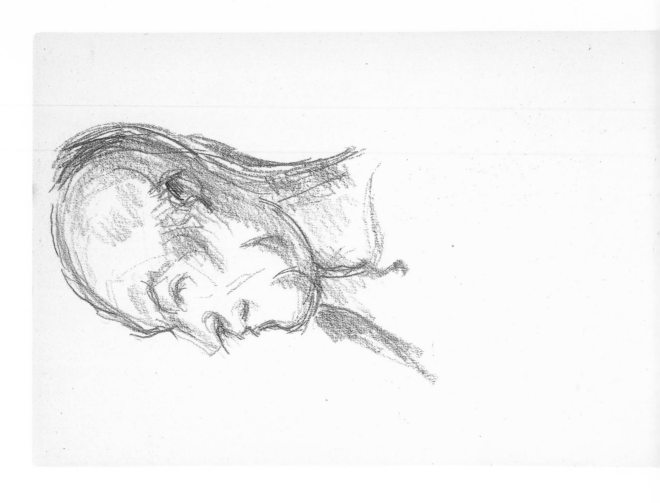

Benedetto da Maiano
Filippo Strozzi (detail)
Marble

Page 23 verso

Benedetto da Maiano's Filippo Strozzi
After 1878
Graphite pencil; graphite offset from
page 24 recto
Acc. no. 1987-53-18b

Rewald, 1951, p. 26, pl. 147;
Berthold, 1958, no. 83; Chappuis,
1973, no. 558

This is one of four copies by Cézanne
of a Quattrocento bust of the banker
Filippo Strozzi that entered the Lou-
vre in 1878 (no. 693). In viewing it,
he chose many angles, evidently
intrigued by the equally forceful
definition of its forms when seen in
strict profile, as in this drawing and
one in Basel (Chappuis, 1973, no.
560), or in a more complex three-
quarter view, as in the two drawings
in Sketchbook II, pages XXVIII verso,
XXX recto. The profile view, rare in
Cézanne's own portraiture, is, of
course, a convention in Quattrocento
drawn and painted portraits, though
the calm, continuous silhouette typi-
cal of them conveys a different feeling
than the broken, agitated outline in
this drawing.

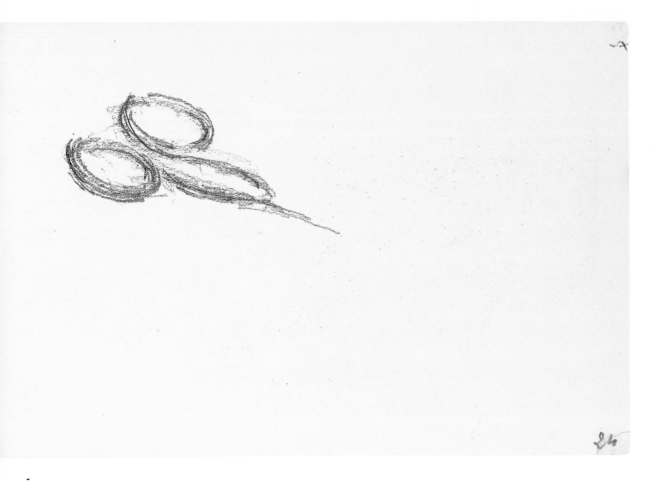

Page 24 recto

Pair of Scissors
Graphite pencil; graphite offset from
page 23 verso
Numbered in pencil: 24
Acc. no. 1987-53-19a

Rewald, 1951, p. 26; Chappuis, 1973,
no. 672A

Unfinished and hence somewhat
cryptic (and sexually suggestive), this
sketch very likely represents the
finger holes and shaft of a pair of
sewing scissors, with the blades
barely begun.

Previously unillustrated.

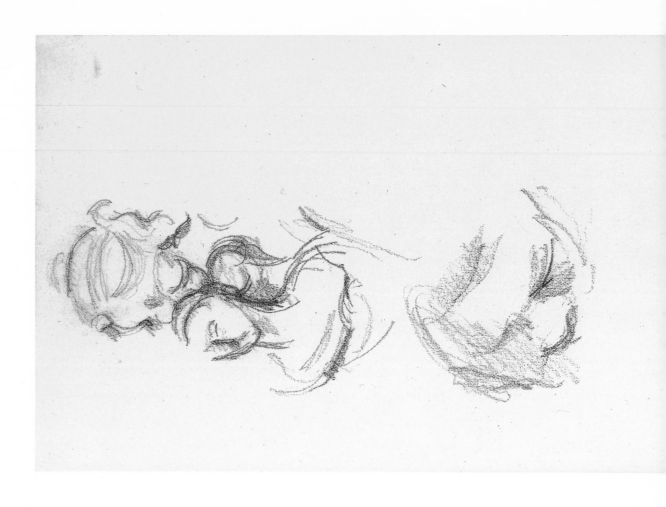

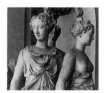

Germain Pilon, The
Three Graces (detail),
from *Monument to Henry
II*. Marble

Page 24 verso

Pilon's Monument to Henry II; *Head*
Graphite pencil
Acc. no. 1987-53-19b

Rewald, 1951, p. 26; Berthold, 1958,
no. 146; Chappuis, 1973, no. 672

This is the least fully realized and the
least interesting of Cézanne's four
copies after Germain Pilon's *Monu-
ment to Henry II* in the Louvre (no.
413). Whereas the other three
(Sketchbook II, p. v recto; Chappuis,
1973, nos. 585, 1113) focus entirely
on the three elegant figures of the
Graces, this one shows only the
upper parts of two figures and the
miniature casket (containing the
sovereign's heart) that they support.

The other sketch, likewise incom-
plete, of a head looking down proba-
bly represents the artist's son (see p.
22 recto in this sketchbook).

Page 25 recto

Drinking Glass
Graphite pencil; graphite offset from
page 24 verso
Numbered in pencil: 25
Acc. no. 1987-53-20a

Rewald, 1951, p. 27

A slight sketch of a banal object,
interesting only as a reminder of that
touching modesty which was one side
of Cézanne's personality.

Previously unillustrated.

Page 25 verso

Puget's Milo of Croton
Graphite pencil
Acc. no. 1987-53-20b

Rewald, 1951, p. 27 (unidentified);
Berthold, 1958, no. 107; Chappuis,
1973, no. 978 (page numbered
incorrectly)

Of Cézanne's twelve copies after
Puget's sculptural group in the Louvre
(see p. 22 verso in this sketchbook),
this is the only one showing it from
the back, with Milo's head turned
completely away. This view is so
eccentric that it is hard at first to
recognize the lion's outstretched paw
in the odd form at the right, but it is
also one in which the twisting of
Milo's agonizing body provided
Cézanne with a striking subject for
study.

Page 26 recto

Antique Bust of Caracalla
Graphite pencil heightened with
watercolor
Numbered in pencil: 26
11.6 x 17.8 cm
Acc. no. 1987-53-21a

Rewald, 1951, p. 27; Berthold, 1958,
no. 56; Chappuis, 1973, under no.
1203; Rewald, 1983, no. 146

A vigorous sketch after the well-
known bust of Caracalla in the Lou-
vre (no. 1106), bristling with the
energy of Cézanne's short, broken
strokes. The shading, already exten-
sively developed in broad pencil
hatching, is reinforced by washes of
blue-gray watercolor, presumably
added in the studio. Other copies
after this bust are on the verso of this
page, in the Louvre sketchbook
(Chappuis, 1973, no. 1019), and in
one at Basel (ibid., no. 1204), but
none has the powerful sculptural
form of the present drawing.

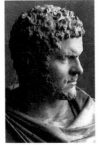

Caracalla (detail)
Antique marble

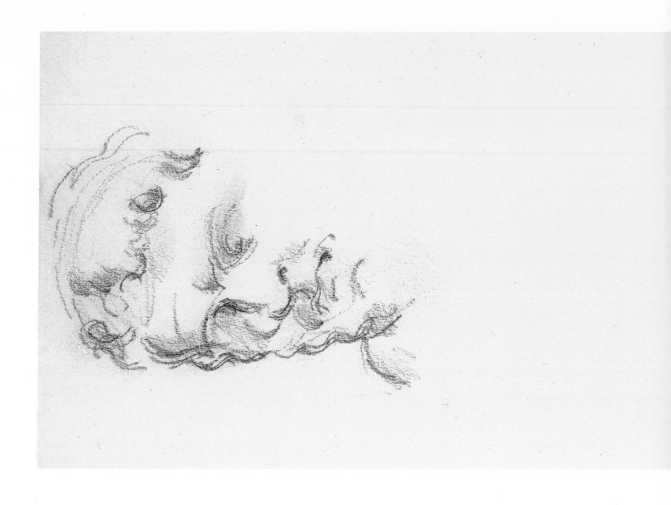

Page 26 verso

Antique Bust of Caracalla
Graphite pencil
11.6 x 17.8 cm
Acc. no. 1987-53-21b

Rewald, 1951, p. 27 (unidentified);
Berthold, 1958, no. 52 (incorrectly
identified); Reff, 1960, p. 147;
Chappuis, 1973, no. 1203

In contrast to the copy of the same
bust on the recto of this page, show-
ing the Roman emperor in his famil-
iar, energetic profile, this one is a
frontal view where the features are
less clearly defined—so much less, in
fact, that a different bust altogether
has been considered Cézanne's model.
The two drawings were undoubtedly
made on the same visit to the Louvre,
and reveal the same interest in study-
ing the play of light and shade over
the rugged marble surface.

Page 27 recto

Graphite offset from page 26 verso
Numbered in pencil: 27
Acc. no. 1987-53-22a

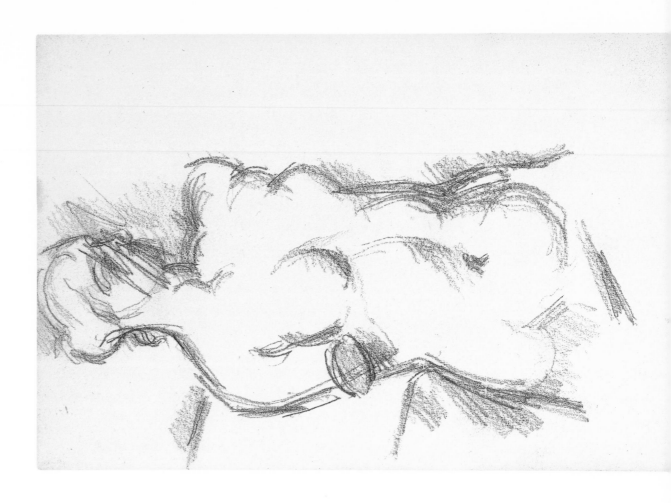

Venus of Milo (detail)
Antique marble

Page 27 verso

Antique Venus of Milo
Graphite pencil
Acc. no. 1987-53-22b

Rewald, 1951, p. 27; Berthold, 1958, no. 15; Chappuis, 1973, no. 636

Few of his copies reveal more poignantly than this one the conflicts Cézanne often experienced in representing the nude female figure, even when frozen in art. The famous Hellenistic statue of Venus in the Louvre (no. 399) appears here stiff and athletic, devoid of its feminine charm and grace. The same is not true of his other copies of the same statue (Chappuis, 1973, nos. 306–10), at least not to this degree; a few even convey the sensuous beauty of the original.

Cézanne himself seems to have been dissatisfied, for he crossed out the figure's face; this aggressive gesture further hints at conflict, like the canceling of the face in another drawing of a woman (ibid., no. 942), but also in one of a man (ibid., no. 392).

Page 28 recto

Graphite offset from page 27 verso
Numbered in pencil: 28
Acc. no. 1987-53-23a

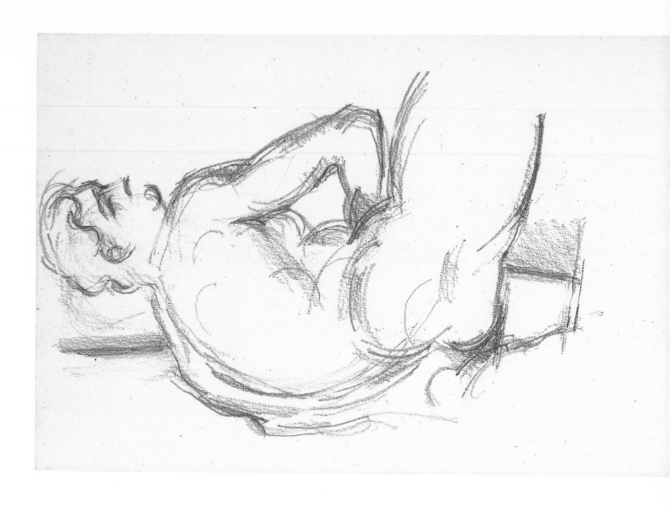

Pierre Puget
Hercules Resting
Marble

Page 28 verso

Puget's Hercules Resting
Graphite pencil
Acc. no. 1987-53-23b

Rewald, 1951, p. 27, pl. 130;
Berthold, 1958, no. 117, pl. 131;
Reff, 1966, pp. 41–44; Chappuis,
1973, no. 1006

Just as Puget was Cézanne's favorite sculptor, so the monumental *Hercules Resting* was his favorite statue in the Louvre (no. 1465), the one he drew more than any other work there: in addition to this copy, seventeen others are known, including three in Sketchbook II (pp. XVIII recto, XXVI *bis* verso, XLIV verso) and fourteen elsewhere (Chappuis, 1973, nos. 575–76, 578, 999–1005, 1058–60, 1196). Most of them show the statue not from the front, where Hercules'

identifying club and lion skin are visible, but from the rear, where he appears an anonymous, athletic figure, like the Puget Atlases that Cézanne also drew (see p. 15 recto in this sketchbook). The powerfully muscled shoulders and back, their bulging curves further emphasized, are indeed what Cézanne concentrates on in this sketch, whose vigor matches that of its subject.

Page 29 recto

Numbered in pencil: 29 (cut)
11.5 x 18.2 cm
Acc. no. 1987-53-24a

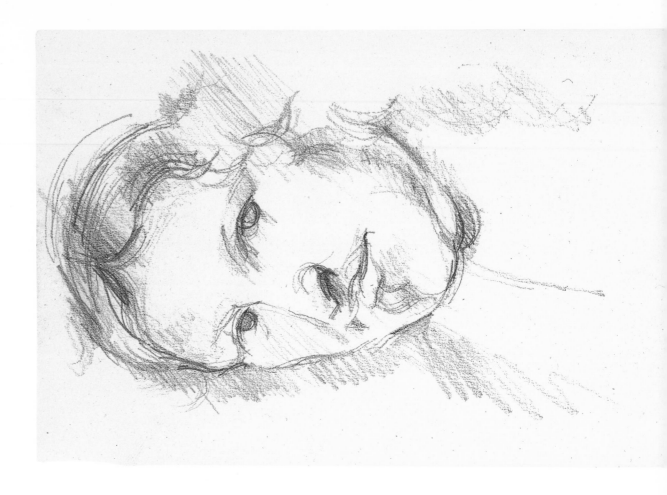

Claude Lefèbvre
Portrait of a Man (detail)

Page 29 verso

Lefèbvre's Portrait of a Man
Graphite pencil
11.5 x 18.2 cm
Acc. no. 1987-53-24b

Rewald, 1951, p. 27, pl. 5 (incorrectly identified); Berthold, 1958, no. 296 (unidentified); Reff, 1960, p. 148 (incorrectly identified); Chappuis, 1965, p. 298, fig. 11; Chappuis, 1973, no. 1127

Portraits, from busts of Roman emperors to a photograph of Delacroix, account for a large number of the works Cézanne chose to copy— a surprisingly large number, if one accepts the familiar notion of his indifference to human personality. Here he has sought to reproduce the worldly, benevolent attitude of an unidentified dignitary protrayed by the seventeenth-century master Claude Lefèbvre (Louvre, no. 530), and at the same time has created a drawing of great rhythmic power and tonal subtlety. The depiction of the long, wavy hair in parallel, curving strokes is especially impressive.

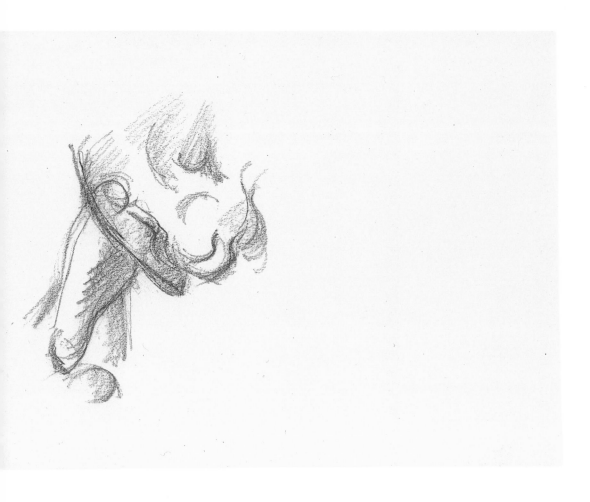

Page 30 recto

Lion's Head, after Barye
Graphite pencil
11.6 x 16.3 cm
Acc. no. 1987-53-25a

Rewald, 1951, p. 27

Cézanne's position is so close to the subject of this drawing, and his reduction of its forms to a pattern of curving lines and patches of shading so extreme, that it is not at first recognizable, and has not in fact been identified previously. As the photograph of the work itself and his own more easily recognizable copy in Sketchbook II, page XL verso, show, this drawing reproduces the lion's face and right paw of Antoine-Louis Barye's sculptural group *Lion and*

Serpent. Now in the Louvre (no. 907), it was before 1911 in the Tuileries Gardens; after 1886 a plaster cast was also on view in the Musée de Sculpture Comparée (no. G4).

Previously unillustrated.

Antoine-Louis Barye
Lion and Serpent. Bronze

Page 30 verso

Graphite offset from page 31 recto
11.6 x 16.3 cm
Acc. no. 1987-53-25b

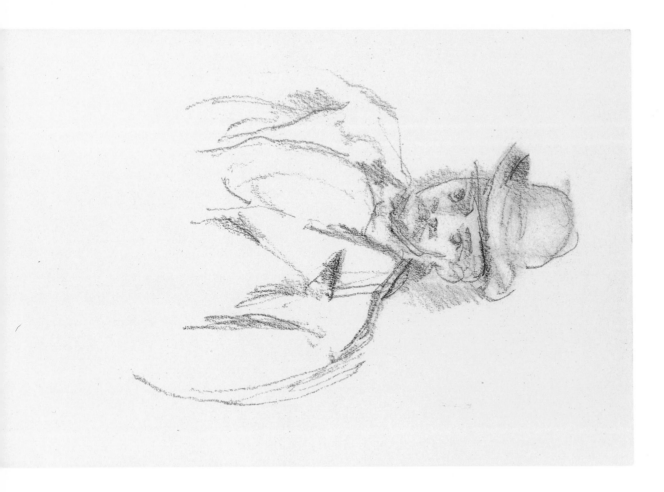

Page 31 recto

Man Wearing a Hat
Graphite pencil
11.5 x 18.2 cm
Acc. no. 1987-53-26a

Rewald, 1951, p. 27, pl. 34 (unidentified); Chappuis and Ramuz, 1957, p. 78, pl. 10 (as Vollard); Andersen, 1970, no. 260 (unidentified); Chappuis, 1973, no. 1191 (as Vollard)

A rapid sketch, with fine light lines and softly blurred shading, evidently made from life. The subject has been identified as the art dealer Ambroise Vollard, whom Cézanne met in 1896, when Vollard was beginning his career. But comparison with Cézanne's well-known portrait, painted only three years later (Venturi, 1936, no. 696), and above all with the preparatory drawing for it (Chappuis, 1973, no. 1194), makes this identification seem unlikely.

Page 31 verso

Two Figures
Graphite pencil
11.5 x 18.2 cm
Acc. no. 1987-53-26b

Rewald, 1951, p. 27; Berthold, 1958, no. 283; Chappuis, 1973, no. 1191A

The absence of Cézanne's habitual control is so complete in this scribbled sketch that it is difficult to recognize his hand at all. And if comparison with other very free sketches made from imagination like this one (Chappuis, 1973, nos. 935–37, 968–69) confirms the attribution, the subjects remain enigmatic. It has been called a study for his *Apotheosis of Delacroix* (Venturi, 1936, no. 245) and a copy after Rubens's *Henry IV Receives the Portrait of Maria de' Medici* (Louvre, no. 2088), but neither suggestion seems convincing.

Previously unillustrated.

Page 32 recto (missing)

Rewald, 1951, p. 27 (as blank)

Page 32 verso (missing)

Rewald, 1951, p. 27 (as blank)

Page 33 recto

Female Bather, after Vernet
Graphite pencil
Numbered: 33 (erased)
Acc. no. 1987-53-27a

Rewald, 1951, p. 27 (unidentified);
Berthold, 1958, no. 236, pl. 34 (page
incorrectly numbered); Chappuis,
1973, no. 676 (page incorrectly
numbered)

Once again Cézanne isolates a single
figure in copying after a multi-figured
composition in the Louvre, in this
case, Joseph Vernet's *Women Bathers*,
or *Morning* (no. 921), from which he
draws the bather undressing, seen
from behind, at right center. The
pose clearly interested Cézanne, who
discovered a variant of it in Marcanto-
nio's famous print *The Judgement of
Paris* and, combining the two old
master sources, painted one of his
female bathers in the same pose (see
Venturi, 1936, no. 265).

Bathers, detail from
Joseph Vernet, *Women
Bathers*

Jean-Antoine Houdon
Flayed Man. Plaster cast

Page 33 verso

Houdon's Flayed Man
Graphite pencil
Acc. no. 1987-53-27b

Rewald, 1951, p. 27, pl. 133;
Berthold, 1958, no. 166; Chappuis,
1973, no. 1110

The subject of this copy and two
others of the same work (Chappuis,
1973, nos. 1109, 1111) is easily recog-
nized as Jean-Antoine Houdon's
Flayed Man in the version with the
right arm extended horizontally (the
other, with the arm raised, is often
illustrated instead). Where Cézanne
might have seen this version, how-
ever, is harder to determine: although
reduced casts were common in the
studios of nineteenth-century artists,
the low viewpoint from which
Cézanne has drawn the figure sug-
gests that it is life-size, and contrary
to what is sometimes stated (e.g., by
Berthold), no cast of that size was
exhibited in the Musée de Sculpture
Comparée or, of course, in the Lou-
vre. A cast was in the Ecole des
Beaux-Arts, but given Cézanne's
disdain for that institution and the
academic art it fostered, it is unlikely
that he would have gone there. But in
whatever context Cézanne saw the
Flayed Man, it was not as an anatomi-
cal model: all of his copies show a
greater interest in analyzing the
rhythmic movements of the contours
than in understanding the skeletal
structure and musculature.

34

Page 34 recto

Numbered in pencil: 34
Acc. no. 1987-53-28a

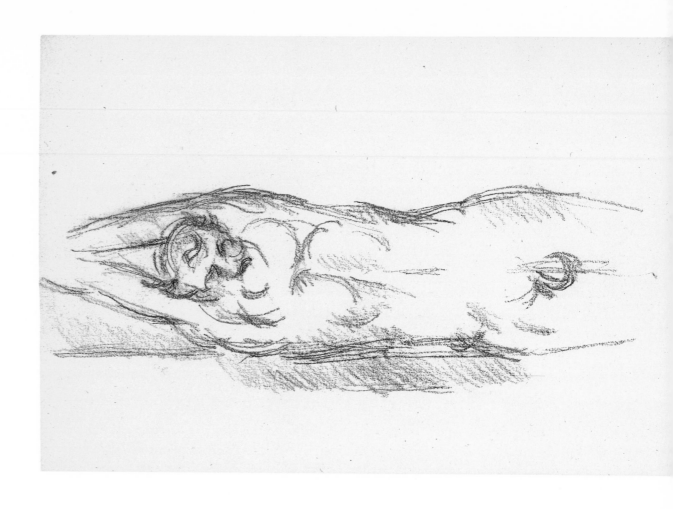

Marsyas. Antique
marble

Page 34 verso

Antique Marsyas
Graphite pencil
Acc. no. 1987-53-28b

Rewald, 1951, p. 27; Berthold, 1958,
no. 46; Chappuis, 1973, no. 607

This drawing after a Hellenistic
statue of Marsyas in the Louvre (no.
230) is an interesting pendant to the
one after Houdon's *Flayed Man* on
page 33 verso of this sketchbook. One
is seen from the back, the other from
the front. One is a figure for scientific
study, flayed to reveal the muscula-
ture, the other, a tragic figure in
ancient myth, about to be flayed for
having challenged the god Apollo.
Yet neither seems to have interested
Cézanne as a model of realistic anat-
omy; and in the drawing of Marsyas
he was even less concerned with
defining the forms of the torso and
arms than in suggesting through soft,
diagonal strokes the varied tones of
the shading and the cast shadows.

Page 35 recto

Graphite pencil; graphite offset from
page 34 verso
Numbered in pencil: 35
Acc. no. 1987-53-29a

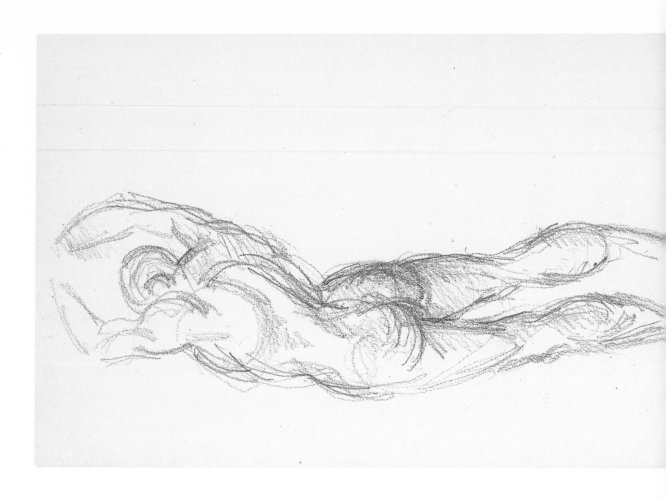

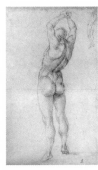

Luca Signorelli
Standing Male Nude

Page 35 verso

Signorelli's Standing Male Nude
Graphite pencil
Acc. no. 1987-53-29b

Rewald, 1951, p. 28 (unidentified);
Berthold, 1958, no. 281, pl. 136
(unidentified, incorrectly listed as
Sketchbook II, p. XXXVI recto);
Neumeyer, 1958, p. 41, pl. 21; Reff,
1960, p. 148; Hoog, 1971, p. 53;
Chappuis, 1973, no. 998 (incorrectly
listed as Sketchbook II, p. XXXI recto)

Like the Hellenistic *Marsyas* on page
34 verso of this sketchbook, this more
expansive, energetic figure, copied
after a drawing by Luca Signorelli in
the Louvre (Reiset, 1866–69, no.
343), shows a nude man with both
arms raised above his head. The same
is true of the Risen Christ in Michel-
angelo's *Resurrection* drawing, which
Cézanne also copied (Sketchbook II,
p. XXXI verso), and of course, of the
other copies of the same Signorelli (p.
38 recto in this sketchbook, p. XXXI
recto in Sketchbook II). The evident
object of his persistent interest in this
unusual figure pose, or at least its
counterpart in his own work, is the
type of bather with both arms raised
that appears in a number of late paint-
ings (Venturi, 1936, nos. 580, 727,
729).

Page 36 recto (missing)

Rewald, 1951, p. 28 (as blank)

Page 36 verso (missing)

Rewald, 1951, p. 28 (as blank)

Page 37 recto (missing)

Rewald, 1951, p. 28 (as blank)

Page 37 verso (missing)

Rewald, 1951, p. 28 (as blank)

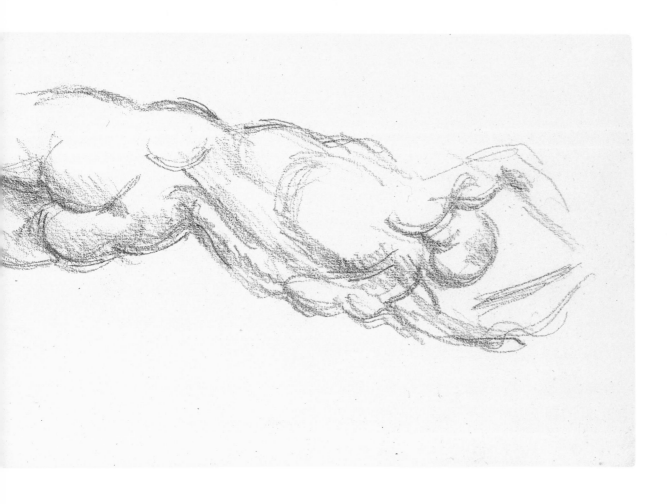

Page 38 recto

Signorelli's Standing Male Nude
Graphite pencil
Numbered: 38 (erased)
Acc. no. 1987-53-30a

Rewald, 1951, p. 28 (unidentified);
Berthold, 1958, no. 280 (unidentified); Reff, 1960, p. 148; Chappuis,
1973, no. 996

Another copy after the Signorelli
drawing in the Louvre (see p. 35 verso
in this sketchbook), this one concentrating on the upper half and representing the strongly plastic forms of
the back and buttocks more fully.

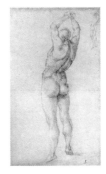

Luca Signorelli
Standing Male Nude

Page 38 verso

Graphite smudges
Acc. no. 1987-53-30b

Page 39 recto (missing)

Sketch

Rewald, 1951, p. 28 (as Sketch)

Page 39 verso (missing)

Page 40 recto (missing)

Rewald, 1951, p. 28 (as blank)

Page 40 verso (missing)

Rewald, 1951, p. 28 (as blank)

Page 41 recto

Numbered in pencil: 41
Acc. no. 1987-53-31a

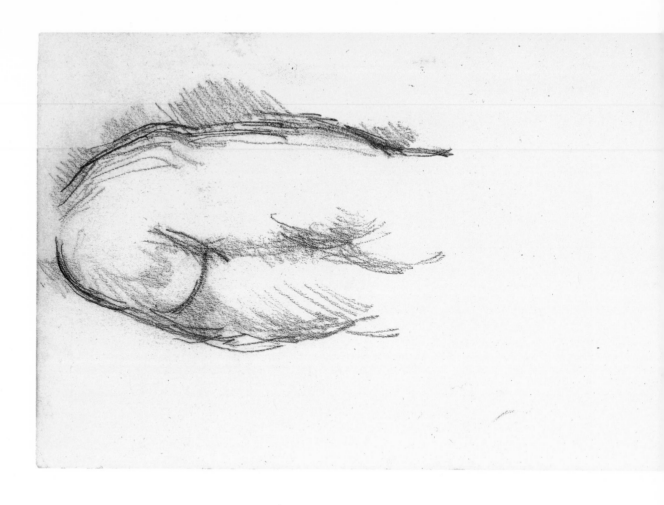

Hermes
Antique marble

Page 41 verso

Antique Hermes
Graphite pencil
Acc. no. 1987-53-31b

Rewald, 1951, p. 28 (unidentified);
Berthold, 1958, no. 308 (unidentified); Reff, 1960, p. 148; Chappuis,
1973, no. 330 (unidentified)

This incomplete sketch of an armless
torso—a fragmentary image of a
fragment—can be identified with
some certainty as a copy after the
upper half of the *Hermes Richelieu*, a
well-known Lysippean statue in the
Louvre (no. 573), seen from the right
side. No other armless antique statue
or torso in the Louvre corresponds as
closely to Cézanne's drawing, nor was
any as famous—and he invariably
chose the most famous works of
antiquity. The problem with this
identification is precisely the missing
right arm, which is indeed missing
today but at some time in the mid-
nineteenth century had been restored
(see Froehner, 1869, no. 177). Just
when it was removed, neither the
later Louvre catalogues (Héron de
Villefosse, 1896, no. 573; Michon,
1918, no. 573) nor the conservation
file on the work indicates; but it was
presumably after about 1890, since
Fürtwangler (1893; see 1895 ed., pp.
289–90) implies that the arm was still
present. Hence, Cézanne's copy,
probably made about that time, may
well be the earliest record of the
statue's present condition.

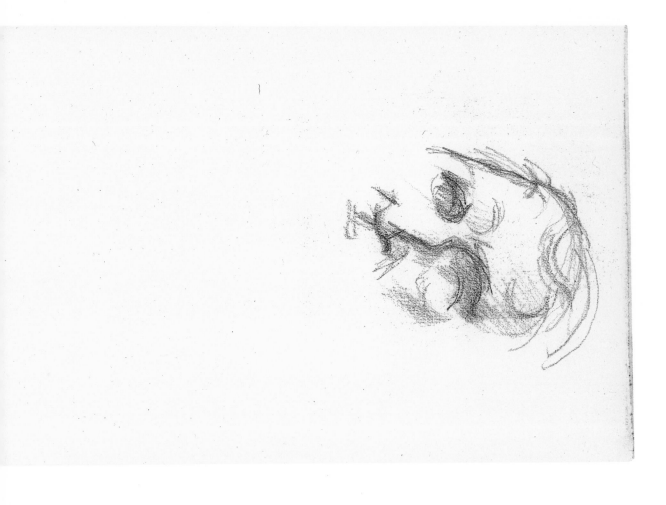

Page 42 recto

Coustou's Père de La Tour
Graphite pencil; graphite offset from
page 41 verso
Numbered: 42 (erased)
11.6 x 18.1 cm
Acc. no. 1987-53-32a

Rewald, 1951, p. 28; Berthold, 1958,
no. 194; Chappuis, 1973, no. 1116

Cézanne's interest in the expressive power of the many portrait busts he copied in the Louvre is nowhere more apparent than in his seven drawings after Guillaume Coustou's bust of Pierre-François Darerès de La Tour (Louvre, no. 1091), a larger number than his drawings after any other bust, ancient or modern. It is easy to see why he was attracted by the emotional intensity of this incisively modeled likeness of the Superior of the Oratorian Order, harder to understand why he exaggerated this intensity to the extent that he has here and in some of the other drawings. Indeed he has cast the eyes in so strong a shadow that they appear sightless, not shrewd as in the original, and has bent the hooked nose to the point where it seems deformed. Three of the other copies are in Sketchbook II, pages IV recto, XII verso, XLIV recto; the remaining three are in Basel (Chappuis, 1973, nos. 1117–19).

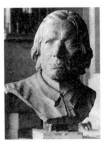

Guillaume Coustou
*Pierre-François Darerès de
La Tour.* Terra-cotta

Page 42 verso

Person's Head
Graphite pencil; graphite offset from
page 43 recto
11.6 x 18.1 cm
Acc. no. 1987-53-32b

Rewald, 1951, p. 28; Andersen, 1970,
no. 56 (unillustrated); Chappuis,
1973, no. 1116A (incorrectly illus-
trated as no. 628)

Previously identified by three
scholars, only one of whom actually
saw it, as a study of Cézanne's wife,
this slight sketch may equally well
represent his son. Since he was
clearly fascinated by this strongly
foreshortened view of the head, he
drew his two favorite models looking
down in this way many times (e.g.,
Chappuis, 1973, nos. 666, 723, 725;
nos. 860, 863, 867–69), and it is some-
times difficult to distinguish them.

Page 43 recto

Still Life
Graphite pencil; graphite offset from
page 42 verso
Numbered in pencil: 43
Acc. no. 1987-53-33a

Rewald, 1951, p. 28

The objects in this still life are so
simplified and truncated as to be hard
to recognize: one may be a bowl or
part of a lamp similar to the one on
page 15 verso in this sketchbook; the
other, bulb-shaped, may be anything.

Previously unillustrated.

Page 43 verso

Seated Man; Legs of Bather
c. 1890?
Graphite pencil
Inscribed in brown ink at bottom,
page inverted: Mlle Aimée / Braquet /
rue Ponchet, 45
Acc. no. 1987-53-33b

Rewald, 1951, p. 28; Andersen, 1970,
no. 261 (incorrectly described and
illustrated); Chappuis, 1973, no. 439

This figure bears a striking resemblance to one of the cardplayers in the first and largest of Cézanne's paintings of that subject (Venturi, 1936, no. 560), which have reliably been dated 1890–92. But the simplified treatment of the tiny figure and the absence of cards in his hands make it impossible to be certain; and such a date is hard to reconcile with that of the male bather that extends onto this page from page 44 recto.

Cardplayers
(Venturi, 1936, no. 560)

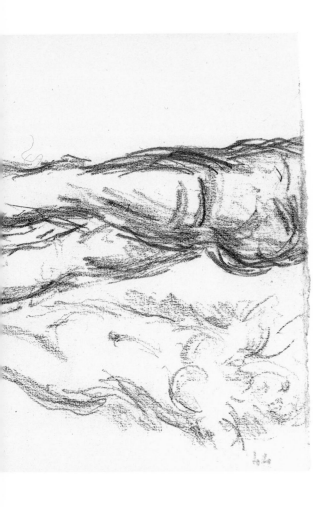

Page 44 recto

Two Bathers
c. 1890?
Graphite pencil
Numbered in pencil: 44
11.6 x 9.5 cm; attached to page 43
Acc. no. 1987-53-33b

Rewald, 1951, p. 28; Andersen, 1970, no. 261 (incorrectly described and illustrated); Chappuis, 1973, no. 439

The standing bather, who appears, when shown completely, in a powerfully twisted and contracted pose, thrusting one leg behind the other, clasping both hands behind his head, and turning his upper body to a nearly frontal position, while his lower body faces to the left, is one of the most familiar types in Cézanne's art. He appears in paintings from the mid-1870s to the mid-1890s (Venturi, 1936, nos. 263, 268, 587, 724), in watercolors spanning the same period

Bathers
(Venturi, 1936, no. 590)

(Rewald, 1983, nos. 119–20, 494–95), and in many drawings; among the latter are two others in this sketchbook (pp. 44 verso–45 recto, 46 recto) and three in Sketchbook II (pp. xxxviii recto, xliii verso, xlix recto). On the other hand, the small female bather on this page seems to occur nowhere else in the work.

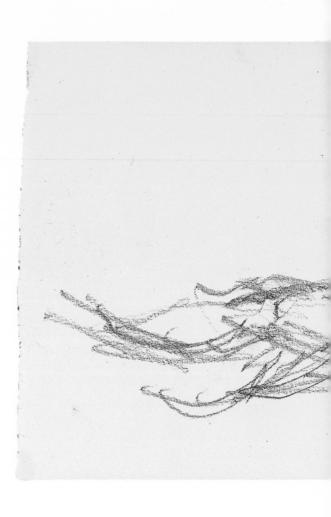

Page 44 verso

Male Bather's Legs
Graphite pencil
11.6 x 9.5 cm; attached to page 43
Acc. no. 1987-53-33a

Rewald, 1951, p. 28

The legs in this sketch are a continuation of those of the bather in the sketch on page 45 recto, extending from below the buttocks to mid-calf.

Previously unillustrated.

Page 45 recto

Standing Male Bather
Graphite pencil
Numbered in pencil: 45
11.6 x 12.4 cm
Inscribed in brown ink at left: Mademoiselle / Marie Louise / 7 Villa Monceau
Acc. no. 1987-53-34a

Rewald, 1951, p. 28; Chappuis, 1973, no. 442

Although its execution is rough and now somewhat smudged, and its representation of anatomy rudimentary, this sketch conveys great power through the large, rhythmically repeated curves and the broadly simplified planes. The type of male bather whose upper half alone is shown here—it continues onto page 44 verso—is one of the most familiar in Cézanne's work (see pp. 43 verso, 44 recto, 46 recto).

Alonso Cano
The Dead Christ

Page 45 verso

Cano's Dead Christ
Graphite pencil; watercolor
11.6 x 12.4 cm
Inscribed in brown ink at right:
Soccio, 7 rue / Maitre Albert
Acc. no. 1987-53-34b

Rewald, 1951, p. 28 (incorrectly
identified); Berthold, 1958, no. 273,
pl. 50; Chappuis, 1973, no. 524

A partial copy after Alonso Cano's
Dead Christ, undoubtedly made from
the wood-engraved reproduction in
the chapter on Cano in Charles
Blanc's *Histoire des peintres de toutes les
écoles, Ecole espagnole* (Paris, 1869); the
shading in fine, parallel strokes sug-
gests such a graphic model. Concen-
trating on the figure's head and torso,
Cézanne omits the legs, yet curiously
includes the hands of the angel sup-
porting Christ, as if he were repro-
ducing the original mechanically,

without interpretation. This copy, in
turn, provided a model for one of his
bather types (see Sketchbook II, front
endpaper); indeed, the watercolor
version of this type (Rewald, 1983,
no. 124) may have been made directly
from this copy, which contains sev-
eral watercolor washes.

Page 46 recto (missing)

Three Bathers
Numbered: 46

Venturi, 1936, no. 900; Rewald, 1951, p. 29 (as missing); Chappuis, 1973, under no. 1192; Rewald, 1983, no. 120

This missing page can be identified with the watercolor of three bathers (p. 20, fig. 4; location unknown).

Page 46 verso (missing)

The Dinner

Venturi, 1936, no. 1219; Rewald,
1951, p. 29 (as missing); Chappuis,
1973, no. 1192; Rewald, 1983, under
no. 120 (as from Sketchbook I)

This missing page (location unknown)
can be identified as the drawing *The
Dinner* (p. 20, fig. 5).

Page 47 recto

Notations
Graphite pencil; watercolor; graphite
offset from missing page 46 verso (see
p. 20, fig. 5)
Numbered in pencil: 47
Inscribed in graphite pencil: Sceau /
terrine / pot / balai[s?] / fontaine 7
F[rancs], 50 / [ill. wd.] / de lin
Acc. no. 1987-53-35a

Rewald, 1951, p. 29

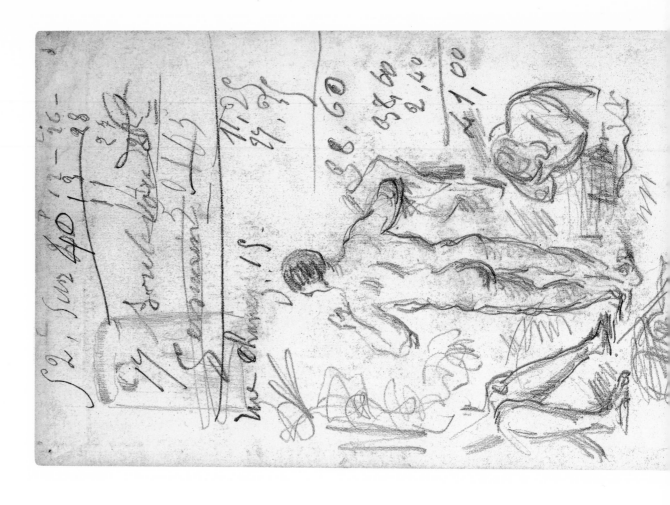

Five Bathers
(Venturi, 1936, no. 389)

Page 47 verso

Three Male Bathers; Pitcher
c. 1882
Graphite; graphite offset from back
endpaper
Inscribed in graphite pencil: 52 c[m]
sur 40 [written over 20] / 17 Boule-
vard St / Germain / rue Chanez 15 /
[several groups of numbers]
Acc. no. 1987-53-35b

Rewald, 1951, p. 29, pl. 106;
Chappuis, 1973, no. 423

Above, beneath the inscriptions, a
faint sketch of a pitcher.

Below, a swiftly drawn study for the
central part of a composition of male
bathers, of which the closest exam-
ples are the *Five Bathers* (Venturi,
1936, nos. 389–90). The studies of a
single bather on pages 43 verso, 44
recto, and 45 recto in this sketchbook
are for the right side of the same
composition, as is a watercolor that
once belonged to this sketchbook
(p. 20, fig. 4). Since the paintings are

by general agreement dated 1879–82,
and this sketchbook was begun in
1882, the latter is the likely date for
the whole group of studies.

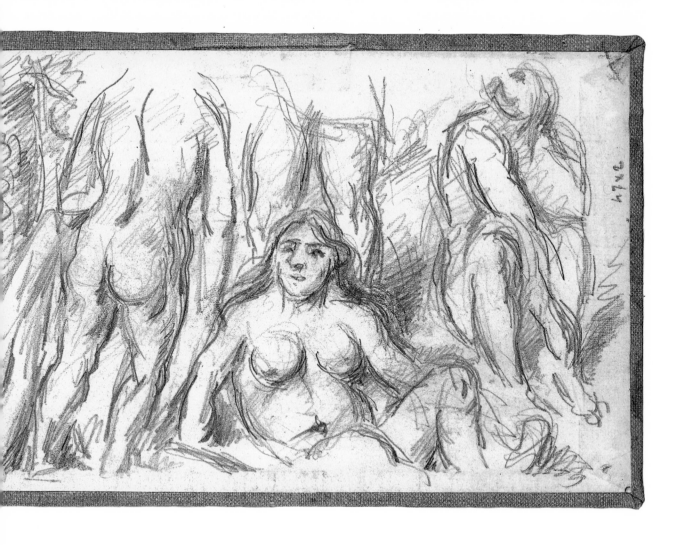

Back endpaper

Four Female Bathers
c. 1882
Graphite; traces of watercolor
Numbered in pencil: 47 x 2
Acc. no. 1987-53-362

Rewald, 1951, p. 29; Chappuis, 1973,
no. 512

A study for paintings of four female bathers (Venturi, 1936, nos. 384, 386), showing the standing figures incompletely and the reclining one in a slightly different position. In the larger drawing intermediate between this one and the paintings (Chappuis, 1973, no. 514), the figures and landscape setting are worked out more carefully. Since that drawing as well as the paintings are generally dated 1879–82, and this sketchbook was begun in 1882, that is the likely date of the present drawing, too. Even more than the tightly constructed paintings, where the verdant landscape provides some breathing space, the closely packed figures here, their bodies intricately fitted together in a relief-like design, project a strong sense of closure, even of claustrophobia.

Four Female Bathers
(Venturi, 1936, no. 386)

Back cover

Linen-covered board; spots of oil
paint and watercolor
12.5 x 18.6 cm
Acc. no. 1987-53-36b

Sketchbook II

Theodore Reff

with notes on mediums
and additional pages by
Innis Howe Shoemaker

Notes to Sketchbook II

The sketchbook pages are an off-white wove paper. The primary medium is graphite pencil, sometimes heightened with watercolor. Spots, stains, or traces of other mediums, which have no relationship to the image, are listed after the primary medium, separated by semicolons. Offsets from the images on adjacent pages are noted last. Residual stains from tape used previously for mounting are not noted.

The dimensions of the pages of Sketchbook II are 12.7 by 21.6 centimeters. Dimensions are noted in the descriptions only for sheets that differ significantly from the standard dimensions.

Page numbers are noted where they are still visible. Sketchbook II is numbered in Roman numerals at the lower right corner of the recto page, in a soft blue-gray pencil.

Pages known to be missing from Sketchbook II are noted in the sequence of the book, corresponding to Rewald, 1951, which is the earliest known inventory of the pages.

Bibliographical sources are cited in abbreviated form, using the author's name and date of publication, with full references appearing in the Bibliography.

The numbers given for the works in the Musée du Louvre are those that appear in the series of museum catalogues published between 1922 and 1924, which are listed in the Bibliography.

Front cover

Linen-covered board; spots of oil
paint and watercolor
13.7 x 21.6 cm
Numbered in blue ink at left: IIII; at
lower right in black ink [inverted]: IV
Acc. no. 1987-53-37a

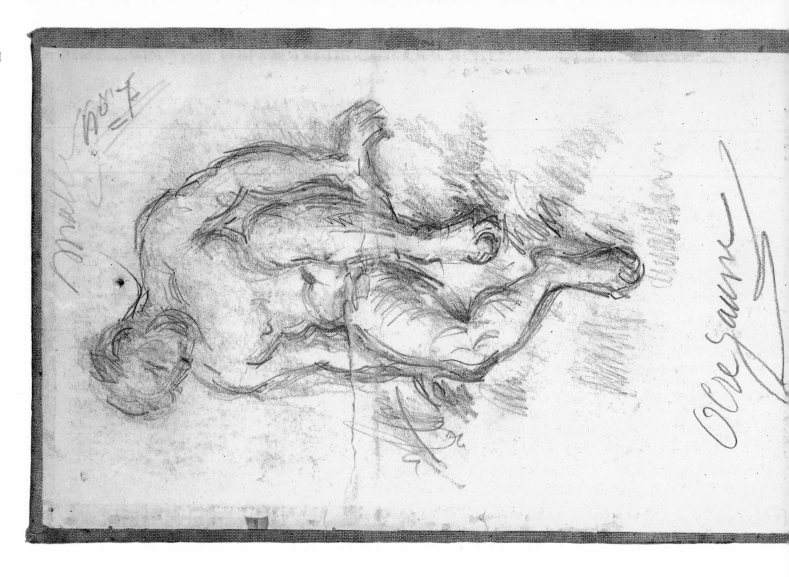

Front endpaper

Seated Male Bather
After 1882
Graphite pencil
Inscribed at top: matte / [in foreign hand:] No 7; at bottom: Ocre jaune
Acc. no. 1987-53-37b

Rewald, 1951, p. 43 (transcribed incorrectly); Chappuis, 1973, no. 528

A study for one of the most familiar bather types in Cézanne's work, the one seated on the opposite river bank in several compositions of five or six male bathers dating from the 1880s (e.g., Venturi, 1936, nos. 541, 582, 590). Since the pose is clearly based on the copy after Cano's *Dead Christ* in Sketchbook I, page 45 verso, this study can be dated after 1882, like the copy itself; the closely related watercolor of this bather (Rewald, 1983, no. 124) has been dated a few years

Bathers
(Venturi, 1936, no. 541)

later. In adapting Cano's figure, Cézanne preserves the strongly inclined upper body but reverses the positions of the legs (omitted in his copy), thereby reinforcing the bather's downward movement and suggesting that he is about to slide off the bank into the water.

Page 1 recto

Standing Bather; Notations
Graphite pencil; traces of oil paint
and watercolor
Numbered in pencil: 1
Inscribed in graphite pencil at top:
Jan Davidz[on] de Heem / Ecole
hollandaise; in the center, left
column: Blanc d'Argent 4 / Brun
Rouge 1 / laque fine 2 / Bleu cobalt 2 /
Bleu outremer 4 / Sienne naturelle 1 /
Terre Verte 4 / Vert Véronèse 2; right
column: Edouard / Vermillon / fran-
çais / Noir pêche / Pincelier / Palette;
at bottom, page inverted: Cobalt 4 /
Bleu minéral 1 / Jaune Brillant 5 / ocre
jaune 2 — No 6 / Emeraude 1 / Terre
Verte 5 / Blanc Argent 5 / Laque
garance foncé 1; at lower left: Laque
fine / Terre verte
Acc. no. 1987-53-38a

Rewald, 1951, p. 43 (transcribed
incorrectly); Chappuis, 1973, no. 507

The reference to De Heem is proba-
bly to the chapter on him in Charles
Blanc's *Histoire des peintres de toutes les
écoles, Ecole hollandaise* (Paris, 1861).
Other references to the same publica-
tion are on page LII verso of this
sketchbook.

The rapid outline sketch beneath the
writing is of a bather of indeterminate
sex, bending forward with its arms on
its raised right leg. This figure type
appears in Cézanne's work at widely
different times (see p. XXVI recto in
this sketchbook).

Page 1 verso

Graphite smudges; traces of oil paint
and watercolor
Acc. no. 1987-53-38b

Page II recto (missing)

Rewald, 1951, p. 44 (as missing)

Page II verso (missing)

Rewald, 1951, p. 44 (as missing)

Page III recto

Bowler Hat and Garment
Graphite pencil; traces of oil paint
Numbered in pencil: III
Acc. no. 1987-53-39a

Rewald, 1951, p. 44; Chappuis, 1973,
no. 548

Previously described as a "fabric . . . [that] swells like a wave" (Chappuis), the object in the foreground of this sketch is more likely a bowler hat partly covered by a garment, very much like the same objects, more explicitly represented, on page XXXVIII verso of this sketchbook.

Page III verso

Graphite offset from page IV recto
Acc. no. 1987-53-39b

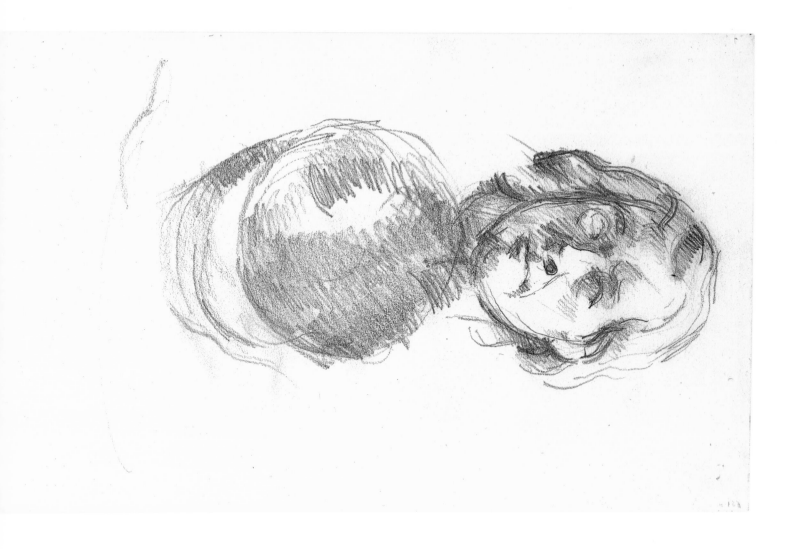

Page IV recto

Coustou's Père de La Tour
Graphite pencil; traces of oil paint
Numbered: IIII (erased)
Acc. no. 1987-53-40a

Rewald, 1951, p. 44, pl. 148;
Berthold, 1958, no. 189; Chappuis,
1973, no. 669

Guillaume Coustou
*Pierre-François Darerès de
La Tour*. Terra-cotta

Guillaume Coustou's bust of Pierre-
François Darerès de La Tour (Louvre,
no. 1091) was Cézanne's favorite
among the many portraits of all peri-
ods that he copied in the museums. In
addition to the copies in this sketch-
book (pp. XII verso, XLIV recto) and
the one in Sketchbook I (p. 42 recto),
there are three in the Basel museum
(Chappuis, 1973, 1117–19). In the
present drawing and several of the
others, we see the bust in a nearly
frontal view, strongly illuminated

from one side, so that the dramatic
contrast of light and shade reinforces
the Oratorian father's stern, brooding
expression.

The other sketch, previously identi-
fied as a bowl or as a boy's head seen
from above, is more likely a hat,
perhaps a cap with a visor, also seen
from above.

Page IV verso

Graphite offset from page v recto;
traces of watercolor
Acc. no. 1987-53-40b

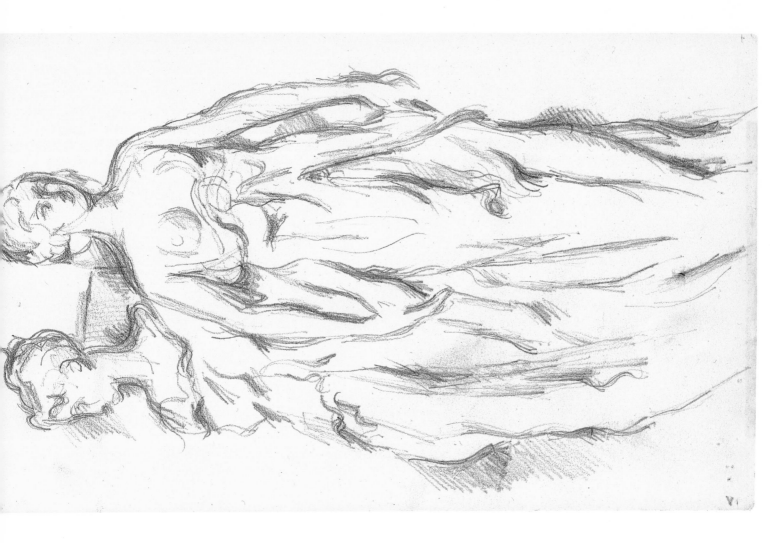

Page v recto

Pilon's Monument to Henry II
Graphite pencil
Numbered in pencil: v
Acc. no. 1987-53-41a

Rewald, 1951, p. 44, pl. 135;
Berthold, 1958, no. 144; Hoog, 1971,
p. 16; Chappuis, 1973, no. 1112

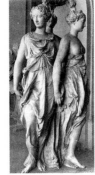

Germain Pilon, The
Three Graces, from
Monument to Henry II.
Marble

This is surely the most interesting of
Cézanne's four copies after Germain
Pilon's *Monument to Henry II* in the
Louvre (no. 413) and one of the most
impressive drawings in this sketch-
book. Unlike the other copies, which
show the figures very incompletely
(Sketchbook I, p. 24 verso; Chappuis,
1973, no. 1113) or rather schemati-
cally (ibid., no. 585), this one invests
the depiction of Pilon's tall, elegant
Graces with all the freshness and
vigor of Cézanne's mature graphic
style and bathes them in a brilliant
light. His confidence in drawing them
is also evident in the majestic way
they fill the surface, giving the small
sketchbook page the imposing scale of
a much larger sheet.

Page v verso

Graphite offset
Acc. no. 1987-53-41b

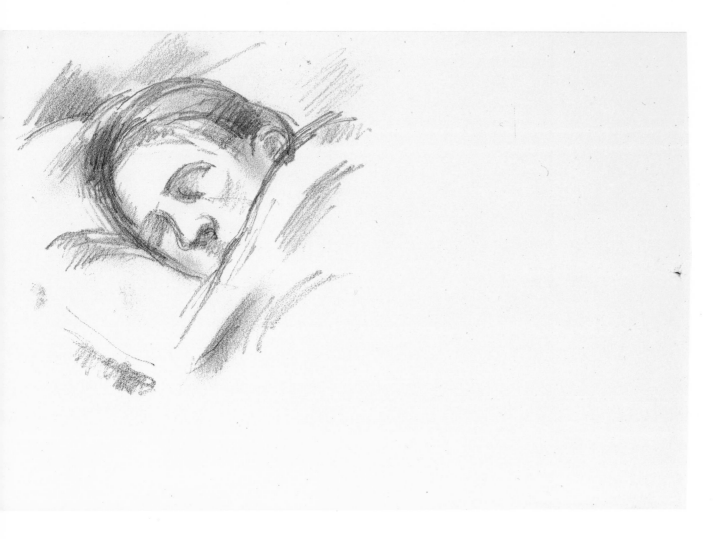

Page VI recto

The Artist's Son Asleep
c. 1885
Graphite pencil
12.7 x 19.7 cm
Acc. no. 1987-53-42a

Rewald, 1951, p. 44; Andersen, 1970, no. 188; Chappuis, 1973, no. 856

Estimating the ages of Cézanne's models is often problematic, given his tendency to generalize and simplify; but if his son Paul, born in 1872, must be about ten years old in the drawings of him asleep in Sketchbook I (pp. 2 verso, 3 recto and verso, etc.), he appears in the present drawing about thirteen, the same age as in his confirmation photograph (see Andersen, 1970, no. 160).

The unusual use of smudging creates a tonal effect that has rightly been described as imitating "touches of watercolor" (Chappuis). The smudged tones on the pillow in particular form pale oval shapes, repeating the darker, more strongly marked oval of the head like distant echoes and enhancing the sense of quietness and inwardness.

Page VI verso

Chair Leg
Graphite pencil; graphite offset from
page VII recto
12.7 x 19.7 cm
Acc. no. 1987-53-42b

The sketchbook was held vertically
with the binding at the bottom.

Although barely begun, this sketch of
the curving leg of a chair already
suggests the leg's relation to its back-
ground through the slight cast
shadow.

Previously unillustrated and unre-
corded.

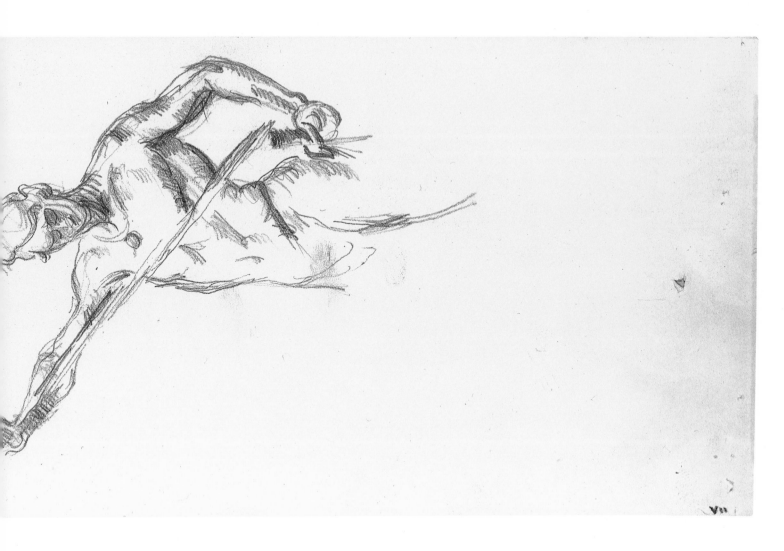

Page VII recto

Mercié's David
Graphite pencil
Numbered in pencil: VII
Acc. no. 1987-53-43a

Rewald, 1951, p. 44, pl. 132;
Berthold, 1958, no. 174; Chappuis,
1973, no. 471

Despite his disdain for the academic painting of the nineteenth century, Cézanne did draw at times after academic sculpture, such as Préault's statue of Clémence Isaure (Chappuis, 1973, nos. 497–98), Rude's popular *Neapolitan Fisherboy* (ibid., no. 681), and Antonin Mercié's bronze statue of David, which he has copied here and in two other sketchbooks (ibid., nos. 470, 472). A great success at the Salon of 1872, the *David* was bought by the State and shown in the Musée du Luxembourg from 1874 on, before being transferred to the Louvre (no. 1844). But Cézanne was evidently less interested in its academic-realist style than in the striking pattern of solids and spaces created by the slender figure and the sword; this is what he dwells on in all three copies.

Antonin Mercié
David. Bronze.

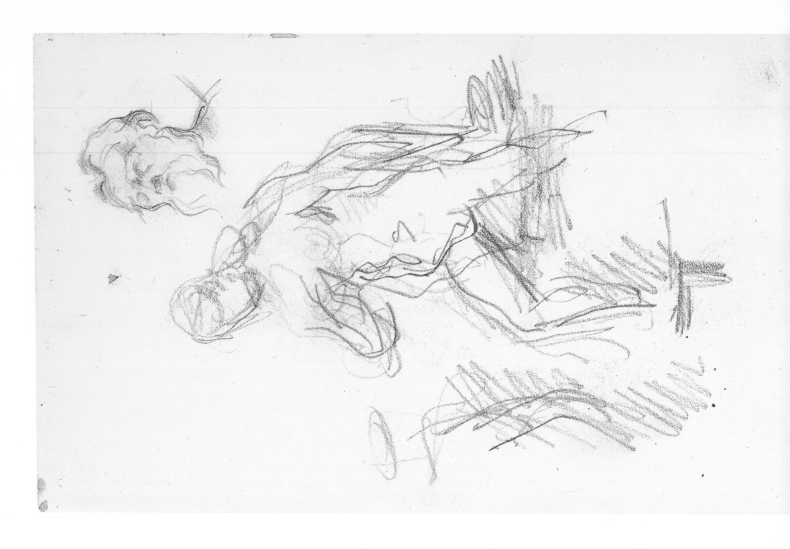

Page VII verso

Female Bather; Head of Diogenes, after Puget
Graphite pencil; traces of oil paint and watercolor
Acc. no. 1987-53-43b

Rewald, 1951, p. 44; Berthold, 1958, no. 298 (unidentified); Chappuis, 1973, no. 313 (unidentified)

Bathers
(Venturi, 1936, no. 540)

A very rapid sketch—clearly a first attempt to visualize a new figure type—for what would become one of the bathers at the left side in a composition of eight female bathers, on which Cézanne worked from the late 1880s onward (Venturi, 1936, nos. 538–40; Rubin, 1977, pl. 195). There is another study of this figure on page XII recto and a study of the whole left side on page x verso of this sketchbook.

The small head of a bearded man is a copy after that of Diogenes in Pierre Puget's monumental relief *The Meeting of Alexander and Diogenes* (Louvre, no. 1468).

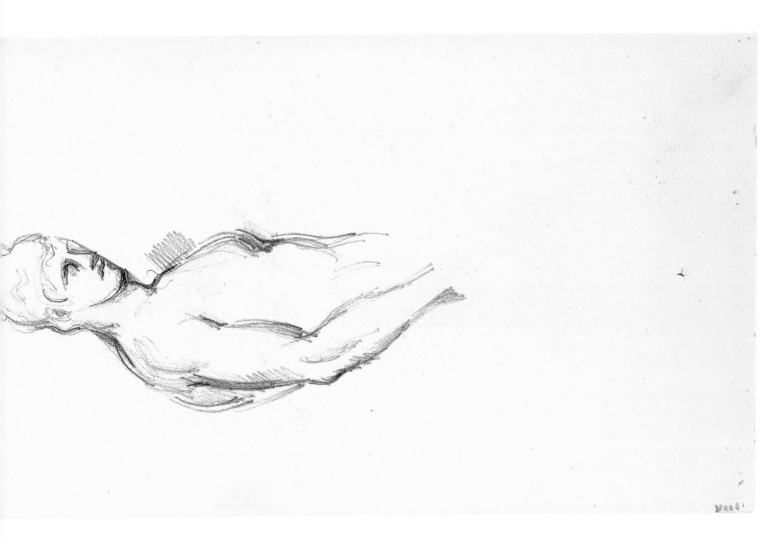

Page VIII recto

Antique Borghese Mars
Graphite pencil; traces of watercolor
Numbered in pencil: VIII
Acc. no. 1987-53-44a

Rewald, 1951, p. 44, pl. 120;
Berthold, 1958, no. 8; Chappuis,
1973, no. 587

An antique replica of a Greek statue of the classical period, the *Borghese Mars* is one of the masterpieces of ancient sculpture in the Louvre (no. 866) and was one of Cézanne's favorites there. His nine drawings after it capture both the relaxed, harmonious posture and the compact, clearly articulated forms. In choosing positions from which to view it, a process made easier by the statue's rotating pedestal, he opted most often for a frontal view (Chappuis, 1973, nos. 1051–53, 1055) and a view of the right side, as in this drawing (see also ibid., nos. 586, 588); but there is also a view of the left side and even one of the back (ibid., nos. 1056, 1054).

Borghese Mars
Antique marble

Page VIII verso

Seated Man
Graphite pencil; traces of watercolor;
oil paint fingerprint
Acc. no. 1987-53-44b

Rewald, 1951, p. 44; Andersen, 1970,
no. 255; Chappuis, 1973, no. 225

Although drawn rather faintly and
swiftly, this sketch clearly shows a
seated man in profile to the right with
his right arm on a table, hence in an
attitude very like one of the cardplay-
ers in the paintings and watercolors
Cézanne made of that subject in
1890–92 (e.g., Venturi, 1936, nos.
559–60; Rewald, 1983, no. 377), as
other scholars have noted. What has
not been observed is that this seated
figure is also like, and in some ways
more like, the one in a watercolor
dated a decade later (ibid., no. 542).

Cardplayers
(Venturi, 1936, no. 560)

Page IX recto

Landscape
Graphite pencil
Acc. no. 1987-53-45a

Rewald, 1951, p. 44; Chappuis, 1973, no. 879

Once again, the degree to which Cézanne has abstracted a pattern of lines and tones from his natural subject, even while striving to represent it fully, makes identifying it difficult. Is this a "terraced landscape," whose "middle distance consists of a slope spreading across to the right," while "the wooden [*sic*] crest of a hill establishes the horizon" (Chappuis)? Or is it a walled garden or field, in which the central form, shaded in vertical strokes, is a high masonry wall surmounted by small plants or lichens? The drawing remains as ambiguous as it is abstractly beautiful.

Page IX verso

Foliage and Trees
Graphite pencil; traces of watercolor;
oil paint fingerprint
Acc. no. 1987-53-45b

Rewald, 1951, p. 44; Chappuis, 1973,
no. 879A

Like many of Cézanne's drawings and
watercolors of landscape subjects,
this one shows so modest a corner of
nature that it is hard to see what
attracted him to it. Perhaps it was the
paired trees at the right, in whose
forked trunks and branches he discov-
ered an interesting pattern of crossed
diagonals.

Previously unillustrated.

Page x recto

Flower
Graphite pencil; graphite offset from
page IX verso
Numbered in pencil: x
12.7 x 14.4 cm
Acc. no. 1987-53-46a

Rewald, 1951, p. 44; Chappuis, 1973,
no. 525A

A swift sketch of a single flower,
probably a peony in bud, with its
stem and leaves.

Previously unillustrated.

Page x verso

Three Female Bathers
Graphite pencil; traces of oil paint
12.7 x 14.4 cm
Acc. no. 1987-53-46b

Rewald, 1951, p. 44; Chappuis, 1973,
no. 525 (described inaccurately)

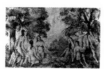

Bathers
(Venturi, 1936, no. 540)

A swift sketch, employing the kind of
agitated scribble Cézanne used when
trying to visualize a new figurative
subject, for the left side of a composi-
tion of eight female bathers (Venturi,
1936, nos. 539–40; Rubin, 1977, pl.
195). There are also two studies for
the central figure of the group on
pages VII verso and XII recto of this
sketchbook.

Page XI recto (missing)

Rewald, 1951, p. 44 (as missing)

Page XI verso (missing)

Rewald, 1951, p. 44 (as missing)

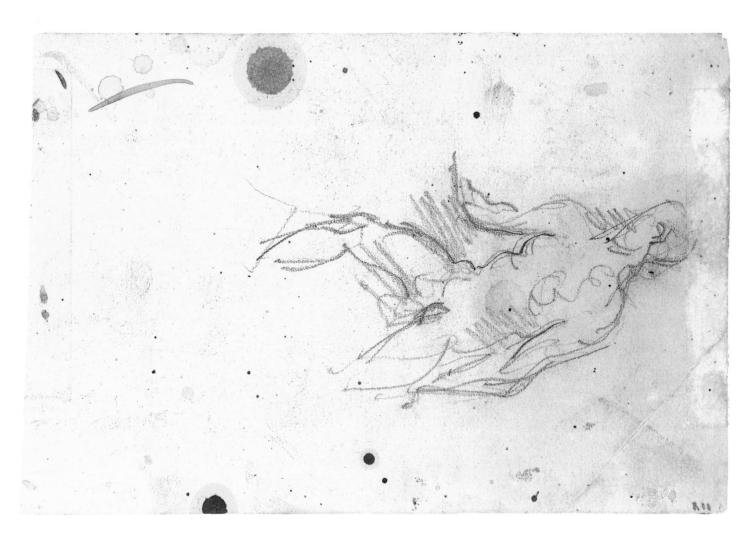

Page XII recto

Female Bather
Graphite pencil; traces of oil paint
and watercolor; oil stains
Numbered in pencil: XII
12.7 x 19.2 cm
Acc. no. 1987-53-47a

Rewald, 1951, p. 44; Chappuis, 1973,
no. 670A

A somewhat more carefully defined
study of the same bather as on page
VII verso of this sketchbook. Having
established the figure's pose through
outlines alone, Cézanne begins at
once to add the shading that suggests
both form and space.

Previously unillustrated.

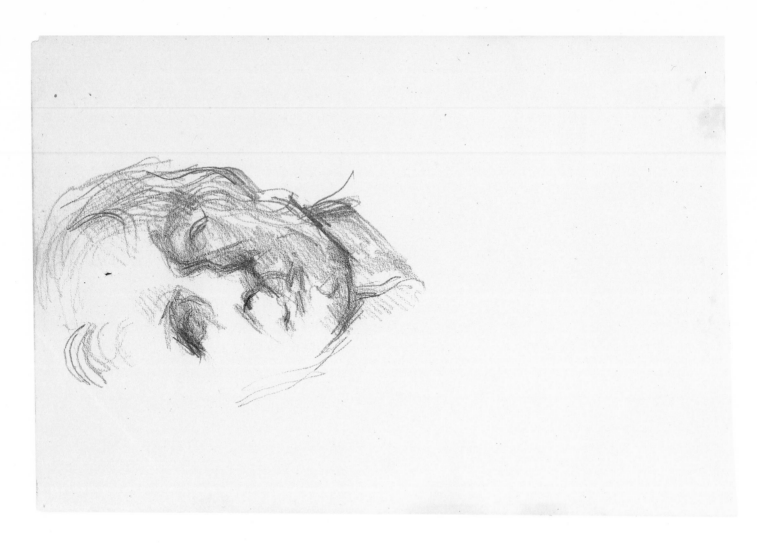

Page XII verso

Coustou's Père de La Tour
Graphite pencil; traces of oil paint
12.7 x 19.2 cm
Acc. no. 1987-53-47b

Rewald, 1951, p. 44; Berthold, 1958,
no. 195; Chappuis, 1973, no. 670

Guillaume Coustou
*Pierre-François Darerès de
La Tour.* Terra-cotta

Of Cézanne's seven copies after Coustou's portrait bust of the Oratorian father Darerès de La Tour in the Louvre (see p. IV recto in this sketchbook), only this and one other (Chappuis, 1973, no. 1117) show a strict frontal view that seems to reinforce the severity of its expression. In the present copy, the oblique illumination casts shadows across one side of the face and around the deeply recessed and vaguely defined eyes, adding its own note of mystery and pathos, even evoking thoughts of blindness. The unusual placement of the head, high on the otherwise empty page, increases the sense of isolation and inwardness.

Page XIII recto

Traces of watercolor and oil paint;
graphite offset from page XII verso
Numbered in pencil: XIII
Acc. no. 1987-53-48a

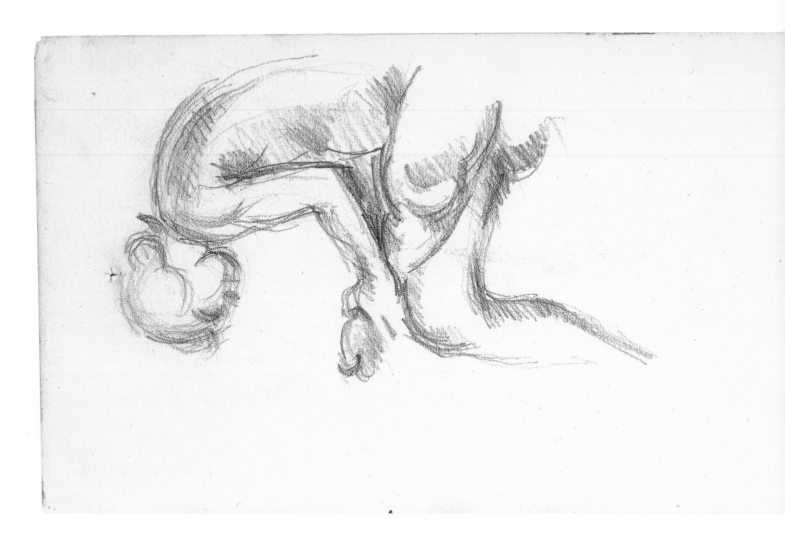

Page XIII verso

Antique Thorn Puller
Graphite pencil; traces of watercolor
Acc. no. 1987-53-48b

Rewald, 1951, p. 44, pl. 129;
Berthold, 1958, no. 35; Chappuis,
1973, no. 562

*Young Man Pulling a
Thorn from His Foot*
Plaster cast of antique
marble

The Hellenistic statue of a young man pulling a thorn from his foot, popularly known as the *Spinario*, of which Cézanne saw a bronze replica in the Louvre (no. 823), has been a favorite model for artists since the Renaissance. One of the figures in Seurat's painting *The Models* (The Barnes Foundation, Merion, Pennsylvania), which is roughly contemporary with this drawing, is based on the same statue. Here Cézanne views it from the left side and slightly below, emphasizing its open, irregular silhouette; in another copy (Chappuis, 1973, no. 561) he sees it from the right and a little above, so that the compact, rounded forms produce a closed silhouette. The view from the left, and especially the foreshortening of the bent left leg, clearly posed a problem that Cézanne's lack of conventional training in anatomy and perspective left him unable to resolve fully.

Page xiv recto (missing)

Rewald, 1951, p. 44 (as missing)

Page XIV verso (missing)

Rewald, 1951, p. 44 (as missing)

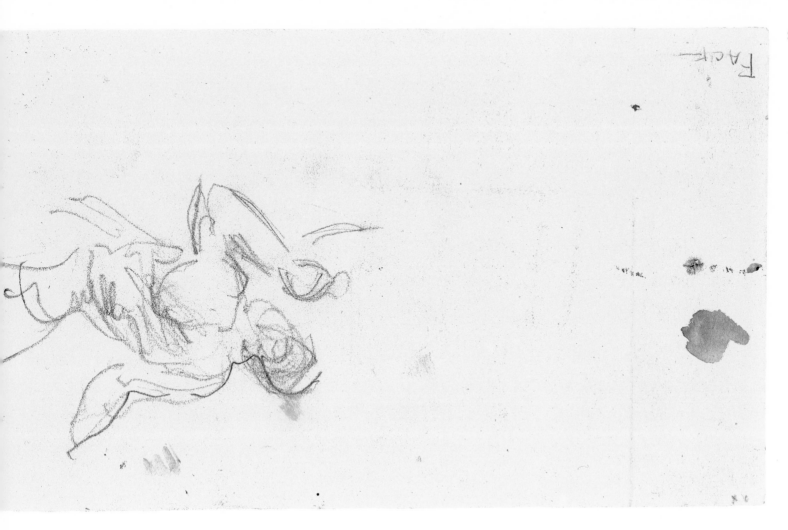

Page xv recto

Male Bather
Graphite pencil; touches of water-
color; watercolor fingerprint
Numbered in pencil: xv
Acc. no. 1987-53-49a

Rewald, 1951, p. 45; Chappuis, 1973,
no. 312

None of the figures in Cézanne's
bather compositions corresponds
exactly to this one in its pose, but one
of the two wrestling figures in paint-
ings of about 1900 (Venturi, 1936,
nos. 727, 729) and in a related water-
color (Rewald, 1983, no. 126, proba-
bly dated too early) is similar enough
to indicate the subject and purpose of
this rough sketch.

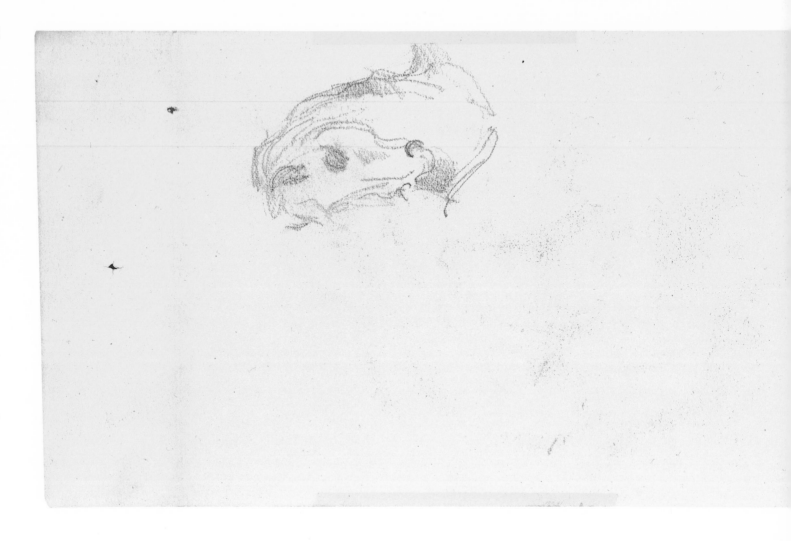

Page xv verso

Horse's Head, after Rubens
Graphite pencil; graphite offset from
page XVI recto
Acc. no. 1987-53-49b

Rewald, 1951, p. 45 (unidentified);
Berthold, 1958, no. 225 (identified by
analogy with the other copy); Chappuis, 1973, no. 312A (unidentified)

A slight, somewhat smudged, yet
charming copy after the head of the
horse in the center of Rubens's *Capture of Jülich*, one of the pictures in the
Maria de' Medici cycle in the Louvre
(no. 2097). A second, more complete
drawing of the same horse is on page
XXVII recto in this sketchbook.

Previously unillustrated.

Horse's head, detail
from Peter Paul Rubens,
Capture of Jülich

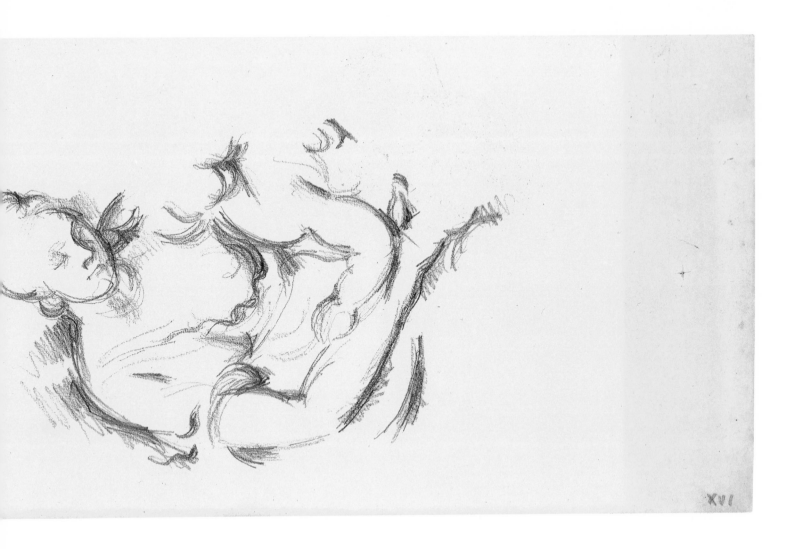

XVI

Page XVI recto

Pigalle's Love and Friendship
After 1879
Graphite pencil; graphite offset from
page XV verso
Numbered in pencil: XVI
Acc. no. 1987-53-50a

Rewald, 1951, p. 45, pl. 126;
Berthold, 1958, no. 162; Chappuis,
1973, no. 1045

Since Jean-Baptiste Pigalle's allegorical group *Love and Friendship* was acquired by the Louvre in 1879 (no. 1445), all of Cézanne's copies after it can obviously be dated after that year. In this drawing, as in three of the four others (Chappuis, 1973, nos. 501, 1044, 1046–47), he focuses on the upper half and especially on the beautiful, maternal figure of Friendship leaning forward to embrace the little Cupid who reaches up to her—an idealized image of motherhood that

Jean-Baptiste Pigalle
Love and Friendship
Marble

may well have had a particular appeal for him. But in none of the other drawings does he concentrate quite so exclusively on this figure, whose bosom forms the very center of the composition, while the Cupid remains a half-recognizable form at the right edge. Nor is any of the others as successful in capturing the vivid whiteness of the marble and the darkness of the shadows.

Page XVI verso

Graphite offset with traces of oil paint
and watercolor
Acc. no. 1987-53-50b

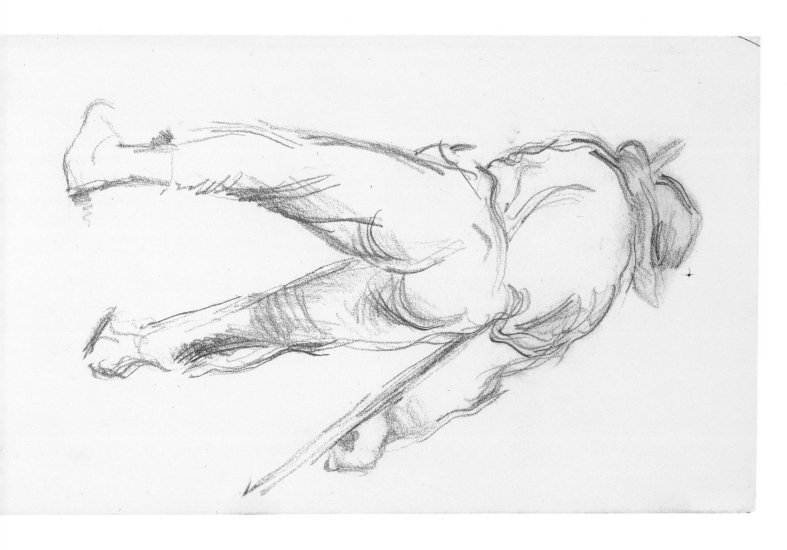

Page XVII recto

Millet's Reaper
After 1879
Graphite pencil
Acc. no. 1987-53-51a

Rewald, 1951, p. 45, pl. 36 (unidenti-
fied); Berthold, 1958, no. 246; Chap-
puis, 1973, no. 1213

A forceful copy after Jean-François
Millet's drawing of a reaper seen from
behind, which was acquired by the
Louvre in 1875 (RF 247) but evidently
not exhibited; Cézanne's actual model
was very likely H. E. Lessore's dry-
point reproduction, published in *J. F.
Millet, Les Travaux des champs* (Paris,
1879). Curiously, the figure does not
seem to have provided Cézanne with
a model for the reapers, likewise seen
from behind, in his watercolor of
1878–80 (Rewald, 1983, no. 54). But

Jean-François Millet
The Reaper

it does recur a decade later in Van
Gogh's painted copy (private collec-
tion, U.S.A.), based on the same
reproduction of the Millet drawing.
The differences between Cézanne's
somewhat simplified and abstract
vision of the reaper and Van Gogh's
very graphic, down-to-earth one tell
us much about both artists.

Page XVII verso

Graphite offset from page XVIII recto
Acc. no. 1987-53-51b

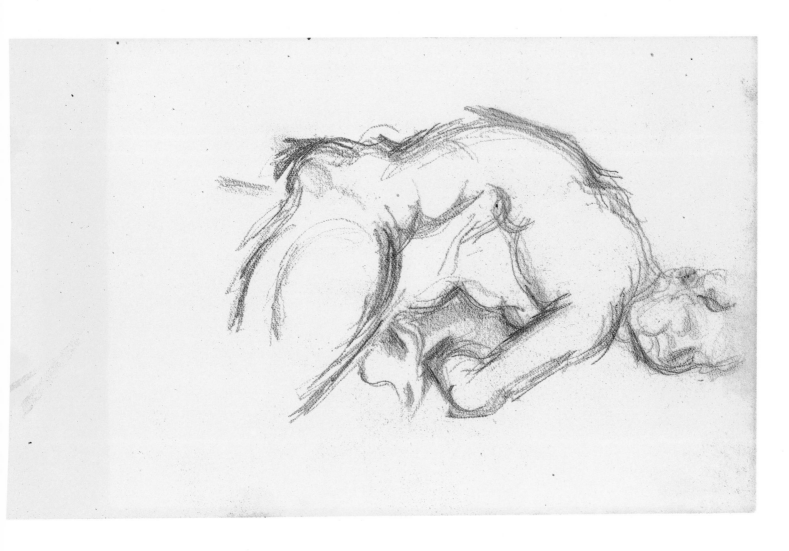

Page XVIII recto

Puget's Hercules Resting
Graphite pencil; traces of oil paint
Numbered: XVIII (erased)
12.7 x 20.6 cm
Acc. no. 1987-53-52a

Rewald, 1951, p. 45; Berthold, 1958, no. 113; Reff, 1966, pp. 41–44; Chappuis, 1973, no. 1057

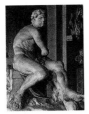

Pierre Puget
Hercules Resting. Marble

To judge from the number of drawings he made of it, Pierre Puget's monumental *Hercules Resting* in the Louvre (no. 1465) was Cézanne's favorite sculpture. There are two more copies in this sketchbook (pp. XXVI *bis* verso, XLIV verso), one in Sketchbook I (p. 28 verso), and fourteen elsewhere (Chappuis, 1973, nos. 575–76, 578, 999–1005, 1058–60, 1196). Yet fully half of these drawings, including all four in the Philadelphia sketchbooks, show the figure in a rear view where the club and lion skin that identify him as the mytho-logical hero are not visible. What seems to have interested Cézanne most was the bulging muscles of the right arm, back, and thigh and the way they enclose the smaller muscles of the chest and stomach, forming a kind of frame around them—a visual motif that he extracts from the realistically modeled anatomy, as if it were a landscape rather than a human form.

Page XVIII verso

12.7 x 20.6 cm
Acc. no. 1987-53-52b

Page XIX recto (missing)

Rewald, 1951, p. 45 (as blank)

Page XIX verso (missing)

Rewald, 1951, p. 45 (as blank)

Page xx recto (missing)

Rewald, 1951, p. 45 (as blank)

Page xx verso (missing)

Rewald, 1951, p. 45 (as having some
touches of watercolor)

Page XXI recto (missing)

Rewald, 1951, p. 45 (as missing)

Page xxi verso (missing)

Rewald, 1951, p. 45 (as missing)

Page XXII recto (missing)

Rewald, 1951, p. 45 (as missing)

Page XXII verso (missing)

Rewald, 1951, p. 45 (as missing)

Page XXIII recto

Oil paint strokes; traces of watercolor
Numbered in pencil: XXIII
12.7 x 18.4 cm
Acc. no. 1987-53-53a

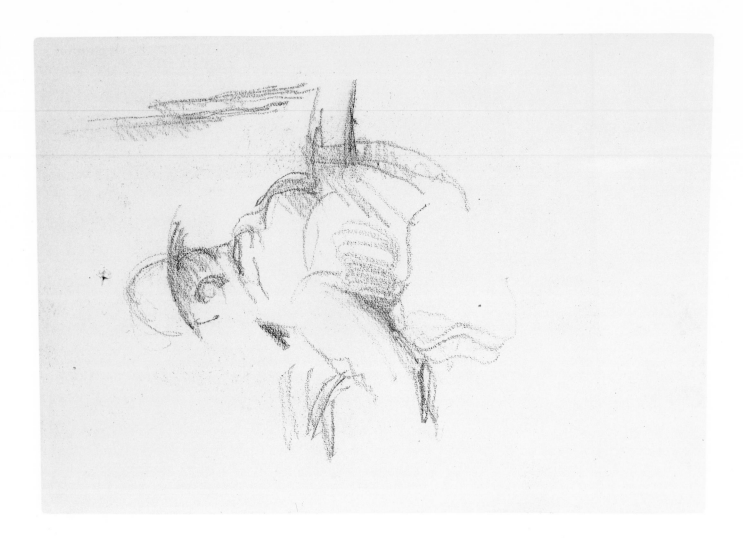

Page XXIII verso

Seated Man
Graphite pencil; graphite offset from
page XXIV recto
12.7 x 18.4 cm
Acc. no. 1987-53-53b

Rewald, 1951, p. 45; Chappuis and
Ramuz, 1957, pp. 79–80, pl. 13
(incorrectly listed as Sketchbook I, p.
43 verso); Chappuis, 1973, no. 1190
(as Vollard)

A rapid sketch of a man wearing the
same kind of coat and hat as in the
more fully developed sketch in
Sketchbook I, page 31 recto, which is
also very similar stylistically. Like the
latter, and indeed by analogy with it,
since the man's features are hardly
defined here, the present sketch has
been identified as a portrait of
Ambroise Vollard, the art dealer
whom Cézanne met in 1896. But
comparison with the portrait Cézanne
painted of him three years later (Ven-
turi, 1936, no. 696), and especially
with the preparatory drawing for it
(Chappuis, 1973, no. 1194), makes
this identification seem unlikely.

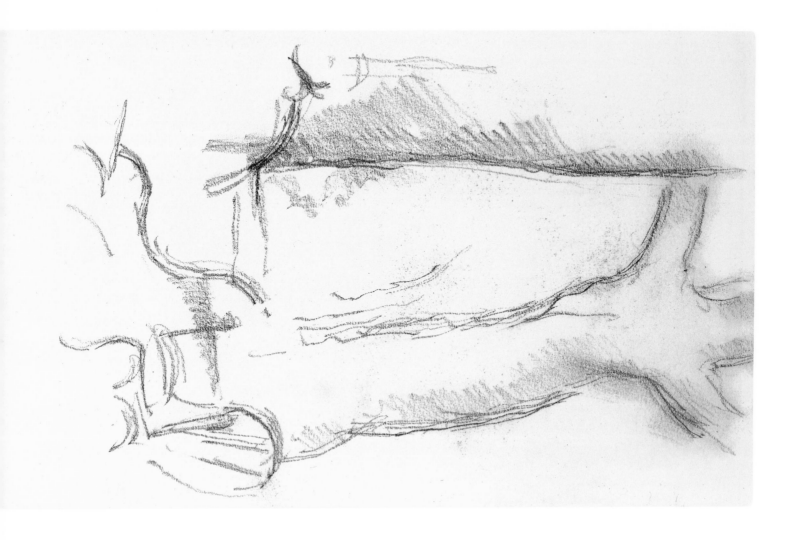

Page XXIV recto

Trees and Chairs
Graphite pencil; graphite offset from
page XXIII verso
Numbered: XXIIII (erased)
Acc. no. 1987-53-54a

Rewald, 1951, p. 45; Chappuis and
Ramuz, 1957, p. 79, pl. 11; Chap-
puis, 1973, no. 1186

The fine, repeated lines and slightly
smudged shading give this sketch,
perhaps made in a park in Paris like
the one on the facing page, a sense of
outdoor atmosphere and light. The
tall, curving tree with spreading
branches, in which "an image of the
crucifixion" has been seen (Chappuis),
also evokes a slender woman with
outstretched arms, towering above
the garden chairs. In any event, this
tree has a strongly human quality,
which is enhanced by its contrast to
the darker, straighter form of the
other tree.

Page xxiv verso

Traces of oil paint and watercolor;
graphite offset
Acc. no. 1987-53-54b

Page xxv recto (missing)

Rewald, 1951, p. 45 (as missing)

Page xxv verso (missing)

Rewald, 1951, p. 45 (as missing)

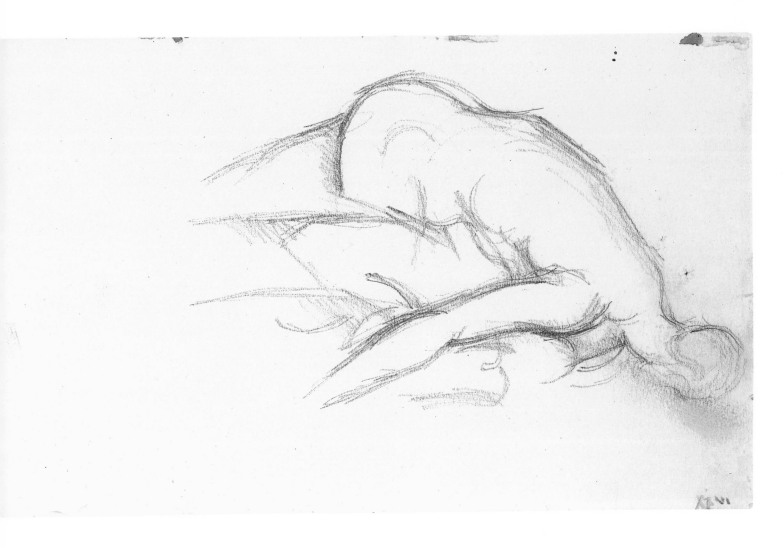

Page XXVI recto

Antique Hermes Fixing His Sandal
Graphite pencil; traces of watercolor
and oil paint
Numbered in pencil: XXVI
Acc. no. 1987-53-55a

Rewald, 1951, p. 45, pl. 128;
Berthold, 1958, no. 38, pl. 125; Reff,
1959, *Art News*, p. 28, fig. 8; Chap-
puis, 1973, no. 683

Surprisingly, this is the only copy
Cézanne made after a statue whose
pose must have interested him
greatly, since he based a number of
his bathers on it throughout his
career. *Hermes Fixing His Sandal* is an
antique replica in the Louvre (no. 83)
of a famous Greek work attributed to
Lysippus. Cézanne's bather, likewise
leaning forward to the right, its right
leg raised, appears both as a male
figure in the mid-1870s (Venturi,
1936, nos. 273–74, 276) and as a
female figure some thirty years later

(ibid., nos. 719, 721). The same
figure type also appears as a woman
taking her bath indoors, in a water-
color of the mid-1880s (Rewald, 1983,
no. 144), and as a small, schematic
figure of indeterminate sex earlier in
this sketchbook (p. 1 recto).

Hermes Fixing His Sandal
(detail). Antique marble

Page XXVI verso

Traces of watercolor; graphite offset
from page XXVI *bis* recto
Acc. no. 1987-53-55b

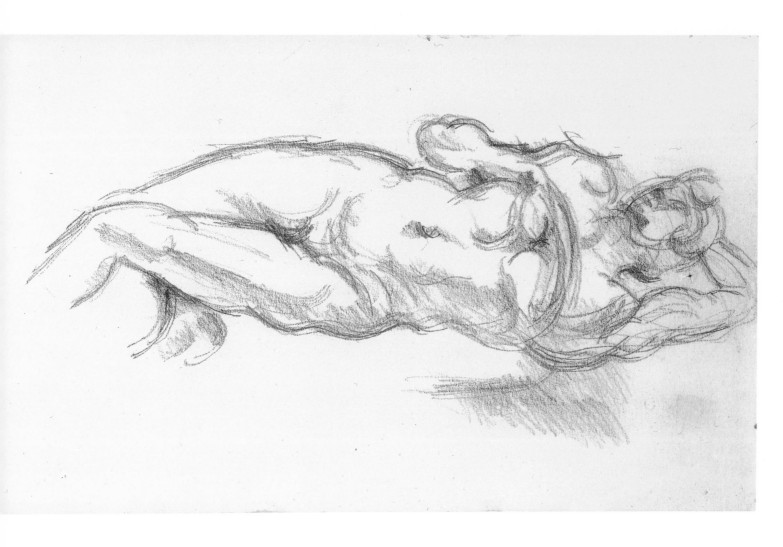

Page XXVI *bis* recto

Michelangelo's Dying Slave
Graphite pencil
Acc. no. 1987-53-56a

Rewald, 1951, p. 45, pl. 125;
Berthold, 1958, no. 62, pl. 160;
Reff, 1959, *Art News*, p. 68, fig. 3;
Chappuis, 1973, no. 1208

For Cézanne, who drew repeatedly after Michelangelo's statues and drawings in the Louvre, as well as after engravings of his paintings, the latter was the greatest artist of the Renaissance, a true "constructor," superior to the more imitative Raphael (Cézanne, 1984, p. 304). Here and in another drawing in this sketchbook (p. XLII verso) and two elsewhere (Chappuis, 1973, nos. 473, 678), Cézanne confronts one of the master's most famous works, the so-called

Dying Slave in the Louvre (no. 696). He seems to have been equally responsive to the figure's powerful masculine proportions and to its languid feminine curves, a conflation of sexual attributes that also occurs in one of Cézanne's most familiar bather types, which in turn was clearly derived from the *Dying Slave* (see p. XXXVIII recto in this sketchbook).

Michelangelo
Dying Slave. Marble

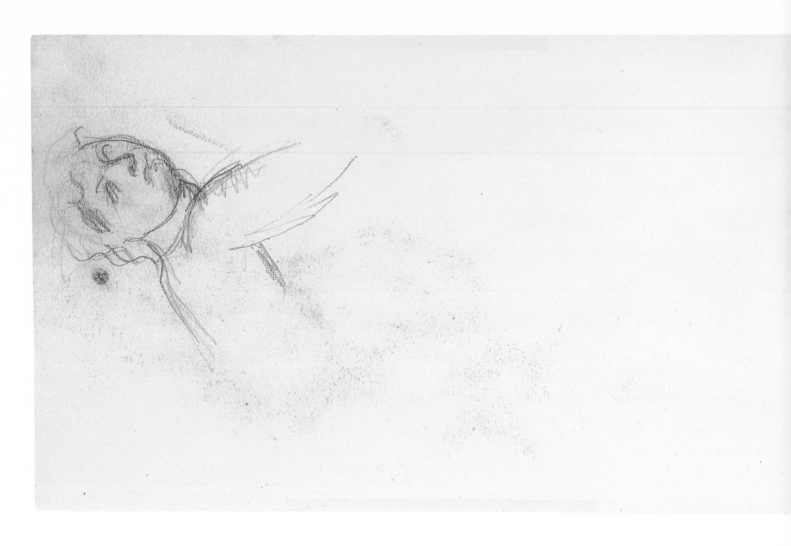

Page XXVI *bis* verso

Puget's Hercules Resting
Graphite pencil; traces of watercolor;
graphite offset from page XXVII recto
Acc. no. 1987-53-56b

Rewald, 1951, p. 45; Berthold, 1958,
no. 124; Chappuis, 1973, no. 1208A

A copy showing the same rear view of
Puget's statue in the Louvre as the
more fully developed copies on pages
XVIII recto and XLIV verso in this
sketchbook. Although slight, this
sketch is interesting as a revelation of
the way Cézanne proceeded, begin-
ning with the head and working
down; two other copies after the
Hercules (Chappuis, 1973, nos. 1002,
1005) are likewise of the head alone.

Previously unillustrated.

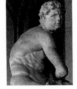

Pierre Puget
Hercules Resting
(detail). Marble

Page XXVII recto

Horse, after Rubens
Graphite pencil; traces of watercolor
and oil paint
Acc. no. 1987-53-57a

Rewald, 1951, p. 45, pl. 153;
Berthold, 1958, no. 224, pl. 156;
Chappuis, 1973, no. 1209

A more fully realized copy than the one on page XV verso in this sketchbook after the horse in Rubens's *Capture of Jülich* in the Louvre (no. 2097). As such it is a clear example of Cézanne's ability, in developing a design further, to discover a graphic pattern—in this case, of circles, arcs, and other curves—that is implicit but not articulated in his model. Whether he found the model in nature or in naturalistic art made little difference; indeed he specifically advised a young colleague to "make studies of the great decorative masters, Veronese and Rubens, but as though you were working from nature" (Cézanne, 1984, p. 278).

Horse's head, detail
from Peter Paul Rubens,
Capture of Jülich

Page XXVII verso

Graphite pencil; graphite offset from
page XXVIII recto
Acc. no. 1987-53-57b

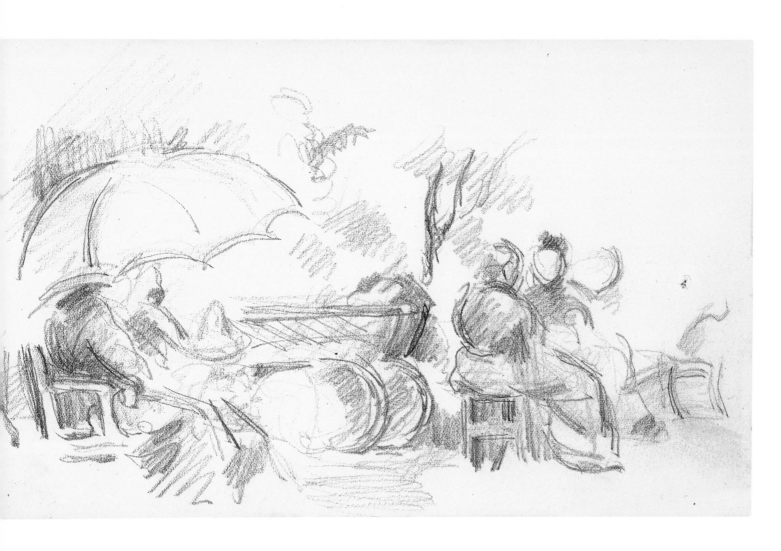

Page XXVIII recto

Women in a Park
Graphite pencil
Acc. no. 1987-53-58a

Rewald, 1951, p. 45, pl. 86; Chappuis and Ramuz, 1957, p. 79, pl. 12; Hoog, 1971, p. 69; Chappuis, 1973, no. 641

Altogether exceptional, especially in Cézanne's later work, is this sketch of nurses and baby carriages in one of the public gardens of Paris—a scene of modern urban life more common in the work of his Impressionist colleagues (e.g., Monet's Parc Monceau pictures of 1878 and Degas's *Nurse in the Luxembourg Gardens* of 1876–80). Unlike them, however, Cézanne pays scant attention to the social content of the subject, and begins instead to develop a design of interlocking, repeated circular forms, while retaining the freshness and light of an outdoor sketch.

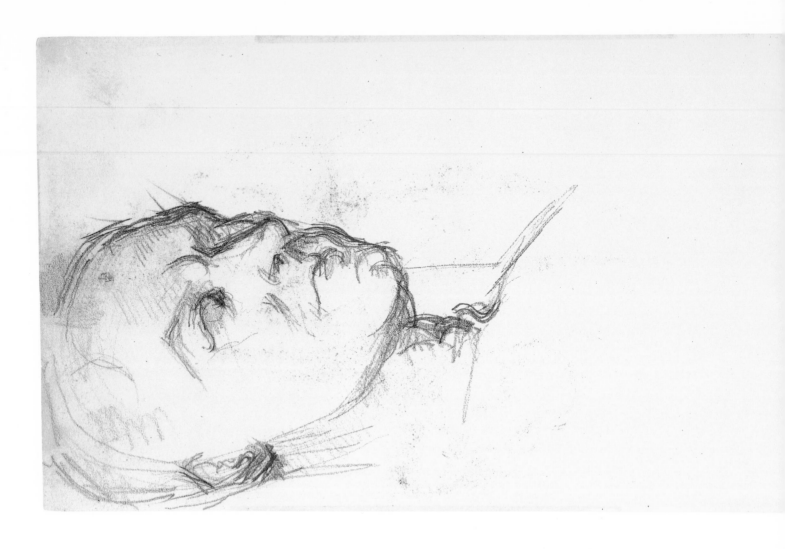

Page XXVIII verso

Benedetto da Maiano's Filippo Strozzi
After 1878
Graphite pencil; graphite offset from
page XXIX recto
Acc. no. 1987-53-58b

Rewald, 1951, p. 45, pl. 146;
Berthold, 1958, no. 85; Chappuis,
1973, no. 556

This is one of three copies in the
Philadelphia sketchbooks after a
Quattrocento bust of the banker
Filippo Strozzi, which entered the
Louvre in 1878 (no. 693). The others
are on page XXX recto in this sketch-
book and page 23 verso in Sketchbook
I; a fourth copy is in the Basel
museum (Chappuis, 1973, no. 560).
Each is distinct in its vision and
graphic style, and the distinctive
quality of the present drawing is its
dramatic intensity: viewed from a

Benedetto da Maiano
Filippo Strozzi (detail)
Marble

position unusually close and slightly
below, the stern face looms up with
an almost awesome power, which is
reinforced by the heavily reworked
contours and unmitigated by the
minimal indications of modeling.

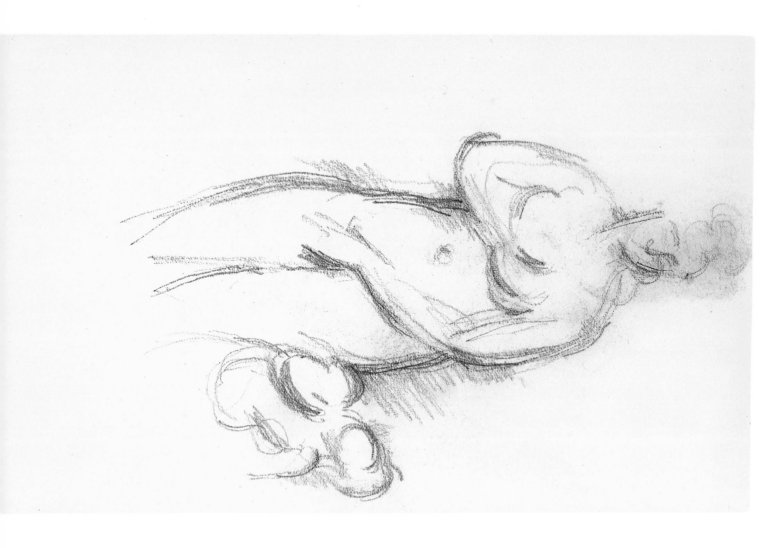

Page XXIX recto

Antique Aphrodite and Eros
Graphite pencil; traces of paint;
graphite offset from page XXVIII verso
Numbered: XXIX (erased)
Acc. no. 1987-53-59a

Rewald, 1951, p. 46, pl. 116;
Berthold, 1958, no. 26; Chappuis,
1973, no. 1042

The least developed of the three
drawings Cézanne made of the Hel-
lenistic group *Aphrodite and Eros* in
the Louvre (no. 335), this is also the
weakest as a representation and as
a graphic statement. In the others
(p. XXXVII verso in this sketchbook;
Chappuis, 1973, no. 1043), he
achieves a balance between the
definition of forms and the tracing
of curvilinear patterns that is less
evident here.

Aphrodite and Eros
Antique marble

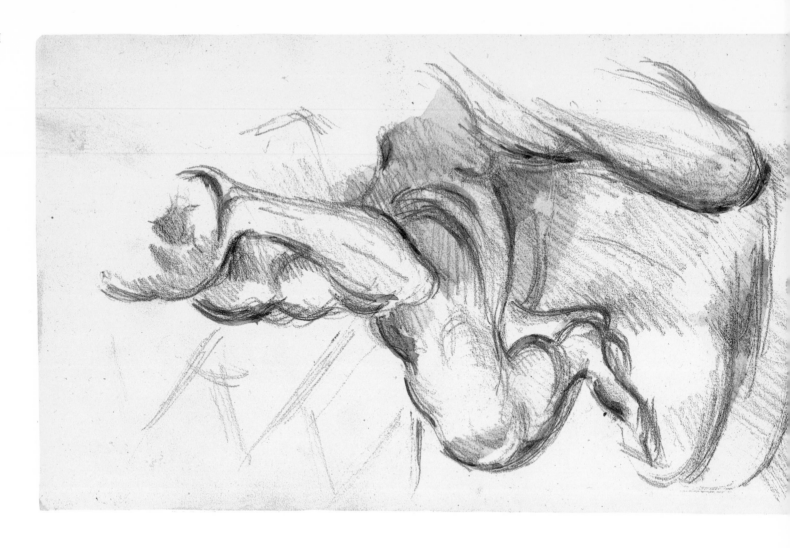

Page XXIX verso

Michelangelesque Flayed Man
Graphite pencil heightened with
watercolor over scored outlines
Acc. no. 1987-53-59b

Rewald, 1951, p. 46, pl. 155;
Berthold, 1958, no. 65; Rewald,
1983, no. 559

The small plaster cast of an anatomi-
cal figure that Cézanne owned (it is
still in his studio outside Aix) was one
of his favorite models throughout his
career. It appears in three paintings
(Venturi, 1936, nos. 61, 706, 709) and
nineteen drawings besides the present
one (Chappuis, 1973, nos. 185, 232,
418, 565–74, 980, 1086–89), seen
from many angles and in many
degrees of completeness. What makes
this drawing unique is the extreme
closeness of the vantage point and the
extreme foreshortening that results.
The muscles of the thighs and right

Flayed Man
(formerly attributed
to Michelangelo)

arm are developed with a force un-
equaled among the other copies; the
thigh muscles in particular form a
sequence of powerful curves converg-
ing at the genitals, which however are
not shown in Cézanne's drawing or in
the cast itself. The original wax
model, now attributed to a Mannerist
follower of Michelangelo, was for-
merly considered a work by the mas-
ter himself—one more reason, no
doubt, for Cézanne's lifelong interest
in it.

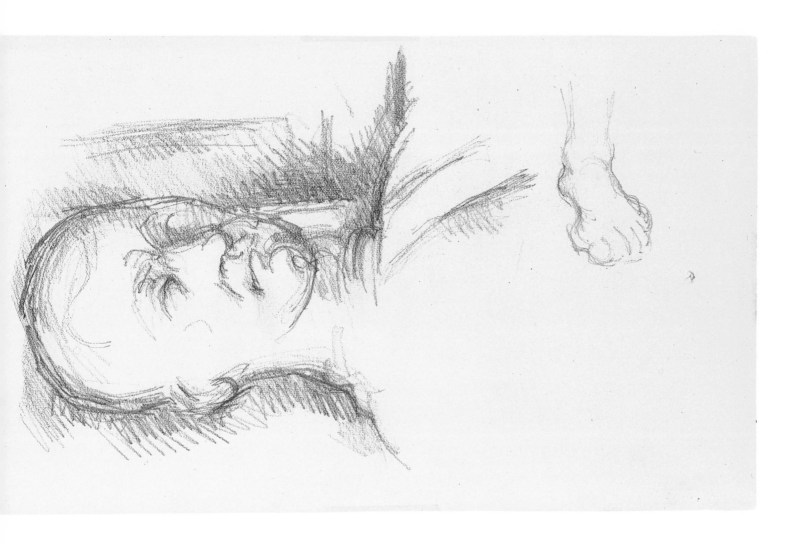

Page xxx recto

Benedetto da Maiano's Filippo Strozzi;
Man's Foot
After 1878
Graphite pencil
Numbered: xxx (erased)
Acc. no. 1987-53-60a

Rewald, 1951, p. 46, pl. 145;
Berthold, 1958, no. 86; Reff, 1959,
Burlington, p. 172, fig. 22; Chappuis,
1973, no. 557

In contrast to the drawing of the same Quattrocento bust in the Louvre on page XXVIII verso of this sketchbook, this one gives a less awesome vision: the bust is seen from a more normal viewing distance, its features are less drastically foreshortened, and while still expressing the Florentine banker's power and pride, they are softened by the more extensive shading and the placement of the bust against a shadowy background. So extensive a treatment of the gallery setting is indeed unusual among Cézanne's copies after sculpture in the Louvre.

The other sketch, of a man's foot, is no doubt also a copy, perhaps of the left foot of Michelangelo's *Dying Slave* (see p. XXVI *bis* recto in this sketchbook). It was installed then in the same gallery as the *Filippo Strozzi*, and its left leg is clearly what appears in the background of one of Cézanne's other copies after the bust (Chappuis, 1973, no. 559).

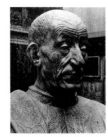

Benedetto da Maiano
Filippo Strozzi (detail)
Marble

Page xxx verso

Standing Female Nude
Graphite pencil over scored outlines
Acc. no. 1987-53-60b

Rewald, 1951, p. 46, pl. 89; Berthold, 1958, p. 40, fig. 51; Lichtenstein, 1964, p. 56, note 6, nos. 14–17; Chappuis, 1973, no. 968; Lichtenstein, 1975, pp. 124–26, fig. 40

A study for the composition *The Toilette*, of which several versions are known: a painting of 1885–90 (Venturi, 1936, no. 254, there dated too early), another of about 1900 (Rewald, 1939, fig. 84), and a watercolor of 1895–1900 (Rewald, 1983, no. 386). As has long been recognized, the image is based on Delacroix's painting *Woman Combing Her Hair (Le Lever)*, which Cézanne must have known from a lithographed reproduction; he made a partial copy of this print in the late 1870s (Chappuis, 1973, no. 459). At that time,

too, he drew another version of *The Toilette* (ibid., no. 467), in which the nude figure is reversed and a maid kneels beside her. But none of these other versions has the expressive power of this drawing, whose compulsively repeated contours and heavy shading—in places scratched into the surface—convey something of Cézanne's anxiety in confronting the nude female figure; though he strives to capture its sensuality, some parts seem more grotesque than alluring.

The Toilette
(Venturi, 1936, no. 254)

Page XXXI recto

Signorelli's Standing Male Nude
Graphite pencil heightened with
watercolor over scored outlines;
graphite offset from page XXX verso
Numbered: XXXI (erased)
Acc. no. 1987-53-61a

Rewald, 1951, p. 46, pl. 115 (incor-
rectly listed as Sketchbook I, p. 35
verso); Berthold, 1958, no. 279 (as
above); Chappuis, 1973, no. 997 (as
above)

This is the most complete and also the
most anatomically descriptive of
Cézanne's three copies after Luca
Signorelli's drawing of a nude male
figure in the Louvre (Reiset, 1866–69,
no. 343). The other two, in Sketch-
book I, pages 35 verso and 38 recto,
are more concerned with capturing
the figure's strongly twisting stance
and energetically outstretched arms,
and they lack the subtly modeled
anatomy of this drawing. How
Cézanne adapted such studies after

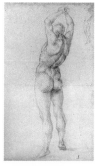

Luca Signorelli
Standing Male Nude

older art to his own ends is evident in
the sketch of a male bather in the
same three-quarter view, with the
arms raised in the same way, on page
XXXIV recto in this sketchbook.

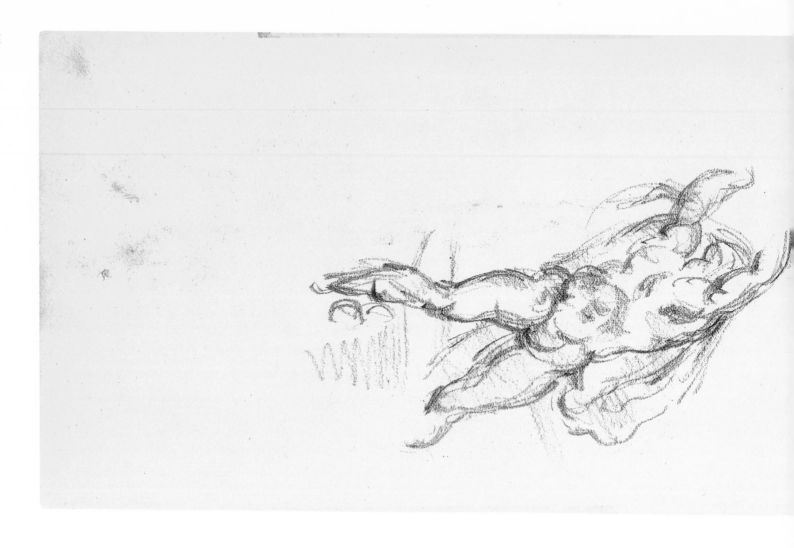

Page xxxi verso

Risen Christ, after Michelangelo
Graphite pencil; graphite offset from
page xxxii recto
Acc. no. 1987-53-61b

Rewald, 1951, p. 46; Berthold, 1958,
no. 153, pl. 133; Chappuis, 1973,
no. 994

His interest in the expressive power
of a figure raising both arms above its
head, which is surely what led
Cézanne to the Signorelli drawing he
copied on the recto of this page, also
led him to copy the dramatically
rising figure of Christ in Michelange-
lo's drawing *The Resurrection* in the
Louvre (Reiset, 1866–69, no. 112),
and probably on the same visit to the
galleries. He had already copied the
Risen Christ twice in a drawing of
about 1867 (Chappuis, 1973, no.

Michelangelo
The Resurrection

172). And like the Signorelli nude,
this Michelangelesque figure now
provided a model for one of Cézanne's
bathers: the one standing on the
opposite bank, rather implausibly
waving his arms, in a painting of
about 1892–94 (Venturi, 1936,
no. 580).

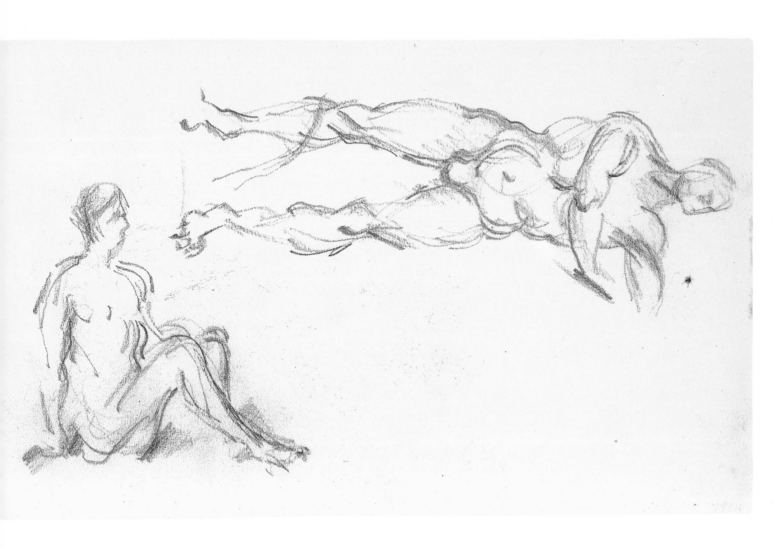

Page XXXII recto

Standing Man, after Signorelli; Seated Bather
Graphite pencil; graphite offset from page XXXI verso
Numbered: XXXII (erased)
Acc. no. 1987-53-62a

Rewald, 1951, p. 46, pl. 114 (unidentified); Berthold, 1958, no. 304 (unidentified); Reff, 1960, p. 148; Chappuis, 1973, no. 995

Two figures drawn under different circumstances—one from a work of art, the other from imagination—but in the same sketchy, nervous style, which however describes their poses adequately. The standing figure is copied from Luca Signorelli's drawing of two women and two men in the Louvre (Reiset, 1866–69, no. 340); the curved line across his right leg, which Cézanne includes almost involuntarily, belongs to the woman standing next to this man. The seated

Luca Signorelli
Two Women and Two Men

figure is a study for a type of bather that recurs frequently in Cézanne's paintings—always at the left side, beneath a tree—from the mid-1870s to about 1890 (Venturi, 1936, nos. 268, 389–90, 541).

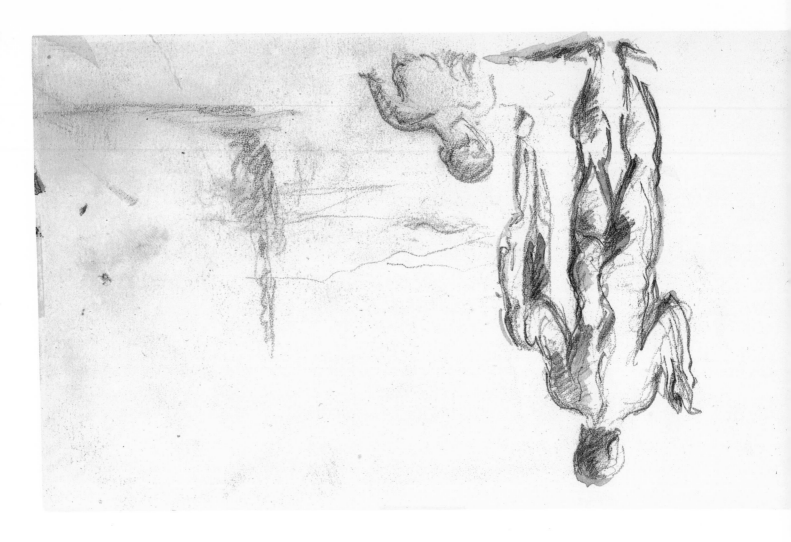

Page XXXII verso

Two Male Bathers
Graphite pencil heightened with
watercolor; traces of watercolor;
graphite offset
Acc. no. 1987-53-62b

Rewald, 1951, p. 46; Chappuis and
Ramuz, 1957, pp. 88–89, pl. 38;
Chappuis, 1973, cited under no. 995;
Rewald, 1983, no. 127

The same figures—one standing on
the river bank, the other in the
water—appear in two of Cézanne's
paintings of male bathers in the early
1890s (Venturi, 1936, nos. 580, 585),
though with slight variations. The
pine tree on the opposite bank also
appears there, but in a landscape
filled with other trees and many more
figures and thus lacking the openness
and airiness that constitute one of the
charms of this delicately watercolored
sketch.

Page XXXIII recto (missing)

Rewald, 1951, p. 46 (as missing)

Page xxxiii verso (missing)

Rewald, 1951, p. 46 (as missing)

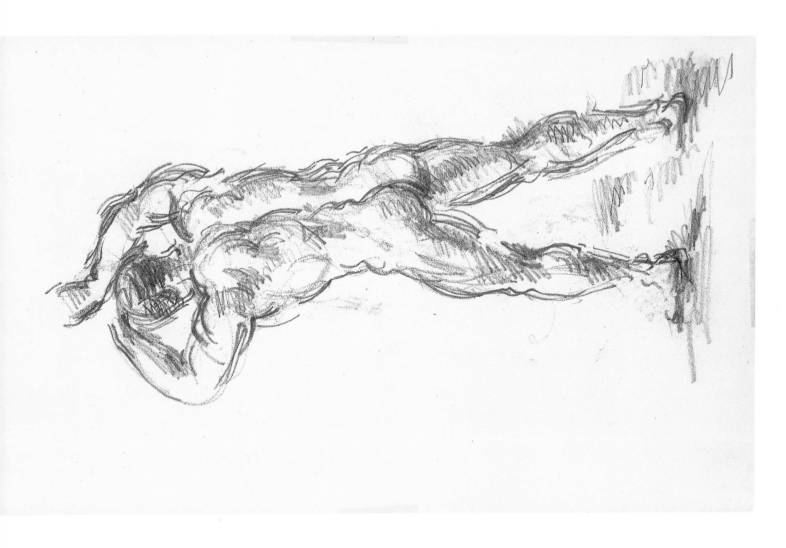

Page xxxiv recto

Standing Male Bather
Graphite pencil; graphite offset
Numbered: xxxiiii (erased)
Acc. no. 1987-53-63a

Rewald, 1951, p. 46, pl. 111; Taillandier, 1961, p. 59; Chappuis, 1973, no. 438

This is probably a study for the standing bather at the right in some of Cézanne's male bather compositions of the early 1890s (Venturi, 1936, nos. 580–81, 588), though there his left arm is raised higher and his right arm lowered. Both figures are undoubtedly based on the Signorelli drawing that Cézanne copied several times, once in this sketchbook (p. xxxi recto); but characteristically, his figure lacks the expansive upward thrust of Signorelli's, as well as its powerfully articulated anatomy.

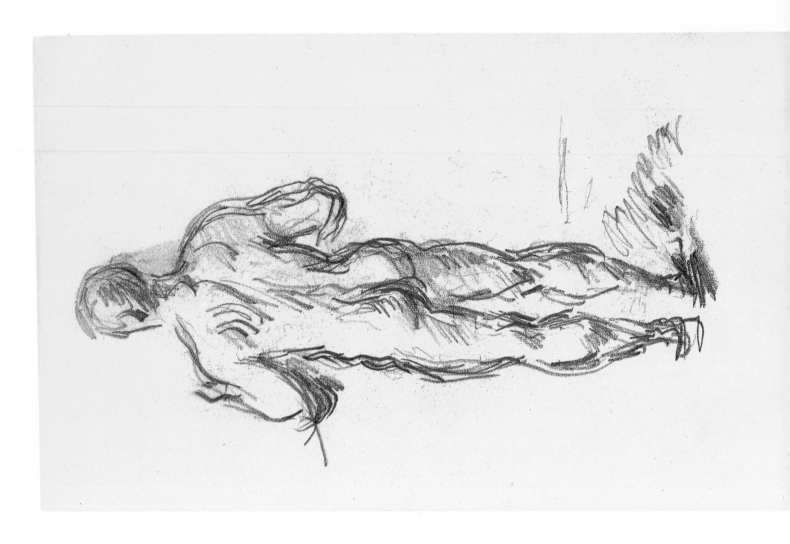

Page xxxiv verso

Standing Male Bather
Graphite pencil; graphite offset from
page xxxv recto
Acc. no. 1987-53-63b

Rewald, 1951, p. 46, pl. 107;
Chappuis, 1973, no. 426

Drawn in the same vehement style,
with short, dark, agitated strokes, as
the male bather on the recto of this
page, and probably on the same occa-
sion, this is a study for the same
multifigure compositions of the early
1890s (Venturi, 1936, nos. 580–81,
588). Like the other bather, it is
based on a Signorelli drawing in the
Louvre, the so-called *Living Carrying
the Dead*, which Cézanne copied sev-
eral times (Chappuis, 1973, nos. 182,
488, 675), and even owned a repro-

duction of, though in this case the
Signorelli source is conflated with an
antique one, the *Roman Orator*, or
Germanicus, in the Louvre, which he
also copied several times (ibid., nos.
559, 993, 1050).

Page xxxv recto

Five Female Bathers
Graphite pencil; graphite offset from
page xxxiv verso
Acc. no. 1987-53-64a

Rewald, 1951, p. 46, pl. 96; Chappuis
and Ramuz, 1957, p. 88, pl. 36;
Hoog, 1971, p. 45; Chappuis, 1973,
no. 649

A study for the left side of a composi-
tion of eight female bathers, known in
two paintings of the early 1890s (Ven-
turi, 1936, nos. 539–40, dated too
early) and one done later in that dec-
ade (Rubin, 1977, pl. 195). Cézanne's
first conception, embodied in a still
more summary sketch of the three
bathers at the left side (p. x verso in
this sketchbook), is here developed
further in the direction of the paint-
ings, though many parts still remain
vaguely defined.

Bathers
(Venturi, 1936, no. 540)

Page xxxv verso

Vulcan, after Boucher
Graphite pencil; traces of watercolor;
graphite offset from page xxxvi recto
Acc. no. 1987-53-64b

Rewald, 1951, p. 47, pl. 127 (uniden-
tified); Berthold, 1958, no. 235;
Chappuis, 1973, no. 991

In copying after the central figure in
Boucher's *Forge of Vulcan* in the
Louvre (no. 46), a mythological hero
like Hercules whose strength and
ingenuity he evidently admired (see
p. xviii recto in this sketchbook),
Cézanne exaggerates the figure's
brawniness and alters its proportions
significantly. Working from the head
down, which here seems quite small,
he enlarges the shoulders and arms,
the torso and thighs, and especially
the lower legs and feet, which here

seem enormous. As a result, the
vantage point implicit in Boucher's
view of the figure, which is already
low, is lowered still further and Vul-
can looms above us like the god he
really is.

Vulcan, detail from
François Boucher,
Forge of Vulcan

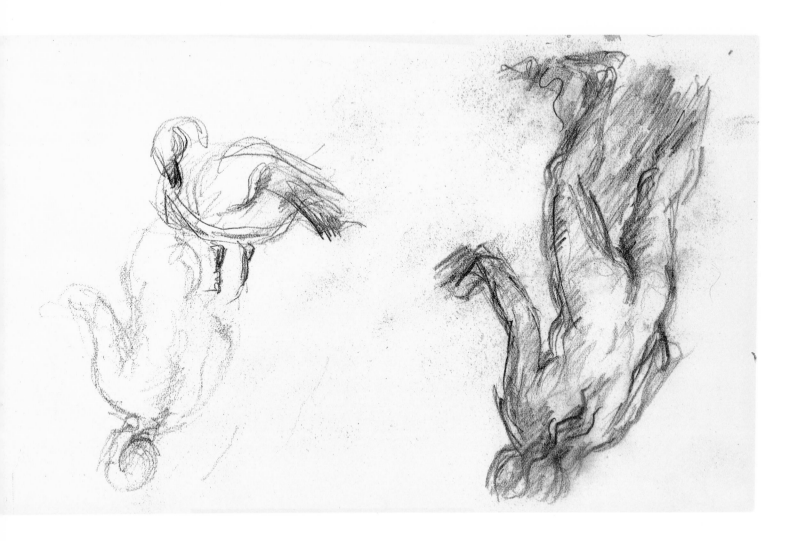

Page XXXVI recto

Two Female Bathers; Swan
Graphite pencil; traces of watercolor;
graphite offset from page XXXV verso
Acc. no. 1987-53-65a

Rewald, 1951, p. 47, pl. 98; Hoog,
1971, p. 40 (left side only); Chappuis,
1973, no. 1134

Two studies for the figure at the far
left in a composition of eight female
bathers, for which a more complete
study of the entire left side appears on
page XXXV recto in this sketchbook.
The same figure already occurs in
earlier compositions of three, four,
and five bathers (Venturi, 1936, nos.
381–86), but the proximity of this
page to the one just cited confirms its
connection with the later paintings.

The swan, sketched with the page
inverted, presumably from life, has
no equivalent elsewhere in Cézanne's
work, not even in his painting of Leda
and the Swan (ibid., no. 550).

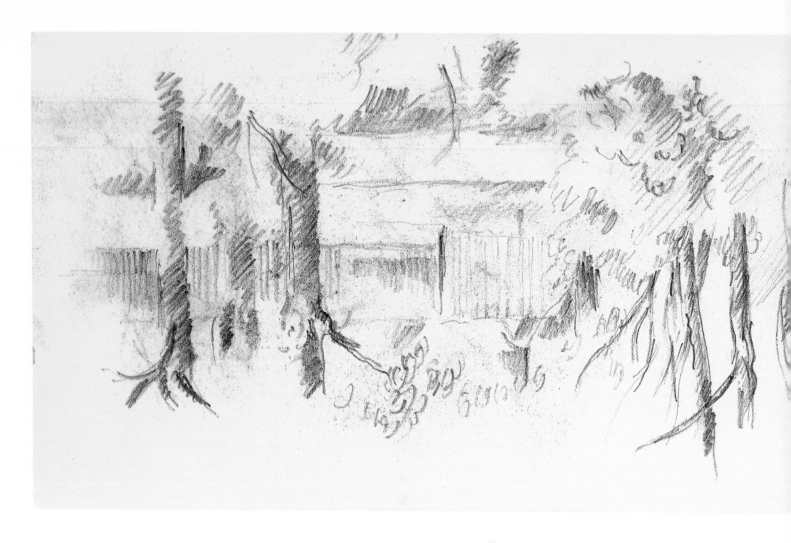

Page XXXVI verso

Landscape
Graphite pencil; traces of watercolor;
graphite offset from page XXXVII recto
Acc. no. 1987-53-65b

Rewald, 1951, p. 47, pl. 57; Taillan-
dier, 1961, p. 24; Hoog, 1971, p. 41;
Chappuis, 1973, no. 763

Previously identified as a view of "the
pool at the Jas de Bouffan," the
Cézanne family's house outside Aix
(Chappuis), this drawing may well
represent another site, and not neces-
sarily in Provence, since there is no
other evidence that this sketchbook
was used there and, conversely, much
evidence that it was used in Paris. In
any event, the views of the pool cited
in support of that identification—two
paintings (Venturi, 1936, nos. 166,
648) and two drawings (Chappuis,
1973, nos. 672, 891)—do not corres-
pond closely enough to make it seem
convincing. The pool itself is not
visible in the present drawing, and
the wall or fence shaded with vertical
strokes does not look quite like "the
grille that surrounded the pool" in the
paintings just cited and in photo-
graphs of the grounds.

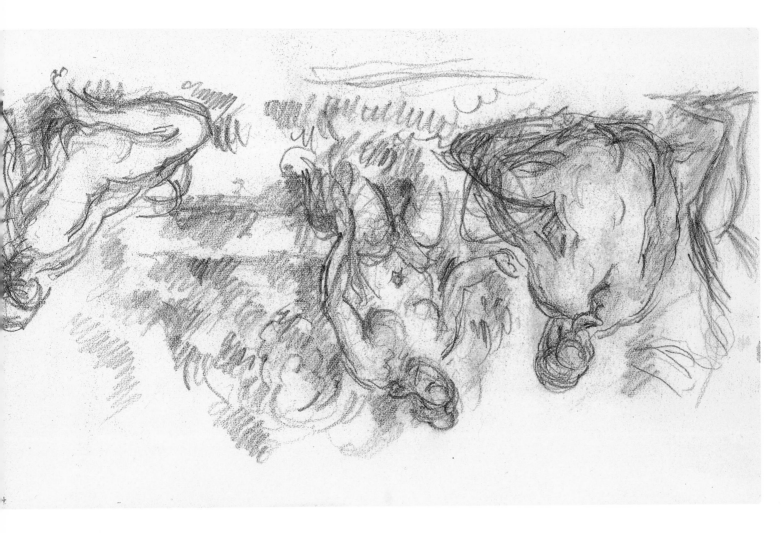

Page XXXVII recto

Four Female Bathers
Graphite pencil; traces of watercolor;
graphite offset from page XXXVI verso
Numbered: XXXVII (erased)
Acc. no. 1987-53-66a

Vollard, 1914, p. 67; Venturi, 1936, no. 1249; Rewald, 1951, p. 47, pl. 97; Rousseau, 1953, pl. 37; Chappuis and Ramuz, 1957, p. 89, pl. 40; Taillandier, 1961, p. 47; Hoog, 1971, p. 64; Chappuis, 1973, no. 650

A study for the left side of a composition of eight female bathers of the early 1890s, like the one on page XXXV recto in this sketchbook, but clarified considerably, so that both the figures and their landscape setting correspond more closely to those in the paintings (Venturi, 1936, nos. 539–40). The crouching bather at the right, in particular, assumes an altogether more credible and graceful pose, and the riverbank and foliage emerge as convincing elements of the setting. Reproduced as early as 1914, and many times thereafter, this light-filled sketch was long seen as representing the finest qualities of Cézanne's bather studies.

Bathers
(Venturi, 1936, no. 540)

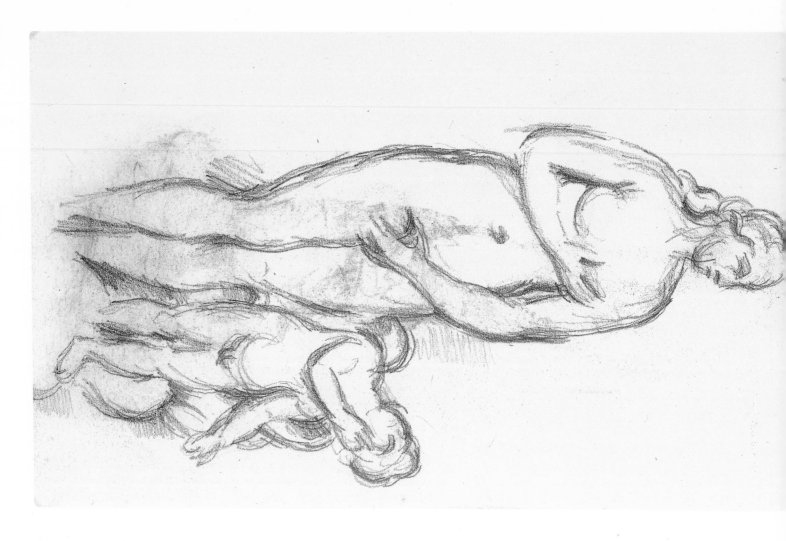

Page XXXVII verso

Antique Aphrodite and Eros
Graphite pencil; graphite offset from
page XXXVIII recto
Acc. no. 1987-53-66b

Rewald, 1951, p. 47, pl. 117;
Berthold, 1958, no. 24, pl. 124;
Chappuis, 1973, no. 1041

This is the most complete and most harmoniously composed of Cézanne's three copies after the Hellenistic group *Aphrodite and Eros* in the Louvre (no. 335); the other two (p. XXIX recto in this sketchbook; Chappuis, 1973, no. 1043) terminate the figure of Aphrodite at the knees and barely indicate that of Eros, so that the touching relationship between them is not apparent. Yet just this exchange between mother and child, which makes the Hellenistic group an ancient counterpart to Pigalle's *Love*

and Friendship, a work Cézanne also copied several times (see p. XVI recto in this sketchbook), may well have been what attracted him in the first place. In any event, it is clear that by choosing a vantage point slightly to the left of the one chosen for the other copies, he has achieved here a more harmonious integration of the two figures, despite their great difference in size.

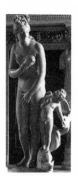

Aphrodite and Eros
Antique marble

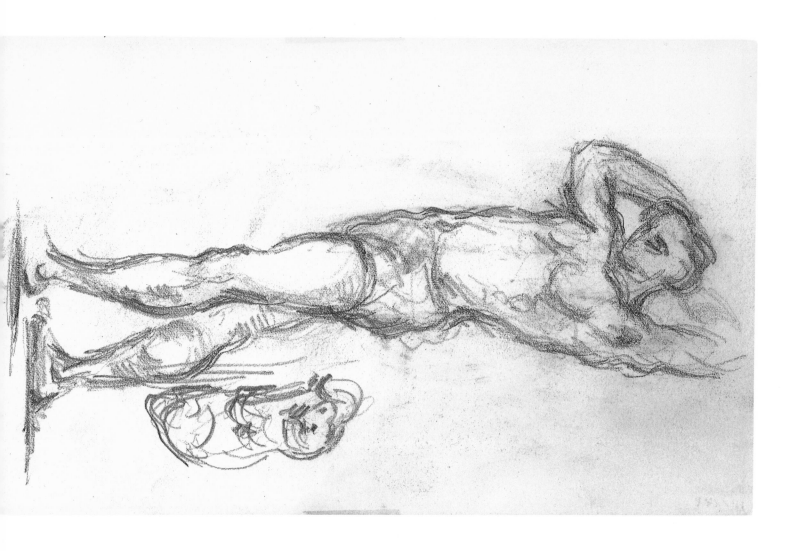

Page XXXVIII recto

Standing Male Bather; Dog
Graphite pencil; graphite offset from
page XXXVII verso
Numbered: XXXVIII (erased)
Acc. no. 1987-53-67a

Rewald, 1951, p. 47, pl. 112; Chap-
puis, 1973, no. 437

The powerfully twisted and con-
tracted pose of this bather, who
thrusts one leg behind the other,
clasps both hands behind his head,
and turns his upper body to a nearly
frontal position, while his lower body
faces to the left, is one of the most
expressive and frequently repeated
poses in Cézanne's work. It appears in
his paintings from the mid-1870s
(Venturi, 1936, nos. 263, 268) to the
mid-1890s (ibid., nos. 587, 724), as
well as in watercolors spanning the
same decades (Rewald, 1983, nos.
119–20, 494–95) and in many draw-
ings, some of them in this sketchbook

(pp. XLIII verso, XLIX recto) and in
Sketchbook I (pp. 43 verso, 44 recto,
44 verso, 45 recto). Its sources are
Michelangelesque sculptures that
Cézanne copied frequently, some-
times in this sketchbook: the *Dying
Slave* in the Louvre and the *Flayed
Man*, of which he owned a cast (see
pp. XXVI *bis* recto and XXIX verso).

The sketch of a dog is perhaps a study
for the one shown in the same posi-
tion in the foreground of a painting of
female bathers (Venturi, 1936, no.
720) begun about 1895.

Page XXXVIII verso

Bowler Hat and Garment
Graphite pencil
Acc. no. 1987-53-67b

Rewald, 1951, p. 47, pl. 77; Chap-
puis, 1973, no. 951

Drawn in swift, heavily repeated
strokes producing strongly contrasted
lights and darks, and enlarged to fill
the entire surface, these familiar
pieces of apparel acquire through
Cézanne's vision the power and gran-
deur of the monumental human forms
he admired in older art. There is a
sketch of the same or very similar
objects, smaller in scale, weaker in
execution, on page III recto of this
sketchbook.

XXXIX

Page xxxix recto

Graphite offset from page xxxviii
verso
Numbered in pencil: xxxix
Acc. no. 1987-53-68a

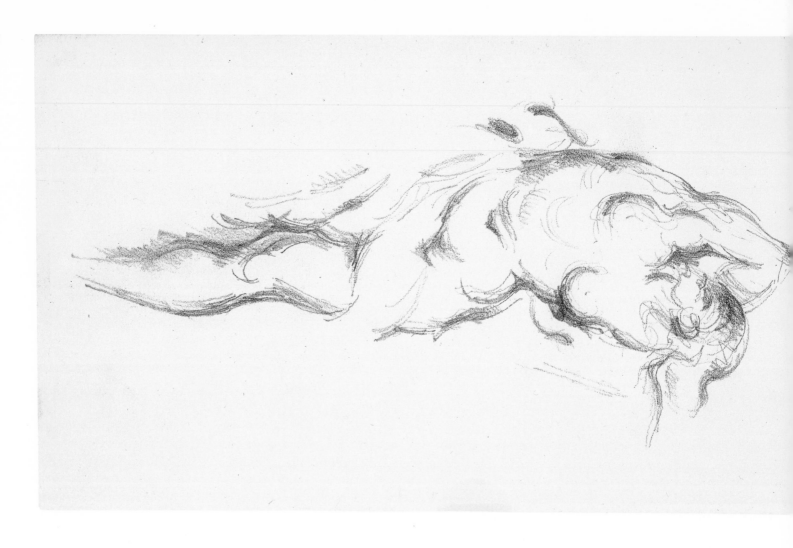

Page XXXIX verso

Allegorical Figure of War, after Rubens
Graphite pencil
Acc. no. 1987-53-68b

Rewald, 1951, p. 47, pl. 140;
Berthold, 1958, no. 208; Hoog, 1971,
p. 56; Chappuis, 1973, no. 1007

Just as Rubens's paintings, and especially the magnificent series on the life of Maria de' Medici, were Cézanne's favorites in the Louvre, so the *Apotheosis of Henry IV* (no. 2095) was by far his favorite among the twenty-one pictures in the series. He was already drawing after it early in his career (Chappuis, 1973, no. 102), and at the end he still kept a photograph of it in his studio. What is remarkable is that all of the subsequent copies—the present one and nine others (ibid.,

Figure of War, detail
from Peter Paul Rubens,
Apotheosis of Henry IV

nos. 489–90, 598, 627, 1138–40, 1215)—isolate from this huge composition a single figure, that of Bellona, or War, lamenting the loss of Henry IV as a great general. It is indeed one of the most conspicuous figures, prominently placed and largely nude, but it must also have appealed to Cézanne as "an expression of extreme pathos, the body twisting in conflict, both arms bent behind the head, the drapery swirling about the legs" (Reff, 1960, p. 145).

Page XL recto

Graphite offset from page XXXIX
verso
Numbered in pencil: XL
Acc. no. 1987-53-69a

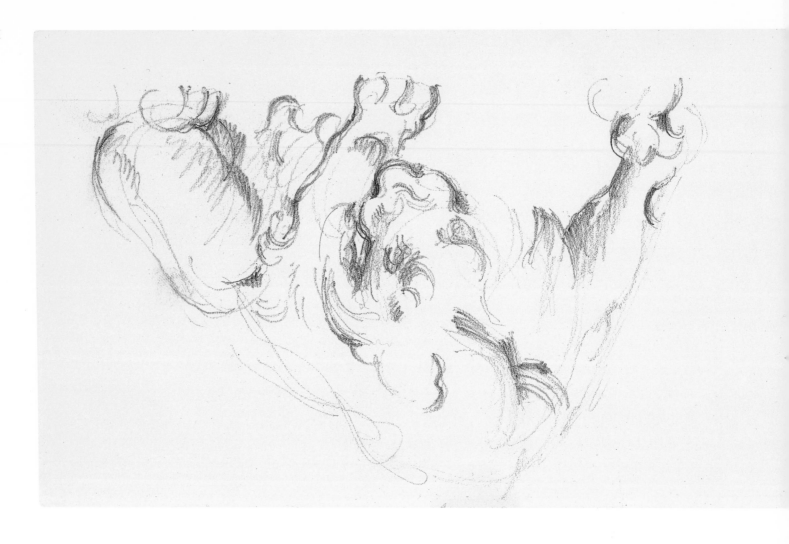

Page XL verso

Barye's Lion and Serpent
Graphite pencil; traces of watercolor
Acc. no. 1987-53-69b

Rewald, 1951, p. 47, pl. 143;
Berthold, 1958, no. 171; Chappuis,
1973, no. 1210

A copy after Antoine-Louis Barye's
bronze group *Lion and Serpent*, which
is now in the Louvre (no. 907) but
before 1911 was in the Tuileries Gar-
dens; after 1886 a plaster cast was also
on view in the Musée de Sculpture
Comparée (no. G4). In contrast to the
very incomplete and rather abstract
copy of the same work in Sketchbook
I, page 30 recto, this one shows the
whole form of the lion; but it too
omits much of the naturalistic detail
that makes Barye's style so compel-
ling, and indeed omits altogether the
serpent to which the lion is reacting.

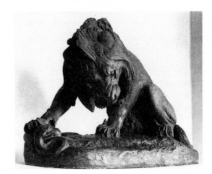

Antoine-Louis Barye
Lion and Serpent. Bronze

Page XLI recto

Traces of oil paint; smudges of graph-
ite; graphite offset from page XL verso
Numbered in pencil: XLI
Acc. no. 1987-53-70a

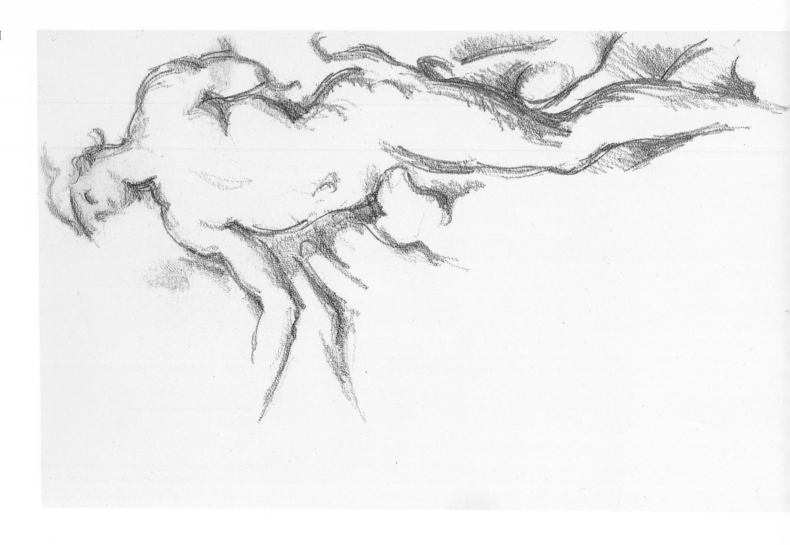

Page XLI verso

Mercury, after Rubens
Graphite pencil
Acc. no. 1987-53-70b

Rewald, 1951, p. 47, pl. 137;
Berthold, 1958, no. 226; Chappuis,
1973, no. 677

In this copy after the messenger god
Mercury in *Maria de' Medici Receives
Offers of Peace* (Louvre, no. 1202), as in
his copies after allegorical figures in
some of Rubens's other paintings in
the series (e.g., Sketchbook I, pp. 14
recto and verso), Cézanne focuses on
a single, marginal figure. If what
attracted him was its bright tonality,
lighter than that of the dressed fig-
ures, he has captured that aspect
effectively by concentrating the shad-
ing at the edges of the rounded forms
and reinforcing the shadows adjacent
to them.

Mercury, detail from
Peter Paul Rubens,
*Maria de'Medici Receives
Offers of Peace*

Page XLII recto

Graphite offset from page XLI verso
Numbered in pencil: XLII
Acc. no. 1987-53-71a

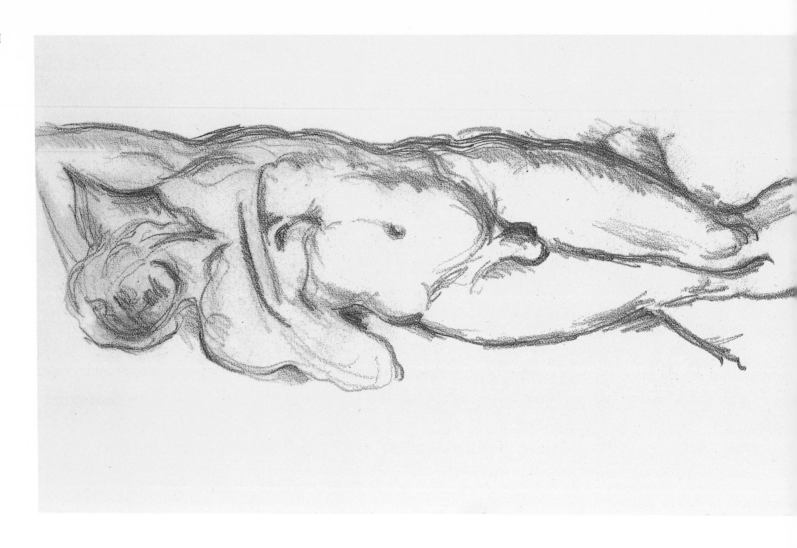

Page XLII verso

Michelangelo's Dying Slave
Graphite pencil
Acc. no. 1987-53-71b

Rewald, 1951, p. 47, pl. 124;
Berthold, 1958, no. 61; Chappuis,
1973, no. 375

Like the drawing of the same statue
on page XXVI *bis* recto in this sketch-
book, this one shows a direct frontal
view, clearly the principal one for
Michelangelo, in which the figure's
arms, head, and body form a rela-
tively closed and balanced mass. In
the other drawings (Chappuis, 1973,
nos. 473, 678), the statue is seen more
from the left side and produces a
more open, irregular design. Evi-
dently responding to this closed
aspect of the frontal view, Cézanne
reinforces the contours repeatedly,
bringing out the contrast between the
uninterrupted, rippling vertical at the
right and the series of cascading
curves at the left, though he also
begins to articulate the interior forms
through shading.

Michelangelo
Dying Slave. Marble

218

Page XLIII recto

Graphite offset from page XLII verso
Numbered in pencil: XLIII
Acc. no. 1987-53-72a

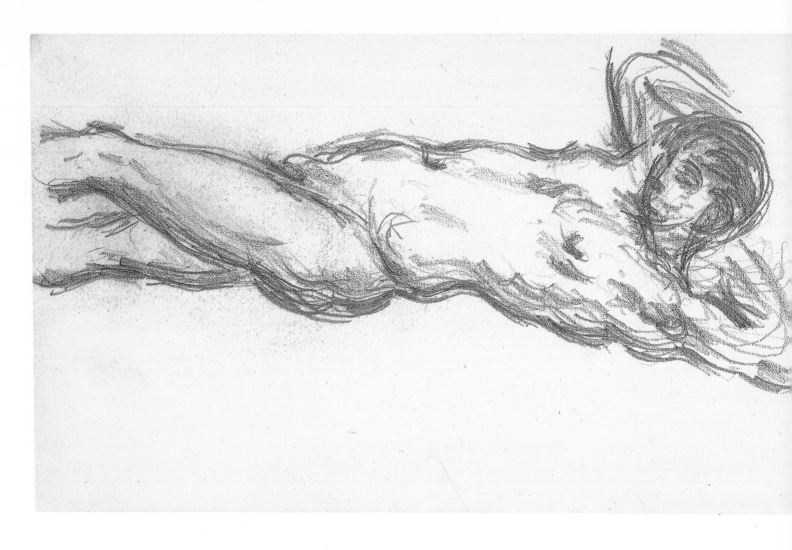

Page XLIII verso

Standing Male Bather
Graphite pencil
Acc. no. 1987-53-72b

Rewald, 1951, p. 47, pl. 113; Hoog, 1971, p. 65; Chappuis, 1973, no. 443

Another study of the same bather as on page XXXVIII recto in this sketchbook, but very different in character. Terminated just below the knees and enlarged to fill the page, the figure looms up here with much greater power, both two-dimensional and sculptural, for the heavily repeated lines not only define a more striking silhouette, but also reinforce the softer shading strokes to create a strong sense of plastic form. The figure's stance is subtly altered, too: the left leg is now bent forward and flexed, while the right one becomes truly vertical and weight-supporting in the spirit of classical *contrapposto*.

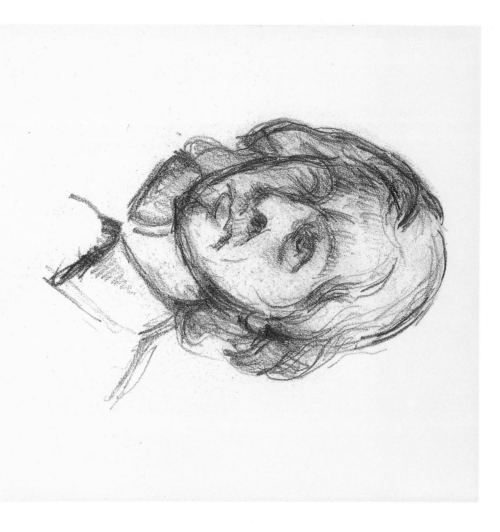

Page XLIV recto

Coustou's Père de La Tour
Graphite pencil; graphite offset from
page XLIII verso
Numbered: XLIIII (erased)
Acc. no. 1987-53-73a

Rewald, 1951, p. 48, pl. 149;
Berthold, 1958, no. 190; Chappuis,
1973, no. 668

A more subtly developed and refined
copy after Guillaume Coustou's terra-
cotta bust in the Louvre than the one
on page IV recto in this sketchbook.
The head is seen from the same angle,
slightly to the right, and is illumi-
nated in the same way from the far
right, but the play of light and shade
across the features, including pas-
sages of reflected light in the shadows
at the left, is more closely observed;
and the eyes have a more definite
expression. As a result, the Oratorian

Guillaume Coustou
*Pierre-François Darerès de
La Tour.* Terra-cotta

father appears here more brooding
and troubled than in the other copies,
each of which has its own distinct
mood.

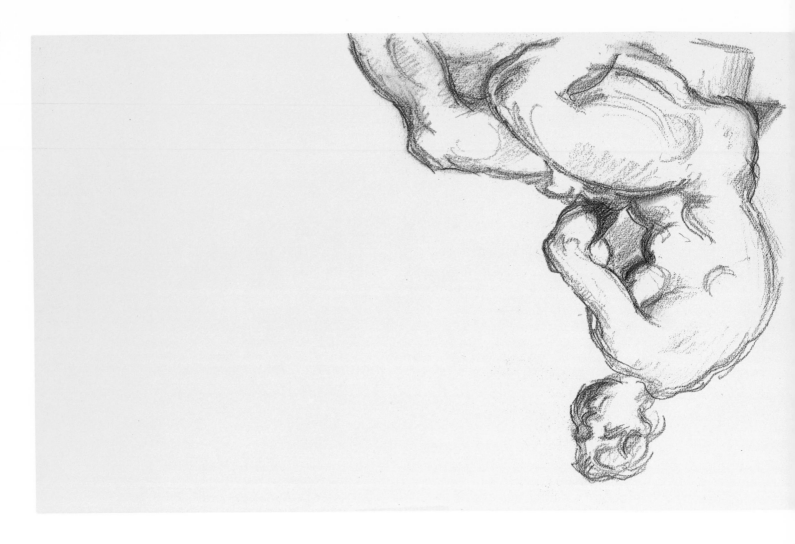

Page XLIV verso

Puget's Hercules Resting
Graphite pencil; graphite offset from
page XLV recto
Acc. no. 1987-53-73b

Rewald, 1951, p. 48; Berthold, 1958,
no. 111; Reff, 1966, p. 41, note 86;
Chappuis, 1973, no. 577

A drawing after Puget's statue in the
Louvre that is similar to the one on
page XVIII recto in this sketchbook,
but with some interesting differences.
Holding the sketchbook horizontally
rather than vertically, Cézanne is able
here to indicate almost the entire
length of the figure's extended leg,
giving the silhouette a more open,
irregular character. He also relies
more on shading, applied in well-
defined areas, to describe the power-
fully rounded forms, rather than on

his usual heavily repeated contours.
As a result, the statue seems a more
concrete, tangible object situated in a
more specific milieu; only some indi-
cations of the architecture of the
gallery, such as appear in a similar
copy (Chappuis, 1973, no. 578),
would be needed to complete the
evocation of the setting.

Pierre Puget
Hercules Resting. Marble

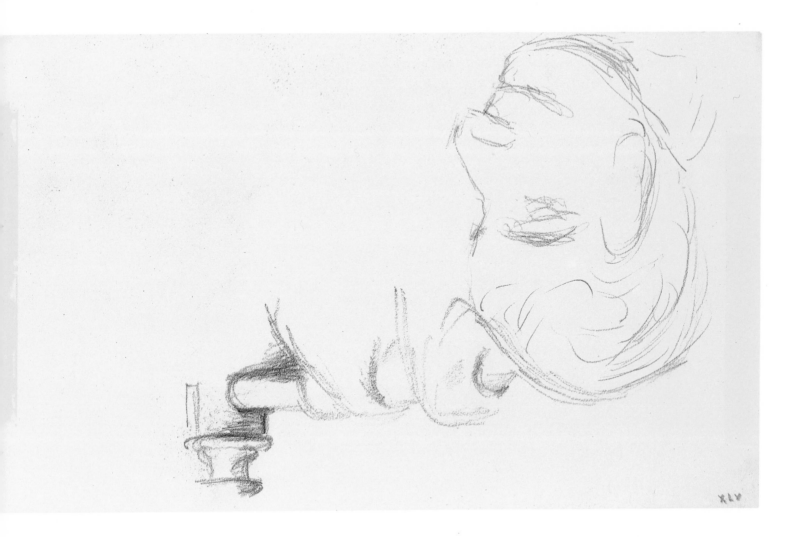

Page XLV recto

Foot of Bed; Boy's Head
Graphite pencil; graphite offset from
page XLIV verso
Numbered in graphite: XLV
Acc. no. 1987-53-74a

Rewald, 1951, p. 48

A sketch of the foot of a brass or iron
bed, showing the corner post and
horizontal bar, over which two pieces
of clothing are draped.

The other drawing, of a boy's head in
profile to the right, is clearly not by
Cézanne; it may be by his son, whom
he sometimes allowed to draw in his
sketchbooks.

Previously unillustrated (Chappuis
lists incorrectly as his no. 855).

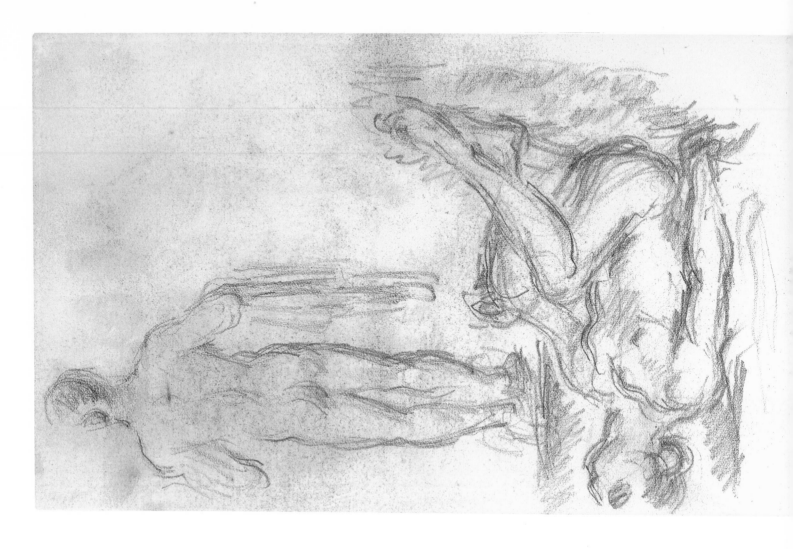

Page XLV verso

Two Male Bathers
1892–94
Graphite pencil; graphite offset from
page XLVI recto
Acc. no. 1987-53-74b

Rewald, 1951, p. 42, pl. 110; Chap-
puis, 1973, no. 432

Both of these bathers are among the
most familiar types in Cézanne's
work, appearing in paintings from the
mid-1870s to the mid-1890s. In this
sketchbook alone, there are half a
dozen studies of the same figures,
alone or together (pp. XXXII recto and
verso, XXXIV verso, XLVI verso, XLIX
verso, L recto). And since it is evident
from other drawings that the sketch-
book was used in 1885–1900, these
can best be understood as studies for
bather paintings of those years and
particularly of the early 1890s (Ven-
turi, 1936, nos. 541, 582, 590). The
seated figure in the present drawing is
in fact closest in the positions of its
arms and legs to the one in *Group of
Bathers* (ibid., no. 590) of 1892–94.

Bathers
(Venturi, 1936, no. 541)

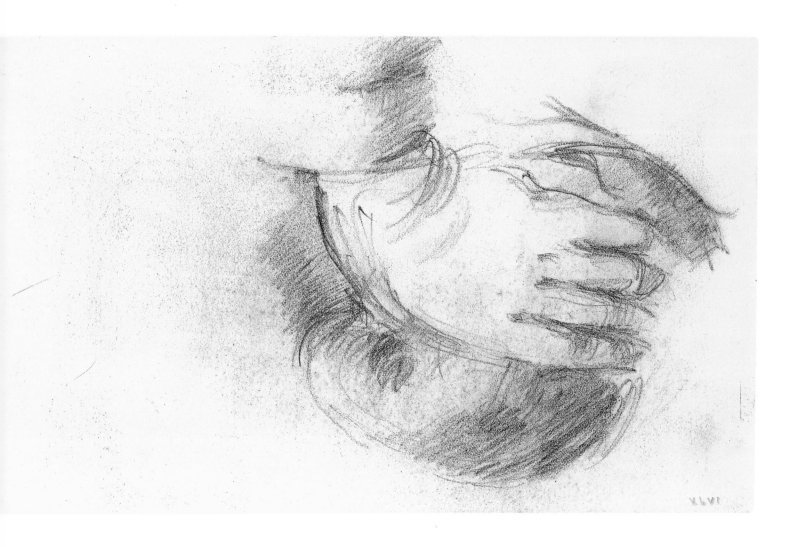

Page XLVI recto

The Artist's Son, Hand behind His Head
Graphite pencil over scored outlines;
graphite offset from page XLV verso
Numbered in pencil: XLVI
Acc. no. 1987-53-75a

Rewald, 1951, p. 48; Chappuis, 1973,
no. 420A

The sketchbook was held horizontally with the binding at the right.

The subject of this carefully drawn sketch is hard to decipher; it has been described simply as a "study of a hand" (Rewald), with no mention of the other forms shown. If it is the artist's hand—presumably the left, since he drew with the right—could it be bent so far to the left? And is it emerging from a sleeve or a blanket? Equally enigmatic is the object the hand holds: it has the softness and roundness of a crumpled cloth but not

the wrinkles, and it serves no evident purpose. The more likely interpretation is that the hand is Cézanne's son's right hand supporting his head, as seen from behind and very close to; the "cloth" would then be his hair, and the "blanket" his open collar. The sketch of the son on the following page (p. XLVII recto), now seen from the front and very close to, a sketch likewise extensively shaded with soft, parallel strokes, confirms this interpretation.

Previously unillustrated.

Page XLVI verso

Three Male Bathers
Graphite pencil; graphite offset from
page XLVII recto
Acc. no. 1987-53-75b

Rewald, 1951, p. 48 (described inac-
curately); Chappuis, 1973, no. 420

A study for the three figures at the
left side in paintings of five or six male
bathers (Venturi, 1936, nos. 541, 582,
590) of the early 1890s. The two at
the left are easily recognized, and
indeed appear in many other studies
in this sketchbook (see p. XLV verso).
The one at the right, more briefly
indicated and now obscured by
smudging, is the bather on the oppo-
site bank, lowering himself into the
water, of which there is a more com-
plete and vigorous study on the front
endpaper of this sketchbook.

Bathers
(Venturi, 1936, no. 590)

Page XLVII recto

The Artist's Son
1886–87
Graphite pencil over scored outlines
Numbered in pencil: XLVII
12.7 x 16.2 cm
Acc. no. 1987-53-76a

Rewald, 1951, p. 48; Andersen, 1970, no. 188 *bis* (confused with no. 143); Cooper, 1972, p. 414; Chappuis, 1973, no. 860

A rather careful sketch, now badly smudged, of Cézanne's son bending over, probably while reading or writing, as he is in several more fully realized drawings of the same years (Chappuis, 1973, nos. 853, 863, 867–69). His apparent age, fourteen or fifteen, suggests a date of 1886–87 and not eight years later as has been thought (Andersen); this is also the opinion of other scholars who have studied the whole sequence of portrait drawings of Cézanne *fils* (Cooper, Chappuis).

Page XLVII verso

Hanging Garment
Graphite pencil; graphite offset from
page XLVIII recto
12.7 x 16.2 cm
Acc. no. 1987-53-76b

Rewald, 1951, p. 48; Chappuis, 1973,
no. 860A

The sketchbook was held horizontally
with the binding at the left.

A slight sketch of the notched collar
of a coat or jacket that is evidently
draped over a horizontal bar at the
top; somewhat smudged.

Previously unillustrated.

Page XLVIII recto

Pitcher and Jar
Graphite pencil; graphite offset from
page XLVII verso
12.7 x 18.8 cm
Acc. no. 1987-53-77a

Rewald, 1951, p. 48; Chappuis, 1973,
no. 1080A

The sketchbook was held horizontally
with the binding at the right.

Although very incomplete, this
sketch of two familiar objects pro-
vides an unusually clear model of
Cézanne's vision and working pro-
cess. The half-glazed pottery jar and
the tall, hexagonal milk pitcher are
recognizable largely because they
often appear in his still lifes (e.g.,
Venturi, 1936, nos. 617–19), for both
are shown incompletely, the one

intercepted by the left edge of the
page, the other interrupted in the
middle. What clearly mattered more
was their interaction, the play of
straight and curved lines in their
silhouettes and the shapes these
project against the shaded wall
behind them. For Cézanne, even so
simple a motif could offer material of
absorbing interest.

Previously unillustrated.

Page XLVIII verso

Spirit Stove and Jug
Graphite pencil over scored outlines;
graphite offset from page XLIX recto
12.7 x 18.8 cm
Acc. no. 1987-53-77b

Rewald, 1951, p. 48, pl. 75; Chappuis
and Ramuz, 1957, p. 82, pl. 22;
Chappuis, 1973, no. 1080

Unlike the two domestic objects
shown on the recto of this page, these
two are centered in the field and
relatively complete. They, too,
appear often in Cézanne's still lifes,
especially the jug with the small neck
and handle (e.g., Venturi, 1936, nos.
499, 500, 609); the metal spirit lamp
appears less frequently (Rewald,
1983, no. 563; Chappuis, 1973, nos.
552, 959). A third object, probably a
covered sugar jar (see Venturi, 1936,
nos. 496–97), emerges as a blank

form, indicated solely by its silhou-
ette. Yet the vantage point Cézanne
chooses is so low that these small
household objects seem to loom up
large, as they do in the still lifes by
Chardin that he had seen in the
Louvre.

Page XLIX recto

Standing Male Bather
Graphite pencil; graphite offset from
page XLVIII verso
Numbered in pencil: XLIX
Acc. no. 1987-53-78a

Rewald, 1951, p. 48; Berthold, 1958,
p. 40, pl. 54; Chappuis, 1973, no. 436

Another study of the bather with
both hands clasped behind his head,
whose occurrence in Cézanne's work
and sources in older art were dis-
cussed previously (see p. XXXVIII recto
in this sketchbook). What is surpris-
ing in the present study—yet not
really surprising, for Cézanne—is the
redrawing of the lower legs to extend
them further: having drawn and
painted this bather countless times,
he seeks once more to approach it as if
for the first time.

Page XLIX verso

Male Bathers
Graphite pencil; graphite offset from
page L recto
Acc. no. 1987-53-78b

Rewald, 1951, p. 48, pl. 108 (incor-
rectly described); Hoog, 1971, p. 28
(left half only); Chappuis, 1973,
no. 421

Still another example of Cézanne's
ability (and need) to return to the
same problem repeatedly, each time
seeking a more satisfying solution.
Here the two bathers he so often
drew (see p. XLV verso in this sketch-
book) are drawn once again, with
slight variations in the positions of the
seated figure's legs and the standing
figure's stance. A second, fainter
sketch of the latter indicates his place-
ment in the paintings based on these
studies (Venturi, 1936, nos. 541, 582,
590).

Bathers
(Venturi, 1936, no. 590)

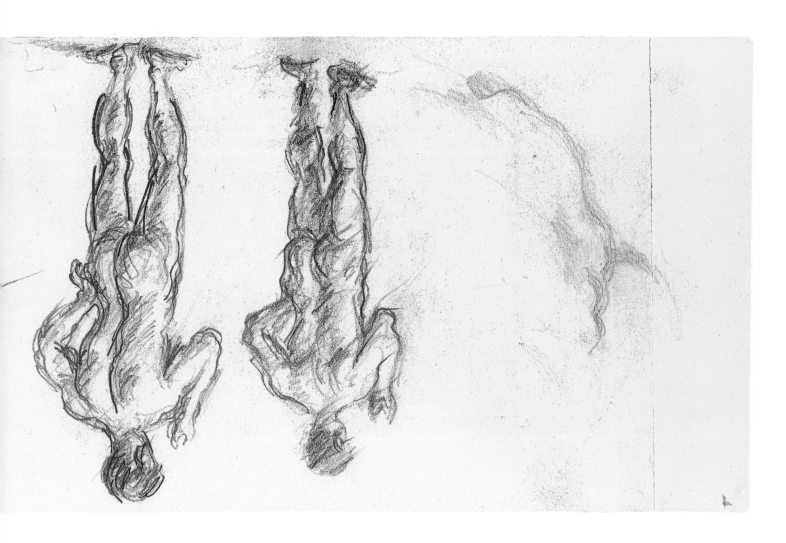

Page L recto

Standing Male Bather; Puget's Atlas
Graphite pencil; graphite offset from
page XLIX verso
Numbered in pencil: L
Acc. no. 1987-53-79a

Rewald, 1951, p. 48, pl. 109
(described incorrectly); Chappuis,
1973, no. 427

Two more studies of a bather type
Cézanne had already drawn and
painted many times (see p. XLV verso
in this sketchbook), but with a new
variation: the right arm, instead of
holding a towel, is now bent down
with the hand placed on or near the
hip. A further stage in this develop-
ment is seen in the corresponding
figure, now turned slightly to the left,
in a lithograph (Venturi, 1936, no.
1156) and two paintings (ibid., no.
387, dated too early; Rubin, 1977, pl.
203) of the late 1890s. Yet even the
two studies on this page, obviously
made on the same occasion, suggest

stages in a development, so numerous
are the subtle differences between
them. The placement of the right
hand relative to the hip, that of the
left hand relative to the head, the
delineation of the spine and shoul-
ders, the modeling of the buttocks
and calves—none of these is fixed
definitively for Cézanne; all are sub-
ject to an endless process of revision.

The faint sketch at the left, unrecog-
nizable in itself, can be identified by
comparison with the one on the verso
of this page as an incomplete copy
after one of Puget's Atlases.

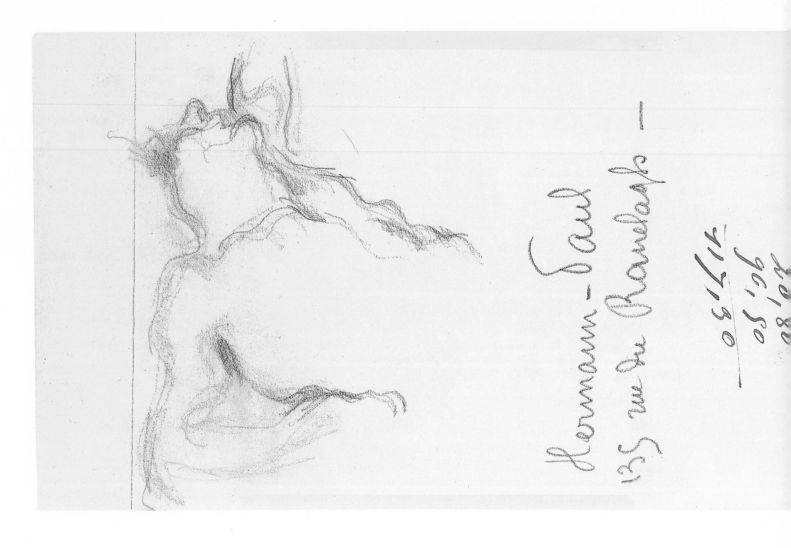

Page L verso

Puget's Atlas
After 1897, before 1905
Graphite pencil
Inscribed in graphite pencil at top:
Hermann-Paul / 135 rue du Rane-
lagh—; in brown ink, page inverted:
[numerical calculation]
Acc. no. 1987-53-79b

Rewald, 1951, p. 48; Berthold, 1958,
no. 130; Chappuis, 1973, no. 689A

The address is that which the graphic
artist Hermann-René-Georges Paul
(1864–1940) had after 1897 (when he
was still at 66 rue de Provence) and
before 1905 (when he was at 73 rue
des Vignes).

The copy on this page and the one
barely begun on the recto are the
latest and most eccentric of the five
that Cézanne drew after the Atlases
flanking Pierre Puget's monumental
portal for the Hôtel de Ville at
Toulon. Those of the Atlas at the
right (Sketchbook I, p. 15 recto;
Chappuis, 1973, no. 391) were evi-
dently made in the Louvre before the

plaster casts from which Cézanne
worked were transferred to the Musée
de Sculpture Comparée (no. G164) in
1886; and those of the Atlas at the left
(these two; Chappuis, 1973, no. 1132)
after the transfer. What is unusual
about the copies on both sides of this
page is the viewpoint Cézanne has
chosen: standing almost directly
below and far to one side—an angle of
vision much more possible at the
Trocadéro than at the Louvre—he
sees the figure's head and torso so
extremely foreshortened as to be
almost unrecognizable as such.

Previously unillustrated.

Page LI recto (missing)

Rewald, 1951, p. 48 (as accounts in
the hand of Cézanne, in ink)

Page LI verso (missing)

Page LII recto

Numbered in pencil: LII
Acc. no. 1987-53-80a

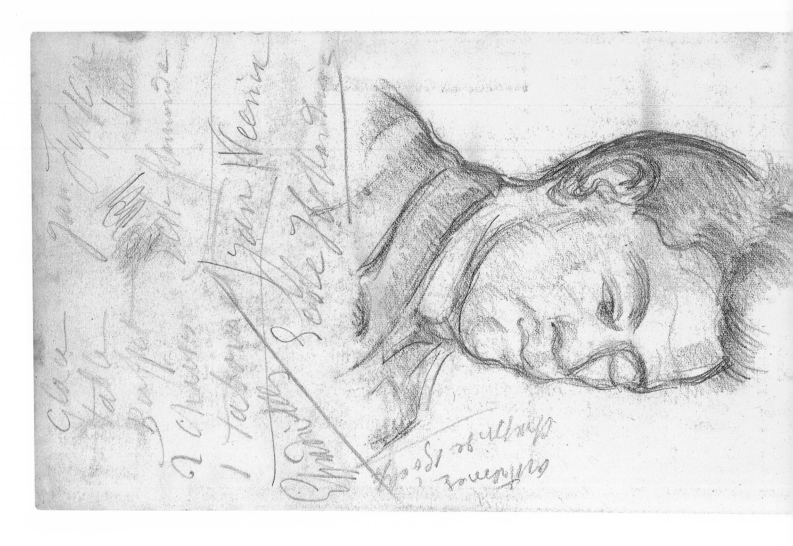

Page LII verso

The Artist's Son
1888–90
Graphite pencil; traces of oil paint;
graphite offset from back endpaper
Inscribed in graphite pencil, page
inverted, at left: Glace / table / Buffet /
2 chaises / 1 tabouret / Espadrilles; at
right: Jan Fyt [ill. wd.] / Ecole Fla-
mande / Jan Weenix / Ecole Hollan-
daise; at left, page horizontal:
outremer / chassis de 150 [ill. wd.]
Acc. no. 1987-53-80b

Rewald, 1951, p. 48, pl. 30;
Chappuis, 1973, no. 660

Although previously unrecognized as
such, this is surely a portrait of
Cézanne's son, who appears sixteen to
eighteen years old, about the same
age as in the well-known drawings of
him posing as Harlequin for the
painting *Mardi Gras* of 1888 (Chap-
puis, 1973, nos. 938–39) and other
drawings of those years (ibid., no.
872, etc.). In his conception of the
bust-length portrait, with the head
turned three-quarters to the right and
the features firmly defined and solidly

modeled, Cézanne may well have
been influenced by his studies in the
Louvre after Renaissance portrait
busts, especially the one of Filippo
Strozzi (see p. xxx recto in this
sketchbook).

The inscribed references are probably
to the chapters on Fyt and Weenix in
Charles Blanc's *Histoire des peintres de
toutes les écoles, Ecole flamande* (Paris,
1864), and *Ecole hollandaise* (Paris,
1861). Another reference to the same
publication is on p. 1 recto in this
sketchbook.

Back endpaper

Notations
Graphite pencil; colored pencil;
watercolor; traces of oil paint;
graphite offset
Numbered in pencil: LII x 2
Acc. no. 1987-53-81a

Rewald, 1951, p. 49

Inscribed, top to bottom: 2 laque /
fine / terre verte / cobalt / Sienne
Naturelle 1 / ocre jaune; second
column, largely canceled: Vermillon /
Outremer / [ill. wd.] 2 / Brun Rouge 2 /
Vert Emeraude 1; upper right: [ill.
wd.] / Baron Gérard / [numerical
calculation] / [ill. wd.] ,50 / Robinet 1 /
Bourse 1 / Essence ,80 / Huile ,40 /
lacet [ill. wd.] ,20 / [sum:] 3,90

Previously unillustrated.

Back cover
Linen-covered board; spots of oil
paint and watercolor
13.7 x 21.6 cm
Acc. no. 1987-53-81b

Andersen, Wayne V. "Cézanne's Sketchbook in the Art Institute of Chicago." *The Burlington Magazine*, vol. 104, no. 710 (May 1962), pp. 196–200.

———. "A Cézanne Drawing after Couture." *Master Drawings*, vol. 1, no. 4 (Winter 1963), pp. 44–46.

———. "Cézanne's *Carnet violet moiré.*" *The Burlington Magazine*, vol. 107, no. 747 (June 1965), pp. 313–18.

———. *Cézanne's Portrait Drawings*. Cambridge, Mass., 1970.

Ashton, Dore. *Picasso on Art: A Selection of Views*. New York, 1972.

Bernard, Emile. *Souvenirs sur Paul Cézanne*. Paris, 1926.

Berthold, Gertrude. *Cézanne und die alten Meister*. Stuttgart, 1958.

Bieber, Margarete. *The Sculpture of the Hellenistic Age*. Rev. ed. New York, 1981.

Cézanne, Paul. *Letters*. Edited by John Rewald. Rev. ed. New York, 1984.

Chappuis, Adrien. *Les Dessins de Paul Cézanne au Cabinet des Estampes du Musée des Beaux-Arts de Bâle*. 2 vols. Olten and Lausanne, 1962.

———. "Cézanne dessinateur: Copies et illustrations." *Gazette des Beaux-Arts*, vol. 66 (1965), pp. 293–308.

———. *The Drawings of Paul Cézanne*. 2 vols. Greenwich, Conn., 1973.

———, and Ramuz, C.-F. *Dessins de Cézanne*. Lausanne, 1957.

Columbia University, New York. *Cézanne Watercolors*. April 2–20, 1963.

[Cooper, Douglas.] "The Chronology of Cézanne." *Times Literary Supplement*, April 14, 1972, p. 414.

Enlart, Camille, and Roussel, Jules. *Catalogue général du Musée de Sculpture Comparée au Palais du Trocadéro*. 3 vols. Paris, 1925–28.

Froehner, Wilhelm. *Notice de la sculpture antique du Musée National du Louvre*. Paris, 1869.

Fürtwangler, Adolf. *Masterpieces of Greek Sculpture*. London, 1895 (orig. ed. Leipzig and Berlin, 1893).

Gasquet, Joachim. *Cézanne*. Paris, 1926.

Héron de Villefosse, Antoine. *Musée National du Louvre, Catalogue sommaire des marbres antiques*. Paris, 1896.

Hoog, Michel. *L'Univers de Cézanne*. Paris, 1971.

Imbourg, Pierre. "Cézanne et ses logis." *Beaux-Arts*, January 20, 1939, p. 3.

Larguier, Léo. *Le Dimanche avec Paul Cézanne*. Paris, 1925.

Lichtenstein, Sara. "Cézanne and Delacroix." *The Art Bulletin*, vol. 46, no. 1 (March 1964), pp. 55–67.

———. "Cézanne's Copies and Variants after Delacroix." *Apollo*, vol. 101 (February 1975), pp. 116–27.

Michon, Etienne. *Musée National du Louvre, Catalogue sommaire des marbres antiques*. Paris, 1918.

Musée National du Louvre, Paris. *Catalogue des peintures exposés dans les galeries*. 3 vols. Paris, 1922–24.

———. *Catalogue des sculptures du moyen âge, de la renaissance, et des temps modernes*. 2 vols. Paris, 1922.

———. *Catalogue sommaire des marbres antiques*. Paris, 1922.

Museum of Fine Arts, Houston. *Cézanne Sketch Books*. February 2–28, 1962.

Neumeyer, Alfred. *Cézanne Drawings*. New York, 1958.

Reff, Theodore. "Cézanne's Drawings, 1875–85." *The Burlington Magazine*, vol. 101, no. 674 (May 1959), pp. 171–76.

———. "Cézanne: The Enigma of the Nude." *Art News*, vol. 58, no. 7 (November 1959), pp. 26–29.

———. "New Sources for Cézanne's Copies." *The Art Bulletin*, vol. 42 (June 1960), pp. 147–49.

———. "Cézanne's Bather with Outstretched Arms." *Gazette des Beaux-Arts*, vol. 59 (1962), pp. 173–90.

———. "Cézanne and Hercules." *The Art Bulletin*, vol. 48 (March 1966), pp. 35–44.

Reiset, Frédéric. *Notice des dessins . . . exposés . . . au Musée Impérial du Louvre*. 2 vols. Paris, 1866–69.

Rewald, John. *Cézanne, sa vie, son oeuvre, son amitié pour Zola*. Paris, 1939.

———. *Paul Cézanne: Carnets de dessins*. 2 vols. Paris, 1951.

———, ed. *Paul Cézanne: Sketchbook, 1875–1885*. 2 vols. New York, 1982.

———. *Paul Cézanne: The Watercolors*. Boston, 1983.

Rivière, Georges. *Le Maître Paul Cézanne*. Paris, 1923.

Rousseau, Theodore, Jr. *Paul Cézanne*. New York, 1953.

Rubin, William, ed. *Cézanne: The Late Work*. New York, 1977.

Schapiro, Meyer. *Paul Cézanne*. New York, 1952.

———. "The Apples of Cézanne." *Art News Annual*, no. 34 (1968), pp. 35–53.

[Schniewind, Carl, ed.] *Paul Cézanne: Sketch Book Owned by the Art Institute of Chicago*. 2 vols. New York, 1951.

Taillandier, Yvon. *Paul Cézanne*. Paris, 1961.

Venturi, Lionello. *Cézanne, son art—son oeuvre*. 2 vols. Paris, 1936.

Vollard, Ambroise. *Paul Cézanne*. Paris, 1914.

Bibliography

List of Comparative Illustrations

Page 59

Page 60

Pages 88, 167, 186, 222:
Pierre Puget (1622–1694)
Hercules Resting
Marble, height 160 cm
Musée du Louvre, Paris
Photograph: R.W. Ratcliffe

Page 90:
Claude Lefèbvre (1632–1675)
Portrait of a Man
Oil on canvas, 76 x 62 cm
Musée du Louvre, Paris. Inv. 4381
Photograph: Musées Nationaux

Pages 91, 214:
Antoine-Louis Barye (1796–1875)
Lion and Serpent
Bronze, height 135 cm
Musée du Louvre, Paris
Photograph: R.W. Ratcliffe

Page 97:
Joseph Vernet (1714–1789)
Women Bathers (Morning)
Oil on canvas, 98 x 162 cm
Musée du Louvre, Paris. Inv. 8329
Photograph: Musées Nationaux

Page 98:
Jean-Antoine Houdon (1741–1828)
Flayed Man
Plaster cast
Ecole des Beaux-Arts, Paris
Photograph: Giraudon

Page 100:
Marsyas
Antique marble, height 256 cm
Musée du Louvre, Paris
Photograph: Musées Nationaux

Pages 102, 107, 195:
Luca Signorelli (1440–1525)
Standing Male Nude
Black chalk, 41 x 25 cm
Musée du Louvre, Cabinet des Dessins,
Paris. Inv. 1797
Photograph: Musées Nationaux

Page 114:
Hermes
Antique marble
Musée du Louvre, Paris
Photograph: Giraudon

Pages 115, 139, 156, 221:
Guillaume Coustou (1677–1746)
Pierre-François Darerès de La Tour
Terra-cotta, height 39 cm
Musée du Louvre, Paris
Photograph: R.W. Ratcliffe

Pages 118, 145:
Paul Cézanne
Cardplayers, 1890–92
Venturi, 1936, no. 560
Oil on canvas, 134 x 181 cm
The Barnes Foundation, Merion, Pa.
Photograph © Copyright 1989
by The Barnes Foundation

Pages 119, 226, 232:
Paul Cézanne
Bathers, 1892–94
Venturi, 1936, no. 590
Oil on canvas, 30.5 x 40.5 cm
The Barnes Foundation, Merion, Pa.
Photograph © Copyright 1989
by The Barnes Foundation

Page 122:
Alonso Cano (1601–1667)
The Dead Christ
Wood engraving
From Charles Blanc, *Histoire des peintres de
toutes les écoles, Ecole espagnole* (Paris, 1869)
Philadelphia Museum of Art

Page 126:
Paul Cézanne
Five Bathers, 1879–82
Venturi, 1936, no. 389
Oil on canvas, 34.6 x 38.1 cm
Detroit Institute of Arts.
Bequest of Robert H. Tannahill

Page 127:
Paul Cézanne
Four Female Bathers, 1879–82
Venturi, 1936, no. 386
Oil on canvas, 27 x 35 cm
The Barnes Foundation, Merion, Pa.
Photograph © Copyright 1989
by The Barnes Foundation

Pages 132, 224:
Paul Cézanne
Bathers, 1883–87
Venturi, 1936, no. 541
Oil on canvas, 39 x 53 cm
Private collection
Photograph courtesy John Rewald

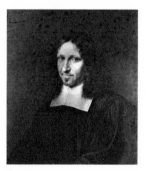
Page 90

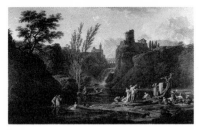
Page 97

Page 145:
Antonin Mercié (1845–1916)
David
Bronze, height 188 cm
Musée du Louvre, Paris
Photograph: Bulloz

Pages 146, 152, 203, 207:
Paul Cézanne
Bathers, 1883–87
Venturi, 1936, no. 540
Oil on canvas, 39 x 44 cm
Private collection
Photograph courtesy John Rewald

Page 147:
Borghese Mars
Antique marble
Musée du Louvre, Paris
Photograph: R.W. Ratcliffe

Page 158:
*Young Man Pulling a Thorn from His Foot
(Spinario)*
Plaster cast of antique marble

Pages 162, 187:
Peter Paul Rubens (1577–1640)
Capture of Jülich
Oil on canvas, 394 x 295 cm
Musée du Louvre, Paris. Inv. 1781
Photograph: Musées Nationaux

Page 163:
Jean-Baptiste Pigalle (1714–1785)
Love and Friendship
Marble, height 144 cm
Musée du Louvre, Paris
Photograph: R.W. Ratcliffe

Page 165:
Jean-François Millet (1814–1875)
The Reaper
Black chalk, 28.3 x 10.1 cm
Musée du Louvre, Cabinet des Dessins,
Paris

Page 183:
Hermes Fixing His Sandal
Antique marble, height 154 cm
Musée du Louvre, Paris
Photograph: R.W. Ratcliffe

Pages 185, 218:
Michelangelo Buonarroti (1475–1564)
Dying Slave
Marble, height 228 cm
Musée du Louvre, Paris
Photograph: R.W. Ratcliffe

Pages 191, 208:
Aphrodite and Eros
Antique marble, height 180 cm
Musée du Louvre, Paris
Photograph: R.W. Ratcliffe

Page 192:
Formerly attributed to Michelangelo
Flayed Man
Plaster cast

Page 194:
Paul Cézanne
The Toilette
Venturi, 1936, no. 254
Oil on canvas, 32 x 25 cm
The Barnes Foundation, Merion, Pa.
Photograph © Copyright 1989
by The Barnes Foundation

Page 196:
Michelangelo Buonarroti (1475–1564)
The Resurrection
Red chalk, 15.5 x 17 cm
Musée du Louvre, Cabinet des Dessins,
Paris. Inv. 691 *bis*
Photograph: Musées Nationaux

Page 197:
Luca Signorelli (1440–1525)
Two Women and Two Men
Black chalk, 29.5 x 36.8 cm
Musée du Louvre, Cabinet des Dessins,
Paris. Inv. 1794
Photograph: Musées Nationaux

Page 204:
François Boucher (1703–1770)
Forge of Vulcan
Oil on canvas, 90 x 121 cm
Musée du Louvre, Paris. Inv. 1022
Photograph: Musées Nationaux

Page 212:
Peter Paul Rubens (1577–1640)
Apotheosis of Henry IV
Oil on canvas, 394 x 727 cm
Musée du Louvre, Paris. Inv. 1779
Photograph: Musées Nationaux

Page 216:
Peter Paul Rubens (1577–1640)
*Maria de' Medici Receives Offers of Peace
(Treaty of Angoulême)*
Oil on canvas, 394 x 295 cm
Musée du Louvre, Paris Inv. 1786
Photograph: Musées Nationaux

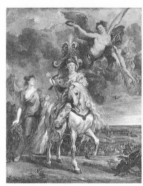

Pages 162, 187

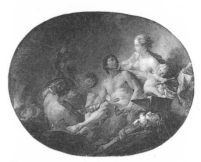

Page 204

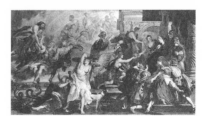

Page 212

Page 216